The Tribal Eye

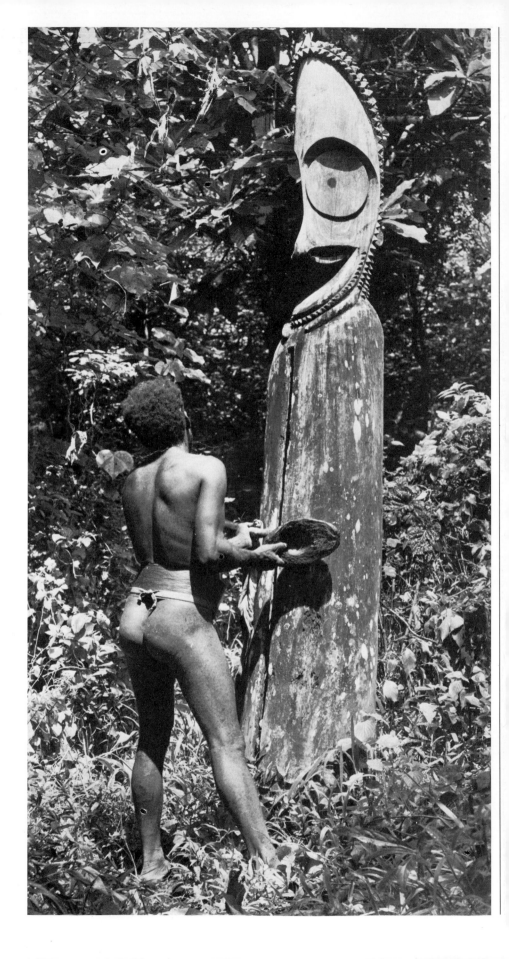

A log-gong. North Ambrym,
New Hebrides

David Attenborough

The Tribal Eye

W. W. Norton & Company Inc.
New York

First published in Great Britain in 1976
by the British Broadcasting Corporation

Copyright © 1976 by David Attenborough

Published in the United States by
W. W. Norton & Company Inc.

ISBN 0-393-04466-1

Printed in England

1 2 3 4 5 6 7 8 9 0

Contents

1 Behind the Mask 13

2 Crooked Beak of Heaven 27

3 Sweat of the Sun 47

4 Kingdoms of Bronze 69

5 Woven Gardens 89

6 Cult Houses 105

7 Across the Frontiers 123

 Further Reading 142

 Index 143

Camera

Philip Bonham Carter
Nat Crosby
Henry Farrar
Ray Henman
John Hooper

Second Camera

John Adderly
Remi Adefarasin
Paul Houlston
Michael Radford
Rick Stratton
Dave Wallace

Location Sound

Alan Cooper
Colin March
John Murphy
Roger Turner
Ian Sansam
Simon Wilson

Studio Sound

Ron Edmunds

Lighting

Robert Julian
Dennis Kettle

Film Editors

Dick Allen
Pam Bosworth

Sound Editors

Alan Bradley
Barry Domleo

Administration

Alexandra Branson
Ann Russell

Research and Museum Direction

Anna Benson Gyles

Directors

David Collison
Michael Macintyre

Executive Producer

Paul Johnstone

Consultants

Humphrey Akenzua
Joan Allgrove
Warwick Bray
Anna Craven

William Fagg
Hans Guggenheim
Kirk Huffman
Peter Macnair

Acknowledgements

This book is based on a series of films made for BBC Television. Films are not produced by individuals but by teams, and it was the great good fortune of 'The Tribal Eye' series that the many people who worked on it should all have become so absorbed in the subject that they contributed to its making in ways that very often went far beyond a routine involvement. Researchers made suggestions about narrative shape; recordists pressed that woolly clichés should be changed into accurate observations; film editors pointed to visual significances that had escaped others; and cameramen, unobtrusively and often unconsciously, shaped the way that the rest of us saw things by their own enquiring and perceptive vision. Above all, the directors, David Collison and Michael Macintyre, listened to everybody, evaluated everything and were the main architects of the finished films. I am grateful to them all, without exception, and their names are listed opposite.

I am also indebted to the expert consultants whose names appear in the same list. They not only deflected me from error on celluloid but most generously strove to repeat the feat on the printed page by reading, wherever possible, the relevant chapters in manuscript. Thereafter, Peter Campbell of BBC Publications with tact, flair and extraordinary expedition, turned the manuscript into a book. My debt to him will be apparent from the pages that follow.

Above all, however, I owe my thanks to the countless people we visited during the course of making the films. They trustingly allowed us to be present on private occasions. They answered all our questions with great patience and were not offended by our insensitivities. Throughout, they treated us with unfailing hospitality and kindness. This book is intended to be a celebration of their genius.

David Attenborough
August 1976

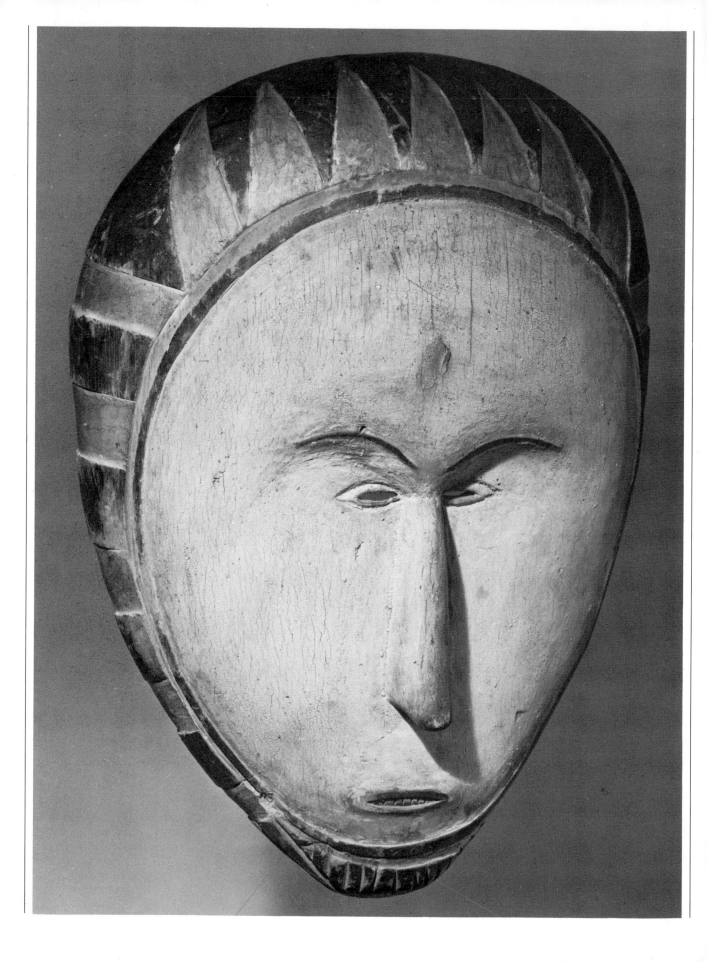

Introduction

Some time in 1904, a young artist, Maurice de Vlaminck, saw in a bistro in a Paris suburb two small African wooden figures standing among the bottles above the counter. African sculpture was not unfamiliar to him. Seven years earlier, one of the first museums to be devoted entirely to the arts and crafts of people overseas had opened, at the Trocadéro in Paris. When Vlaminck and a painter friend of his, André Derain, had first visited the museum they had thought the masks and fetishes there to be grotesque, misshapen and ugly. Now, in the bistro, he was suddenly struck by the expressive power of the two figures on the shelf. He bargained with the proprietor. Eventually, for the price of drinks all round, they became his.

Vlaminck took the figures back to his studio, greatly impressed by what he later described as their 'profound sense of humanity'. Soon afterwards, his father, hearing of his son's new enthusiasm, gave him two more statues from the Ivory Coast and a white mask from Gabon which the wife of a friend had been about to throw into the dustbin. When Derain saw them, he was so excited that he persuaded Vlaminck to sell the mask to him. Picasso, then aged twenty-three, and Matisse, a few years older, saw this particular mask in Derain's studio and became infected with the new excitement. Before long the passion for such barbaric objects spread among Parisian artists who searched for them in the curio shops of the Left Bank. Braque wrote afterwards that these African masks had opened new horizons for him, bringing him into contact with 'instinctive things'. He acquired an austere geometrical mask that had been carved by the Fang people of Gabon and hung it on his studio wall alongside a mandolin and other objects that served as subjects for his still-life studies. Matisse, too, bought many pieces, the foundations of a collection that he was to add to throughout his long life. So a fuse was lit that was to set off an artistic explosion. Its echoes still reverberate in studios and galleries all over Europe and America.

The Parisian artists were not, of course, the first to recognise that objects made by Africans or South Sea Islanders had aesthetic merit. Anthropologists had been describing such things and debating their meaning and value for a quarter of a century. At that time, scientific thought was dominated by the concept of evolution, which Charles Darwin had so recently and so brilliantly demonstrated in the animal world. Anthropologists were looking

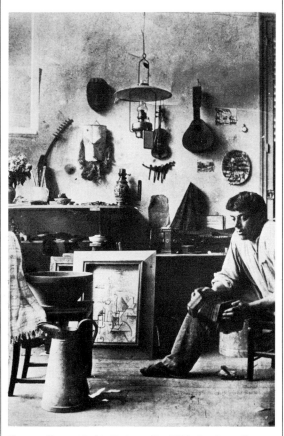

Georges Braque in his Paris studio, 1911. On the wall, a Fang mask from Gabon

Facing
Mask sold by Maurice de Vlaminck to André Derain in 1905. Wood painted white. Fang. Ht 48cm

at their own subject matter from a similar point of view. They assumed that the tribes of Africa and elsewhere represented early stages in the evolution of human society, that they were people who, for some reason, had failed to develop a high sophisticated culture like that of Europe.

There were two theories as to why tribal people carved in such a bizarre, unnaturalistic way. One suggested that the earliest decorations made by mankind were derived from geometric patterns such as those produced when woven or plaited material was pressed into clay. These patterns had then been elaborated into diagrammatic shapes to which their creators attached meanings. A second theory argued that the evolutionary process had worked in exactly the opposite way. According to this view, man's drawing had originally been extremely naturalistic, but this direct inspiration from nature had happened only infrequently. Subsequent generations merely copied from the images created by a few gifted ancestors, with the result that, over the years, the designs had become simplified and distorted. To prove the point, experiments were conducted in which chains of people copied a single drawing and the experimenter triumphantly demonstrated that at the end of the process the design had indeed become greatly changed and stylised.

Anthropologists of both schools, however, were agreed that the products of tribal people were primitive. The artists clearly lacked the manual skill and the aesthetic sensibility to produce properly finished naturalistic works. It occurred to none that the sculptors of Africa had had entirely different goals.

The Parisian artists either knew nothing of these scholarly debates or paid no attention to them. For Vlaminck and his friends, the sculptures they had found were sensational demonstrations that naturalism was not the only way in which an artist could express himself. They recognised that African sculptors had not been concerned to represent the superficial appearance of the world but were, instead, striving to represent a different reality, to make visible the invisible. Thus these exotic sculptures provided solutions to just the problems facing the Parisian painters who were trying to break away from the academic naturalism that had dominated Western European art for nearly two thousand years.

Painters were soon experimenting with shapes suggested by these barbaric images. Picasso, who had been painting gentle almost sentimental pictures of clowns, pierrots and acrobats, started making studies that were to result, in 1907, in *Les Demoiselles d'Avignon*, in which two of the angular, prancing nude figures have heads that are clearly based on African masks. Braque, wanting to abandon conventional rules of perspective, used similar shapes to represent three-dimensional objects on a flat canvas in a way that was to become known as Cubist. Matisse, Derain and Vlaminck painted human figures in a simplified geometrical style, using colours as brilliant as the shapes were angular. A critic, coming reeling from one of their joint exhibitions, called the group *Les Fauves*, the Wild Beasts. And the public was outraged.

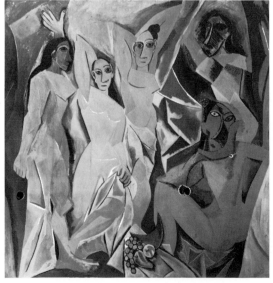
Les Demoiselles d'Avignon by Picasso, 1907

But within a few years, visitors to art galleries began to appreciate the power of these new ways of representing the world. If the Parisian painters owed a debt to African sculptors, they repaid it now, for as people began to understand the new pictures in their art galleries, they also began to recognise the qualities of the sculptures that were exhibited in their ethnographic museums. And now the pendulum swung the other way. Anthropologists had in the past denied great artistic merit to negro sculpture. Now art critics, enthusing about such carvings, denied the value of ethnographic documentation. Indeed, some went so far as to claim that it was better to ignore such background information. It merely confused the spectator's appreciation of the sculptural, plastic qualities of the objects, they said. Roger Fry, the eminent British critic, claimed that the best of African sculptures were 'greater than anything we have produced even in the Middle Ages'.

And yet the label 'primitive' still stuck, even though it has such patronising, indeed insulting overtones. Franz Boas, in his pioneering work on the subject published in 1927, used the title *Primitive Art*. So did Leonhard Adam for his influential paperback of 1940. 'Primitive' has continued to appear in the titles of the numerous sumptuously illustrated surveys that have been published since then. In 1954, a museum was founded in New York to house Nelson Rockefeller's great ethnographic collection; it aimed to display its objects primarily as works of art. Sensing, perhaps, the problems of the word 'primitive', the first name proposed was Museum of Indigenous Art, but this largely meaningless title was soon abandoned and the institution fell back on earlier terminology and became known as the Museum of Primitive Art.

If the description 'primitive' now seems so unsuitable as to be unacceptable, what other word can be used to describe the great body of carvings, bronze castings, bark paintings and fabrics that fill such institutions as the Musée de l'Homme in Paris and the Museum of Mankind in London? 'The art of preliterate non-industrial societies' would be a more accurate description, but it is hardly neat. 'Tribal art' is a succinct alternative. It can be argued that the Incas who created such a sophisticated civilisation in the Andes or the Bini who built an empire in West Africa were hardly mere tribes. And while there are those, particularly in North America, who regard the word 'tribal' as a compliment, there are others who take it as an insult. However, as there is no brief term that is totally acceptable and as 'tribal' is at least less patronising and inaccurate than 'primitive', it is the one that is used in this book.

Today, tribal art is collected with as much passion and financial zest as is lavished on the works of contemporary artists working in European and American cities. Art galleries mount exhibitions of tribal rugs and provide catalogues in which the aesthetic qualities of the exhibits are discussed in the same critical terms as abstract paintings. Hawaiian carvings in sale rooms fetch sums as high as Fauve pictures, and bronzes cast 300 years ago in West Africa can

be relied upon to outprice those made during the same period by the masters of Renaissance Italy.

Works of art are acts of communication. They inform us, powerfully and subtly, of the imaginative world inhabited by their creators. The works of a great painter such as Vermeer can give us a unique emotional insight into life in seventeenth-century Holland. We can sense what Vermeer found beautiful, what he loved and what he feared, how he saw the world and man's place in it. That message is relatively easy for us to comprehend, for we are inheritors of a cultural tradition and a history that extends unbroken to the time of Vermeer and beyond. A Congo statuette can speak just as eloquently, but the world it comes from is substantially different from our own and we share few of its traditions. To understand its message fully, and to appreciate its qualities, we have to know something about the artist who produced it, the society to which he belonged and the purposes for which he made it.

This book, like the television films on which it is based, seeks, therefore, to take some of the masks and statues from the velvet plinths and spotlights of our museums and, without losing sight of their aesthetic merits, examine them afresh in the context of the societies and landscapes that produced them.

The territory of the Dogon

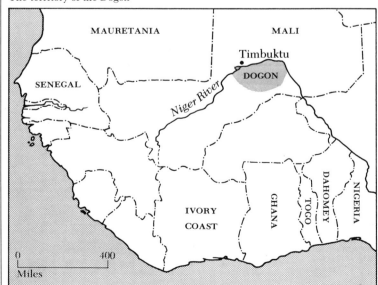

12

Behind the Mask

African sculpture is marvellously varied. Each of the many tribes that carve does so in its own identifiable style, and sometimes in several. Although generalisations about such a vast and diverse output are dangerous, one characteristic links most of the carvings – a bold disregard for realism. The African sculptor, like tribal artists all over the world, has no hesitation in distorting natural proportions if it suits his purpose; and this freedom of style allows him to exploit to the full his genius for conveying the most profound human emotions with simple yet subtle shapes.

Some of the most austerely stylised figures of all are made by the Dogon, a tribe living in Mali, in the Western Sudan. Their sculptors reduce bodies to cylinders, arms to rods, eyes to diamonds, breasts to cones. Yet their images often have a brooding monumental presence that makes many a naturalistic statue pale into vapidity. They also carve a rich variety of masks, forge iron figures, and cast bronzes.

The Dogon are one of the few African tribes whose sculptural traditions have remained very little affected by outside influences. They owe their isolation to their land. It lies south of the Niger River in the wilderness of rock, barren sands and stunted thorn scrub that separates the Sahara from the lushness of the West African rain forest. No trade route crosses it. No natural riches tempt others to claim it. Much of the year it roasts in the grip of a pitiless drought. Its flatness is broken by lines of yellow sandstone cliffs, in places 700 feet high. At their foot, among the jumbled blocks of rock and the bloated trunks of cotton trees, the Dogon build their villages.

Each settlement has its rectangular fields of onion or millet scratched in the thin sandy soil and divided into small square plots to which the women every day carry water from wells perhaps half an hour's walk distant. A few goats graze the sparse thorn bushes. Beside the track that leads into a village stands a sacrificial mound of sun-baked mud, stained white with libations. Inside the village, a maze of high-walled alleys winds between the mud-brick houses. Each house consists of a rectangle of flat-topped chambers grouped around a tiny courtyard with, in one corner, a tall granary capped with a cone of straw thatch. The grandest, the *ginnas*, homes of important families, have elaborate façades divided into squares, each a niche a hand's-breadth across, in which offerings can be left. Embedded in the walls of the houses of

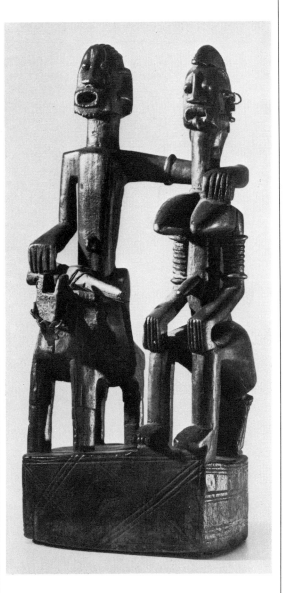

Primordial couple. Wood. Dogon. Ht 57cm

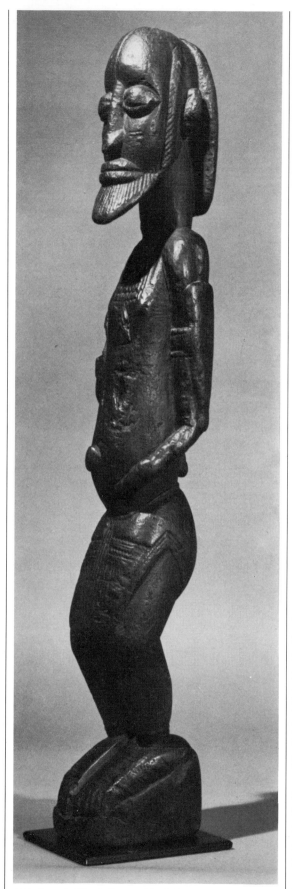

A blacksmith. Wood. Dogon. Ht 63.5cm

hunters are hundreds of bleached animal skulls – ibis, gazelle, monkey, baboon. Every village has at least one *toguna*, a shelter with a low roof supported on wooden pillars and thatched, yards thick, with reeds. In its dark coolness, the men habitually meet. It is a place denied to women. And suddenly, as you turn a corner, you will come upon a shrine, disturbingly like a human face. The deep niches sunk into its façade resemble eyes; white libations and black trickles of congealed blood streak from the altar on its peak down its forehead; its mouth-like entrance is blocked with stones.

You will not wander alone. Even if you had arrived without a guide, men will appear wanting, politely, to know your business, and you will be told, suddenly and unexpectedly, that you may not take this turning or walk across that open space, for the buildings of the village and the whole of the land on which it stands are charged with magical significance.

The village itself symbolises a human body, lying north and south. The *toguna* and the blacksmith's forge in the north mark the head. The *ginnas* and other family houses form the belly. The two seclusion houses for women, on the east and west sides, are the figure's hands. There are two important shrines in the centre which are the genitals, one male and one female, and two lesser altars mark the feet.

A similar symbolism occurs in each *ginna*. The figure here is lying on its right side, as a man does on his marriage bed and as he will be laid in his grave. The kitchen represents his head, the hearth stones his eyes. The main living chamber is his belly and the two jars of water that are always placed on either side of the entrance to it are breasts. His penis is represented by a narrow passage leading to a small workroom where millet is ground.

How meaningful such symbolism is to the villagers and how much these interpretations are merely convenient geographical metaphors is still a matter of anthropological debate. Our knowledge of them comes from Marcel Griaule, the French anthropologist who first visited the Dogon in 1931, and from his followers who have continued his work. Griaule himself had a particular interest in mythology, and the cosmic beliefs of the Dogon fascinated him. Later scholars have suggested that eventually he found more significance in the details of Dogon life than the people do themselves. His supporters reply that if anthropologists have difficulty in comprehending the all-pervasive symbolism perceived by Africans, that is only typical of the many obstacles that can prevent a European from gaining a true insight into the profoundly different subjective world of tribal Africa.

A stranger wandering through a Dogon village would never suspect that the inhabitants are renowned as artists. There are no carvings to be seen. But they are there, hidden. Dogon sculpture is not intended for indiscriminate public display. Most of their statues are intensely private objects, kept concealed from unprivileged eyes.

Nearly all these secret images in a village are made by one man. He is a magician, a man apart from all others – the blacksmith. He

takes iron from the earth, the realm of the dead, and with the aid of fire, fanned by air from the world of the living, he produces images. Dogon mythology tells how the first smith visited heaven and stole a piece of the sun and brought it, an ingot of glowing iron, down the rainbow to earth. At that time the ancestors had not yet acquired a fully human form. Their limbs were sinuous and snake-like. As the smith fled from heaven he carried his hammer cradled in his arms across his chest, and his anvil slung behind him from a rope over his shoulder. He landed on earth with such a crash that he broke both his legs and arms, which is how mankind acquired elbows and knee-joints.

The secrets of how to handle iron and coax it into tools, weapons and images has remained the exclusive possession of the smith's descendants ever since. They may only be revealed to members of his own family, and the child of a smith may only marry another smith's child. A smith is not allowed to own land or to work in the fields. Other men come to him and ask him to make knives and hoes so that they may grow millet and when the harvest comes they will give him a portion of it. Hunters pay him to make spearheads and even to hammer out new parts for their ancient muzzle-loading flint-lock muskets. The priest will commission

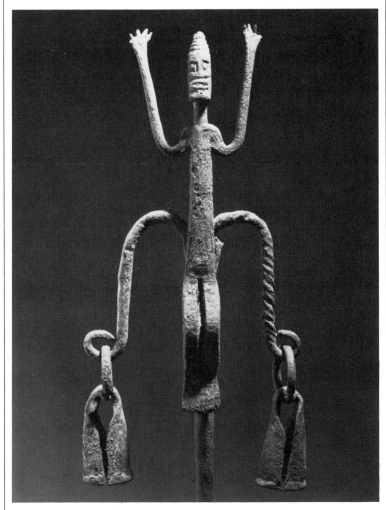

Spirit figure on the head of a ritual staff. Iron. Dogon. Ht of figure 19cm

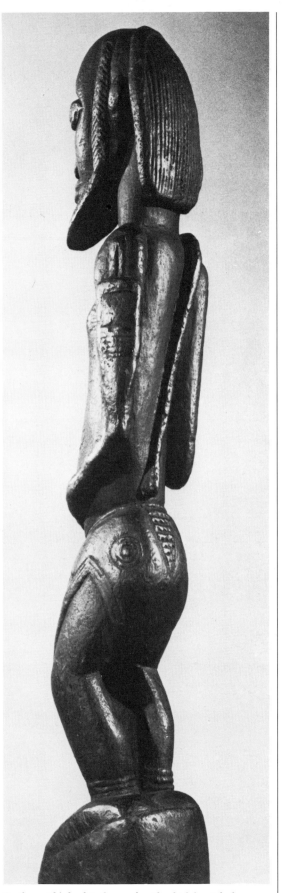

On the smith's back is the crook with which he stole fire.

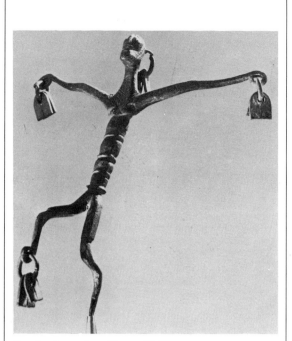
Dancing figure. Iron. Dogon. Ht 15cm

the smith to make simple gaunt figures of iron with splayed hands, often hung with bells, that are placed in the shrines.

The smith also works with wood for he is the carver of most of the masks and figures that are essential for the correct performance of ritual. Dogon life is permeated by rituals. A boy first takes part in them when, at puberty, he is circumcised and made a member of the *awa*, the men's secret society. The *awa* is ruled by the elders. It has its own secret language that women and children cannot understand. Its officials control all the village ceremonials and its members dance at them wearing masks. During the long celebrations that surround circumcision, the initiate must eventually appear wearing a mask that he has made himself, the *kanaga*. It is a simple wedge of wood pierced with holes for eyes, a thin slit for a mouth and surmounted by a cross of Lorraine that some say represents a crocodile and others a man. It is one of the very few carvings not made by the smith. As the young man grows older and becomes more important, he takes an increasingly active part in the ceremonials. He will help to celebrate the important sacrifices necessary to ward off drought and maintain the fertility of the fields. He will dance at the funerals of important men. He will take part in the *sigi*, the long cycle of rituals that provides the spine to a man's religious life and which takes sixty years to complete. And for all these occasions he will require a mask.

Marcel Griaule listed over a hundred different kinds of masks used by the Dogon. They represent antelope, hares, crocodiles and monkeys, spirits, warriors and women from other tribes, for the whole world of the Dogon has to be portrayed in their dances. A man may not wear any mask that takes his fancy. He must apply to the Master of Masks, one of the most senior officials of the *awa*, who will determine what kind of mask he has the right to use. Then he must commission the blacksmith to make it.

A smith with whom we had become friends had been asked to carve a monkey mask. He and the Master of Masks inspected some cotton trees, close relatives of the baosab, growing among the rocks half a mile from the village. Cotton trees have immense cylindrical trunks and stumpy misshapen branches. The smith decided that one of them could provide the wood he required. The Master dug a small hole with his knife in the earth among the roots and, with a muttered prayer, dropped a cowrie shell into it. Cowries, which come across the continent from the Indian Ocean, 3000 miles away, have been used for centuries as currency throughout this country and they are still the essential form of payment in many traditional transactions. The cotton tree was about to be robbed of one of its branches. Some payment, some placation had to be made.

The smith's assistant clambered up the tree with an axe and soon a stout branch crashed to the ground. The smith examined it for cracks or blemishes, quickly cut a section from the middle of its length, and the whole party took it to a small cave among the rocks. There the smith began work. The carving could not be done in the village for others might see it.

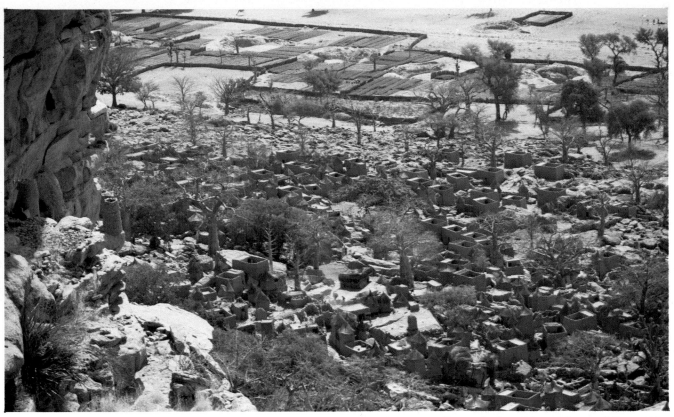

A Dogon village at the foot of the Bandiagara cliffs. At its far edge cultivated fields, and beyond, the beginning of the desert

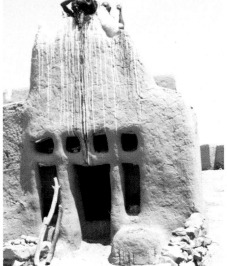

The sacrifice of a goat at a village shrine

A *ginna*, a great house

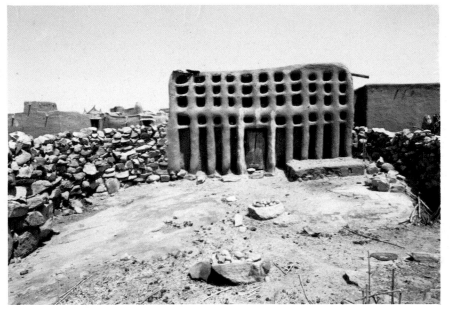

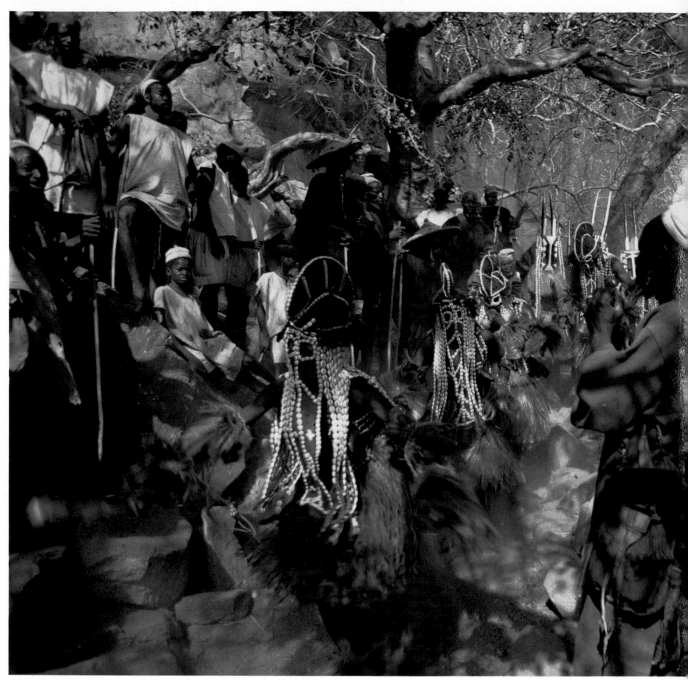

Masked dancers of the Dogon *awa*

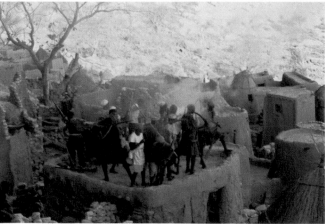

Dogon men dancing at a funeral on the roof of the dead man's house

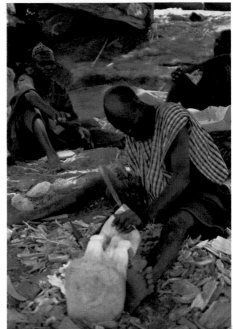

A Dogon smith carving a figure, supervised by the Master of Masks

Staining a newly made monkey mask

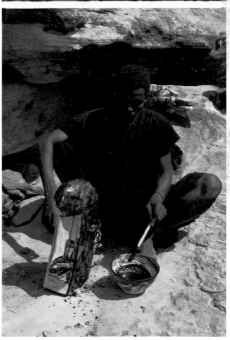

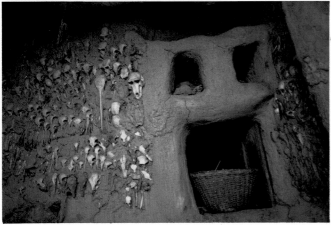

The household shrine of a Dogon hunter

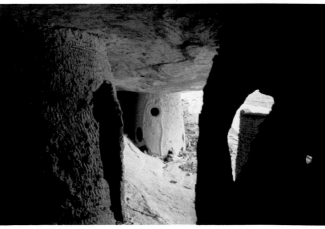

Buildings within a Tellem cave

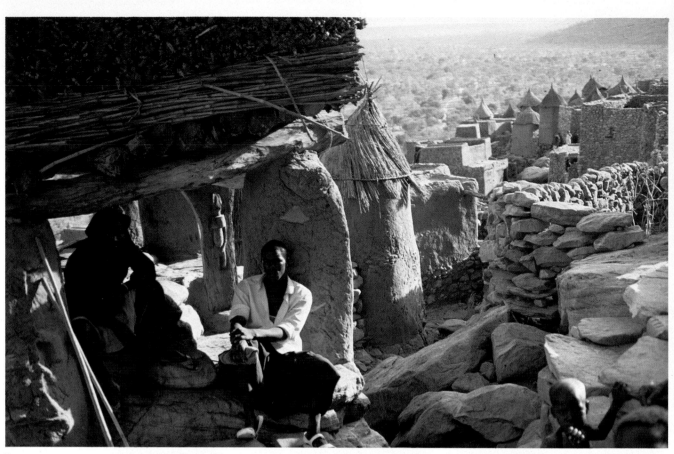

Dogon men sitting in
the *toguna*

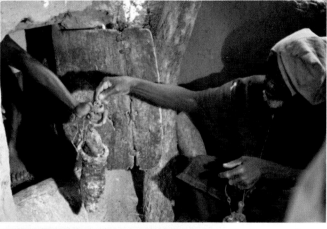

Handing sacred
relics into a Dogon
sacrificial chamber

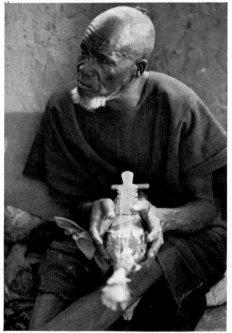

Playing a lute as a goat is sacrificed

The old *hogon*
beside his door

The smith had only one tool – an iron blade that could be fitted into its elbowed shaft so that its cutting edge was either parallel or at right angles to its handle. It could thus serve either as an axe or an adze, according to the demands of the work. The smith first marked proportions on the bark and then began cutting away the white wood, wet with sap. He worked with great deliberation and accuracy, pausing every now and then to assess progress. It seemed that he had a very clear idea in his mind of exactly how the finished mask should appear and just how it lay inside the branch. He said that he had seen only one monkey mask made by anyone else. It had been carved by an old smith from a neighbouring village. That one sighting had been enough to provide him with a mental model. Since then, he had made three monkey masks himself, and this would be the fourth.

That night, the half-finished mask was wrapped in a cloth and taken to his house in the village. The next day, he was back in the cave and at work. Within two days, the carving was finished. The mask had deep-set eyes, pouting lips and a huge swelling fore-head. To complete it, the smith painted it with an opaque black liquid made from the sap of a tree. Then, using an iron skewer heated in a fire kindled on the spot, he pierced its rim with a line of holes to take the rope net which would hold it on the head of its future owner. The threading and knotting of the rope, however, could not be done by him. That was the privilege of another man from the *awa* who came to the cave to do it.

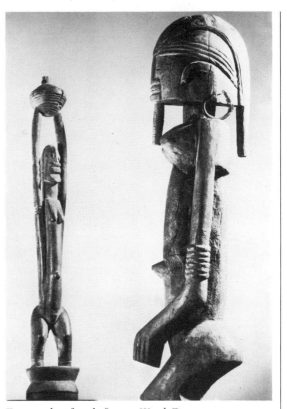
Two standing female figures. Wood. Dogon

The finished mask, in its cleanness and strength of line, could stand comparison with many ancient masks that are now the treasured possessions of Western museums. But this one would not be put on a plinth, on an occasional table or hung on a wall. It would only be seen on the owner's head as he danced to the music of drums with other members of the *awa* on a great ceremonial occasion. Until that time came, it would lie in a sack in an un-obtrusive corner of its owner's house, unregarded.

The smith also makes statues for funerals. Every man and woman is animated by *nyama*, the life-force. As a man approaches the end of his life, his *nyama* begins to ebb away and cause supernatural happenings in the village which wise men can rec-ognise as the portents of approaching death. When death does come, the *nyama* leaves the body totally and roams loose. At this time it is very dangerous and capable of causing damage to the village and its inhabitants. One of the purposes of the funeral rites is to provide a statue in which the *nyama* can lodge. After the ceremony, the statue will join the other figures of ancestors that are kept by the head of the family, hidden within the house. Thereafter they must be nourished regularly with the *nyama* of animals by allowing the life-blood of the sacrificed creatures to pour over them.

During our visit, one of the most senior men in the village decided that it was necessary, for the welfare of his family and fields, to offer such a sacrifice to his ancestors. One corner of the central courtyard of his *ginna* was shaded by a small thatched lean-to roof. In the mud-brick walls beneath it, there were two

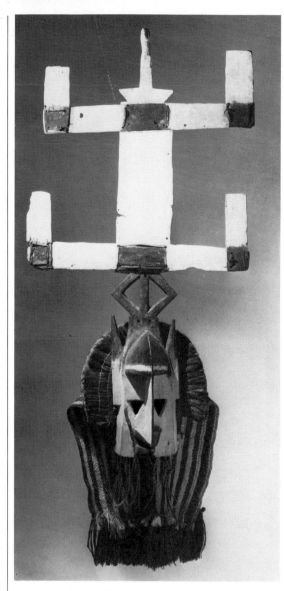

Kanaga mask. Wood. Dogon. Ht 104cm

small wooden doors, one on each side of the corner. The old man, white-bearded, his head shaven except for a small wisp on his crown, dressed in a tunic of rough blue cloth, walked slowly from the living quarters across the courtyard, followed by two attendants. One carried a live goat on his shoulders. The other held two chickens by their bound legs and a large calabash of millet gruel. They squatted beneath the shelter. The old man opened the smaller of the two doors and in silence took out from the cupboard behind a number of rounded objects about a foot long, each hanging from an iron chain. It seemed that they were heavily wrapped in strips of cloth, but it was impossible to be sure for they were all thickly encrusted with ancient libations. One by one, with care and solemnity, they were transferred into the chamber that lay behind the larger door and placed beside the untidy pile of carvings it contained. These also were smothered with the congealed remains of offerings, but it seemed that they were wooden images of human figures.

The old man, crouching beside the door, picked up a four-stringed lyre with a long resonating bowl covered with animal skin and began to chant.

'Forgive us. Excuse us. Antumulum, Yenum, Melegum, Kolowai, all you spirits of the bush.'

As he sang, one of the attendants climbed, stooping, into the chamber. A calabash of millet gruel was handed to him and he sprinkled it over the pile of figures. One by one, the chickens were passed in. Each had its throat cut and drops of scarlet spattered the figures. The goat was pulled inside. Its bleat was silenced; its blood spouted over the images. Still the old man chanted.

'Forgive us, you spirits of our village. Forgive us, you spirits of Ireli and Tireli, of Kundu and Sanga, of Kani and Kamba, of all the villages of our country.'

The sacrificer clambered out of the door, his bare legs and feet splashed with blood.

Two hours later, the skin of the goat was hanging to dry on the courtyard wall, inflated and inside out, and its flesh was being served, together with that of the chickens, from a long wooden dish. Ritual dictated that each member of the household should receive a particular portion – a leg, a wing, a rib. The liver was taken away quietly by the sacrificer. Some he ate himself, some he crumbled over the sodden statues in the sanctuary.

At no time during the ceremony had any of those taking part gazed upon the ancestor statues. Most of those who had eaten the flesh of the sacrificed animals had not even glimpsed the statues. The old man had not looked at them and in any case the details of the carving were so concealed by the libations of numberless sacrifices that it was impossible to guess what sculptural qualities they once possessed. In the past, perhaps, when they were first carved, the people had seen and assessed them. Now their preciousness came only from their associations and their antiquity. They were relics. Their shape was irrelevant.

But the smiths do create sculpture which is intended for intense contemplation in which even the tiniest detail may have great

Facing
Black monkey mask. Painted wood. Dogon. Ht 40.5cm

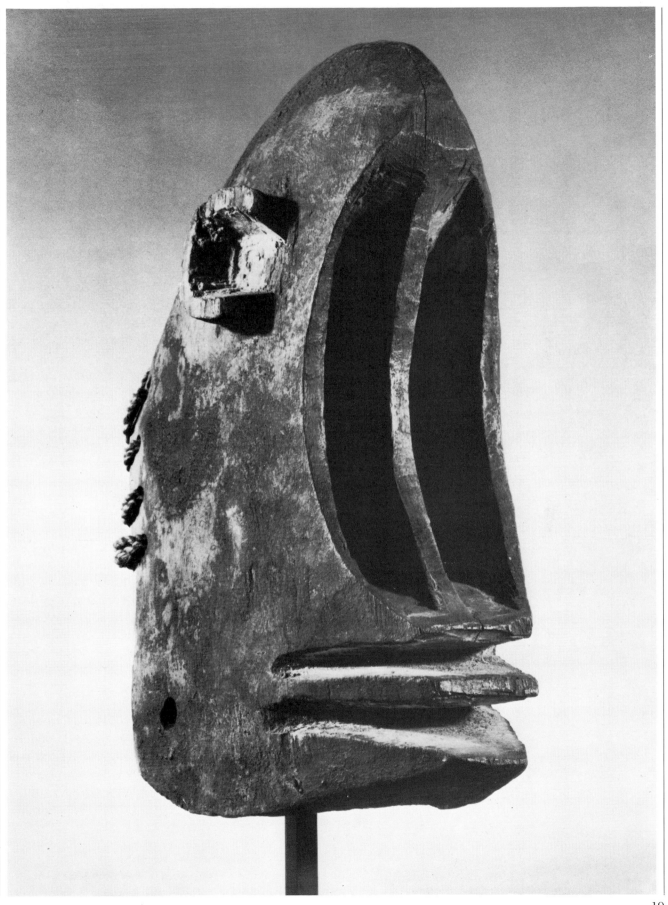

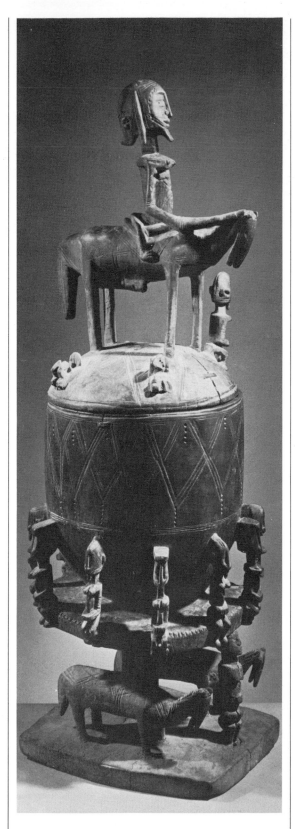

Ritual vessel with equestrian figure on the lid, the bowl surrounded by *nommo* figures. Wood. Dogon. Ht 86cm

significance. These are carvings which proclaim the complex religious concepts of the Dogon and which represent, in metaphor, the structure of the cosmos. They will be exhibited to men as they proceed through the succession of ceremonials held by the *awa* and become more learned in the intricate beliefs concerning the origins of man and his place in the universe. Such images are kept in the sanctuary of a *hogon*, the religious leader and chief of the community. The *hogon* is always an old man, usually the oldest of all in the community, for only those who have spent a lifetime in the service of the gods and the study of their history can understand their complex mysteries.

The first *hogon* was Lébé, one of the earliest ancestors, who once had human shape, but who turned into twin serpents. All *hogons* since then draw their strength, their *nyama*, from him. Each night, in the secrecy of his sanctuary, the *hogon* is licked from head to foot by Lébé, so becoming charged with his ancestor's *nyama*. During the day, he must take care never to sweat, for this would dissipate the precious *nyama* that Lébé had given him. A *hogon* may not walk further away from his village than the distance the fowls wander, for he is so magically powerful, so close to the creator spirit that dwells in the sun, that his feet would scorch the earth and render it permanently sterile. The first *hogon*, when he came to earth, wore iron sandals to prevent such a disaster. Today, even within the village, the *hogon* must wear leather sandals and should it be necessary for him to travel outside the village, he must be carried. That is why a normal man, approaching a *hogon*, must remove his sandals lest it seem that he is presuming to be as important as a *hogon*.

The images of which the *hogon* is guardian are the means by which the ancestral myths are conveyed from generation to generation. To these people without writing, they are as vivid and as eloquent as the Book of Genesis is to a European. Among them are statues of the first smith, of the first *hogon*, and of *nommos*, the ancestors who were born when Amma the Creator copulated with the newly-formed earth. There are chalices supported by *nommo* figures with a horseman on the lid; and stools covered in sacred symbols that are used by the *hogon* during the rituals. And above all, there are the most powerful and magnificent of Dogon images, the primordial couple, the first-born twins of Amma, the greatest of all the *nommos*.

The Dogon have no word for 'art'. But this does not mean that they are not discriminating and critical judges of their sculpture. One evening, sitting with a group of old men in the *toguna*, we produced some photographs of Dogon carvings that are now part of Western collections. They were enlarged to the size of the actual objects. The first was a statue of a *hogon*. The old men looked at it gravely and with wonder, passing it around and talking among themselves. One of the younger of them spoke French, Mali having been French territory, and was able to translate for us. This piece, they said, had come from Kamba. How did they know, we asked. Because the Kamba smith, long since dead, had always carved the face of a *hogon* that way. Look

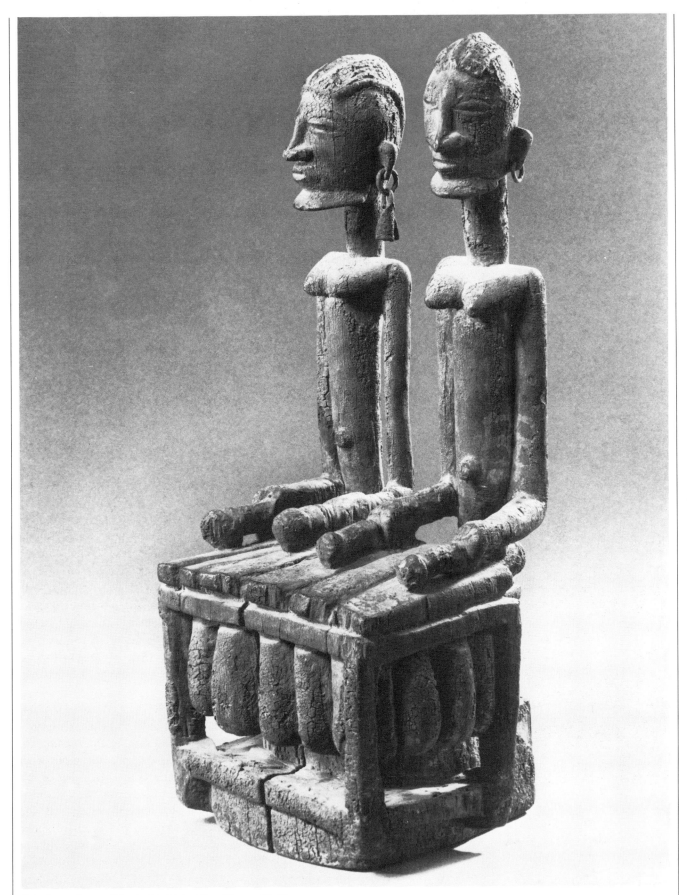

Xylophone players. Wood with thick patina. Dogon. Ht 44cm

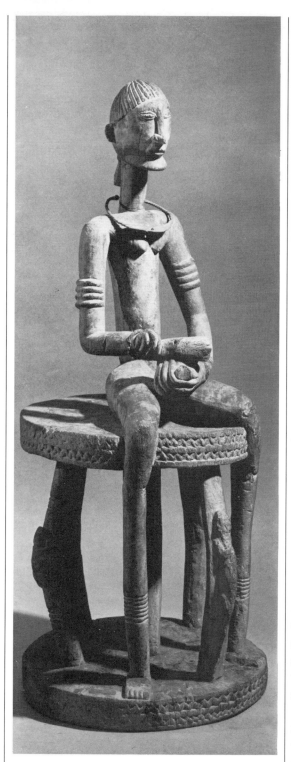

Seated male figure. Wood. Dogon. Ht 73cm

at the ears! Was it easy to tell the work of particular smiths? Usually, they said. Often, a smith had the reputation of doing certain things particularly well. One might be famous for his antelope masks, another for his ancestor figures.

We showed them a photograph of an elaborately carved granary door. It mystified some, but an old white-bearded man was quite certain about it. It must have come, he said, from the sanctuary of a *hogon* in a village twenty miles away across the plateau above the cliffs. No one else had used those particular symbols in that way.

But what about 'beauty'? We had photographs of two different figures of horsemen. Which was the more beautiful, *la plus belle*? The old men looked baffled. As we spoke the question, we realised that it was fraught with possibilities of misunderstanding. What, after all, did we ourselves mean by the word, we who came from Europe where artistic fashions took such violent swings within decades. How could our interpreter translate the word from French to Dogon with any confidence that it meant the same thing to him as it did to us? We tried again. Which was better, *le meilleur*? The old men looked less puzzled. They examined the photographs with care. This one did not show the style of dressing the hair properly. The other figure had details of the horse's harness that perhaps were not carved clearly enough. It was, however, older, and that was important and good. Eventually a judgment was given. The second was better because it was more correct, because it spoke more accurately and eloquently of the ancient truths.

Among the photographs were ones of figures that the men told us had been carved for funeral ceremonies. The funeral of a great man is one of the most spectacular of all Dogon ceremonials. His body lies in his house for several days after his death. The images of his ancestors are brought out of their sanctuary and rested against the corpse so that his *nyama* may quickly join those of his ancestors. On the flat roof above the chamber, women dance day and night. Masked men from the *awa* join them. Ever since his death, his family will have been preparing food to entertain guests at the funeral feast. Millet beer is brewed, goats and chickens slaughtered and cooked. Word goes for many miles along the cliffs that a funeral celebration is to be held and people travel great distances to attend.

We were invited to such an occasion, the last stage of the death rites. We started out, on foot, well before dawn and came to the village just as the sun was beginning to sink from its grilling midday summit. The people were already assembling around an open space just above the village, immediately at the foot of the towering yellow cliffs which formed a superb back-drop to the great drama that was to follow.

The dead man's belongings were placed in the centre of the arena. Old men stood by them and in turn spoke gravely to the silent throng, of the virtues of the dead man. As the afternoon faded into evening, men carrying muskets joined the women singing on the roof. They danced and exulted, firing their

guns into the air with loud explosions and huge plumes of smoke.

Now began a long pageant. Armed warriors in procession were led into the arena by two heralds dressed in brown tunics and simple Phrygian cloth caps, the traditional Dogon costume, and blowing curving trumpets made from the yard-long horns of cattle. The warriors circled the ground, faced inwards, and then suddenly and in unison discharged a thundering fusillade that rang and echoed around the cliffs and filled the air with the acrid smell of burnt gunpowder. It was the signal for the start of a mock battle. Men lunged and slashed savagely with wooden blades and shot at one another's feet. It symbolised, the people said, the battle that the dead man fought during his lifetime for his family and his village, a battle in which he was finally vanquished, as all must be.

As darkness fell, the moon rose, full and silver. The people ringed the arena with blazing torches of palm stems. The drums played and the women sang. There were moments of gravity as a myth was re-enacted; and comic interludes when a dwarfish clown engaged the warriors in mock-heroic sword play, scampering in and out of the pools of torchlight, sometimes bringing a brand of his own and hurling it, in a shower of red sparks, at his chosen opponents. The climax was heralded by the eerie throbbing sound of a bull-roarer, a lance-shaped blade of wood on a string, whirled by a man standing high on a huge boulder above the arena, silhouetted against the star-scattered sky. It announced the approach of the most sacred of all masks, that from which all others derive their power, the Great Mask.

The first Great Mask was carved to provide a resting place for the *nyama* of the first mortal man. After sixty years, however, it decayed and in order that the ancestor's life-force should still have a home, a new one was made. Ever since that time, a fresh Great Mask has been carved every sixty years. Throughout the intervening periods, a long sequence of rituals is held, season after season, building towards the climactic moment when the old Great Mask will be once again discarded and the new one inaugurated. This is the *sigi*. The final festival takes weeks to celebrate and it moves through the Dogon country so that all communities and all Great Masks everywhere are eventually involved. A man's whole life may only encompass one *sigi*, but he is greatly privileged and blessed by it. Only the oldest and wisest of men can have attended two and such people are pointed to with awe.

The Great Mask is one of the simplest. Its face is cut by a long ridge running from mouth to eye. Its head is crowned by an immense finial, twenty feet or more high, plank-shaped and patterned with painted rectangles and diamonds. It is so huge that no man can wear it, and so precious that only the Master of Masks and one or two of the most senior men of the *awa* know which cave in the cliffs is its hiding place. When all the torches in the celebrations had been extinguished, when the moon itself had set and the night was at its blackest, these men carried the Great Mask out of a gorge in the cliffs and on to the arena. There it was set up on the ground, and the people slowly moved past it as it stood

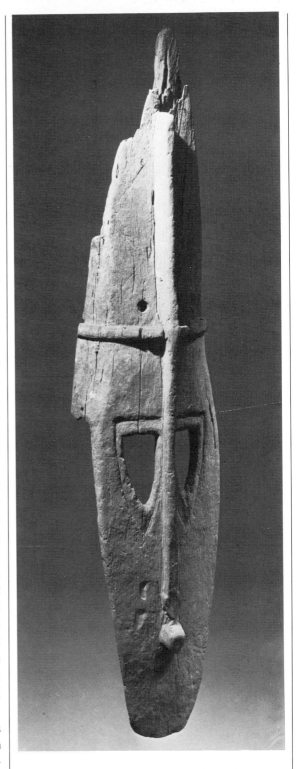

Head of a Great Mask. The missing finial might have been up to 10 metres long. Wood. Dogon. Ht 98cm

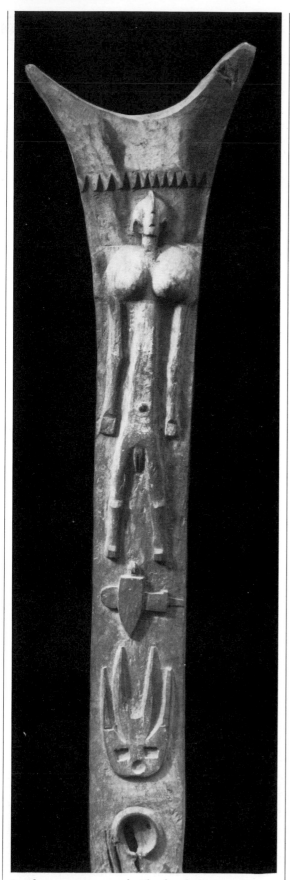

Post from a *toguna*, carved with a female figure, a door-lock and an antelope mask. Wood. Dogon. Ht 260cm

upright, gaunt and simple, lit only by the diamond bright stars above the looming cliffs.

The Dogon lay the bodies of their dead in the slit-like caves that gape in the cliffs above their homes. Even from the foot of the cliffs, you can see that many caves contain buildings. Some have a long wall across their mouths. Others contain towers with windows or rectangular house fronts. When Europeans first came here, most of such caves contained not only huge accumulations of human bones but piles of wooden carvings. One of the commonest types was a figure with its arms upraised and thickly coated with libations. These were ancestor figures, the Dogon said, with their arms lifted, beseeching for rain, but it was not certain who made them.

The Dogon explain that although they now leave their dead in the caves, they have never been cave dwellers. Originally their home was in more fertile country away to the north-west. This was at a time, 700 years ago, when a great trading empire was forming around the upper reaches of the Niger River and the city of Timbuktu. Camel caravans brought slabs of salt across the Sahara to the city's market where it was bartered for gold from the local mines. The rulers of Timbuktu had been converted to Islam some time in the eleventh century. Their court became one of the most splendid in Western Africa and their city a celebrated centre of Islamic learning, rich with mosques and schools of theology. The Islamic faith was zealously spread to the many people who became part of their expanding empire. The Dogon, however, refused to be converted and stuck to their own beliefs. Even today they are called by the other Islamic tribes around them the *Habbé* – the unbelievers.

As a consequence the Dogon were driven farther and farther east and south until they came at last to the great cliffs. They found the caves occupied by a people called the Tellem. It was the Tellem who had built the walls and towers, and who had made the mysterious carvings. Even the Tellem, the Dogon maintain, were not the first people to live there. Earlier still the cliffs had been inhabited by a pygmy people who had supernatural powers. Who else could have lived in the narrowest clefts where a normal man has to bend double? And who but a people with the knowledge of magic could have reached the highest caves which visibly contain buildings but which now, as a consequence perhaps of erosion, are inaccessible to any normal climber.

Carbon dating of the wood from some of the statues from the caves show it to be 600 to 700 years old. This, in itself, does not, of course, prove that the carving was done in ancient times. Recent sculptors might have used ancient wood. But fragments of cloth have also been found in the caves which date from the eleventh century. Some anthropologists accept the story of the origin of these remains largely as the Dogon recount it and consider the carvings, which have a distinctive style, to be the creations of a now-vanished people. Others believe that the Tellem were, in fact, simply the ancestors of the Dogon and that there is a continuous artistic tradition linking the figures from the caves with

the sculpture that is produced today. The question is of real interest because a historical perspective on the artistic development of an African tribe is extremely difficult to obtain. In most of the continent, the combined effect of high humidity and the appetites of termites and other wood-eating insects has meant that few sculptures survive for more than fifty or sixty years. In consequence, we have virtually no idea of how the distinctive styles of the many tribes of Africa have changed over the centuries: whether they have remained almost static, as some used to believe, or whether they have evolved into radically new forms in the space of a few centuries.

This is yet another reason why the sculpture of the Dogon is of such great fascination to the West. The effect of this interest, however, has been that commercial collectors, both African and European, have scoured Dogon country for carvings. All the readily accessible caves have long since been stripped. In the villages, the decorated doors of the granaries have been taken away and often replaced with plain boards. Even the posts of the *toguna* meeting house, which once were embellished with sacred and sexual emblems, have been removed.

We did not expect, therefore, to see carvings of any age still in place. But towards the end of our stay, we visited a village far beyond the group of settlements that are easily reached and usually visited by outsiders. Our truck had become badly bogged in a sand drift and we walked into the village in search of help to push it out. There were few people there – a knot of children, one or two women. We turned a corner of one of the alleys and there, to our astonishment, sitting in his sanctuary, we saw a *hogon*. In earlier times it is very unlikely indeed that strangers such as ourselves would have been allowed to get anywhere near him. The men of the village would have been on guard, ready to guide intruders away and prevent them from disturbing such a sacred personage. But the hold of the ancient beliefs on the villagers seemed to be fading, perhaps as a result of the encroachment of Islam, which every year gains a few more converts among the Dogon.

The abandoned *hogon* sat on a mud-brick bench beneath a thatched verandah. He was staring ahead of him with rheumy, unseeing eyes and chanting, holding a small bronze bell in one hand which he struck with a ring on one of his fingers. He was so old that his mind seemed only just to retain contact with this world. Behind him the door to his house and the roof posts were emblazoned with some of the most spectacular carvings we had seen, either in Dogon country or the museums of Europe and America, where so much Dogon carving is now to be found. From the top of the door to the bottom stretched Lébé, the twin ancestor snakes whose sinuous image is also the falling of rain, the movement of water and the essence of fertility. Beside them was carved a tortoise. This represents the head of a family both symbolically and in ritual practice. Every *ginna* has a tortoise and when the head of the household is away it takes his place, every morning swallowing the first mouthful of food and the first sip of water and

Post from a *toguna*, carved with a male figure, a smith's crook, a doorlock and sandals. Wood. Dogon. Ht 280cm

25

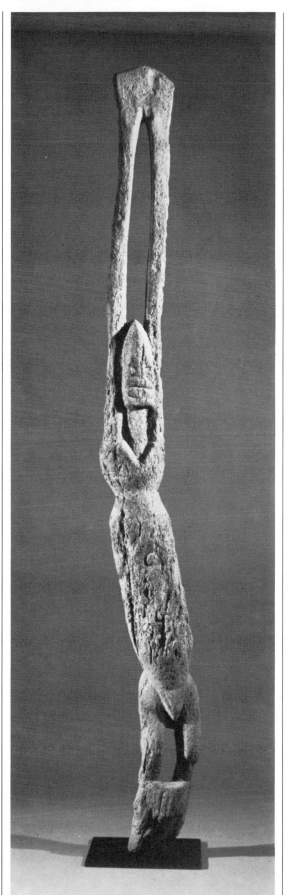

in return giving the family magical protection. On the door, its image was incised with squares, recalling the pattern of the village fields, the niches on the façade of a *ginna*, and the checks of the sacred sheets in which the dead are wrapped. Beside it strode a water bird, a reminder of the long journey taken by the first *hogon* in search of a sacred stone. There were tools – the crook with which the blacksmith had pulled a lump of iron out of the forge of heaven, the short staff of the ancestor who had inaugurated the *awa*, the forked staff of the first *hogon*, its stem the symbol of maleness, its cleft the emblem of femininity. The lock of the door sprouted two long horns, like a gazelle. There was a crocodile and a ram's head and the iron sandals of the first man on earth. And dominating all stood the primordial couple, side by side, their arms stretched rigidly downwards, gazing bleakly out into space. It was, perhaps, the last clue to how the villages must have looked before the appetites of people thousands of miles away had caused them to be stripped of their ancient splendour. It was a reminder of a time when the symbolic images on village walls and shrines had given the people the wisdom with which to shape their lives.

A *nommo* with upraised arms in the Tellem style. Wood. Dogon. Ht 144cm

Masks abandoned in a cave, photographed by Marcel Griaule in 1930s

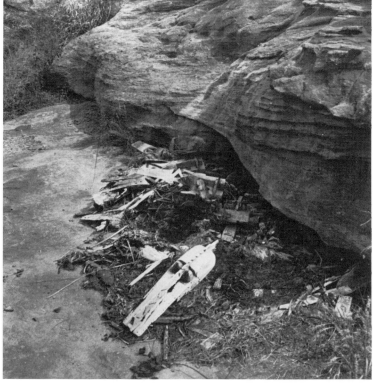

Crooked Beak of Heaven

2

The largest wooden sculptures ever carved by men were the totem poles erected by the people of the Northwest Coast of America. Some poles stood sixty to seventy feet high. Bears, ravens, beavers and wolves crouched on one another's shoulders, teeth bared, tongues protruding, wide eyes staring steadfastly ahead.

The poles were made from red cedar, a giant even among the towering trees of the northern forests, which grows to over 200 feet. Its wood is firm yet easily cut, fine-textured and straight-grained, and free from knots over huge lengths. Doubtless such magnificent material is a great temptation to any sculptor, but the people's impulse to carve on such a stupendous and grandiloquent scale also stemmed from a deep-seated desire for extravagant display. Of all those who built their societies without the help of agriculture, the Indians of the Northwest Coast were probably the wealthiest, and their great chiefs, like dukes and barons elsewhere, demanded monuments to testify to their affluence.

It was the sea that gave them their wealth: halibut, herring and cod; shellfish from the rocky shores; eulachon, a small fish so rich in oil that when dried and threaded on a wick it burns like a candle; and above all, salmon, five different species which swarm up the rivers to spawn in such numbers that, during the season, a party of men could catch thousands in a day. Sea otters were abundant, providing soft dense furs; and porpoises and seals were hunted for meat. The forest, too, contained riches: elk and beaver; mountain goats to provide wool for blankets and horn for ladles; strawberries, huckleberries, wild rhubarb and soapberries for food in summer and autumn. Nettle stems were used for making nets, birch bark for boxes, alder wood for food dishes. Bark, stripped by the yard from the living cedars, was shredded and plaited to make textiles. Spruce roots served as thread for sewing and weaving hats. And the great evergreen conifers provided timber.

The people were superb carpenters. They made boxes, the sides constructed from a single piece of wood bent into four by grooving and steaming, with its ends sewn together. The bottom was also fixed in position by sewing, with a technique so neat that the stitches could not be seen from the outside. The craftsmanship of these boxes was of such perfection that they were water-tight and the women, lacking any kind of pottery, cooked in them,

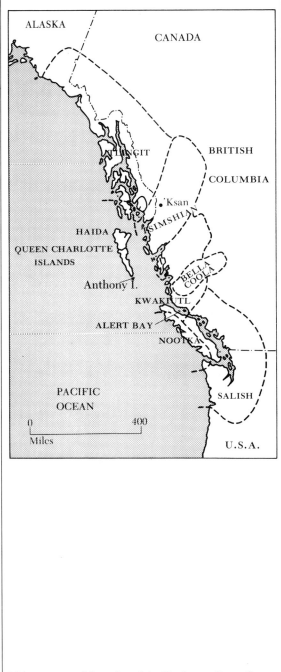

The territories of the tribes of the Northwest Coast of America

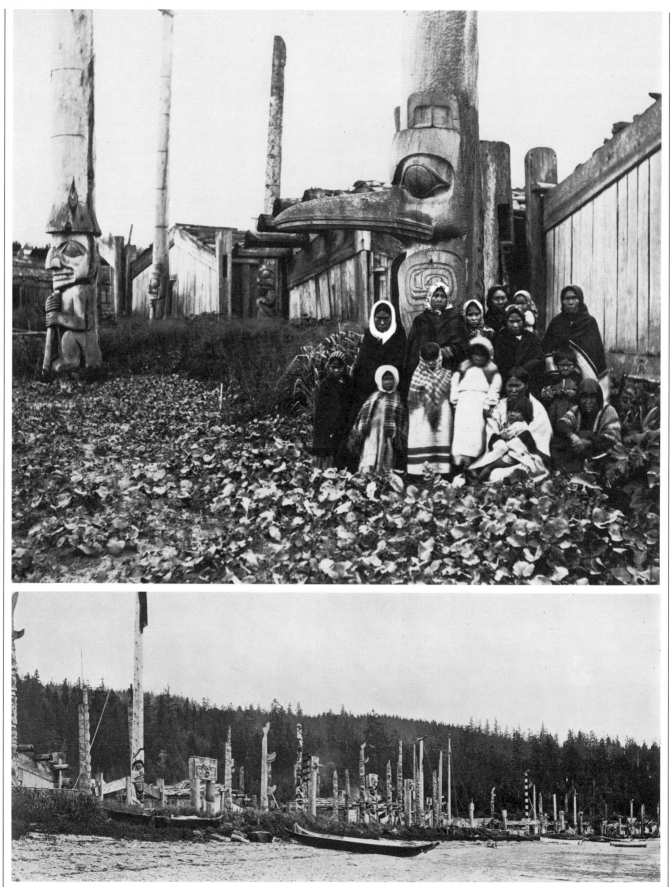

Haida villages on the Queen Charlotte Islands, British Columbia, photographed at the end of the 19th century

heating liquid by taking hot stones from the fire and dropping them in until the contents boiled. Immense canoes were made from the cedar trunks. The inside was hollowed out with adzes and controlled burning, and the sides forced apart by driving thwarts between them. The people also split the long straight-grained logs into planks and with them built huge communal houses, rectangular and gabled, with roof beams sixty feet long made from dressed logs.

The tribes sharing this culture lived in the strip of territory that runs for over a thousand miles from Yakutat Bay in Alaska, south to the Columbia River in Oregon. Their eastern, landward frontier was the foothills of the coastal ranges fifty miles away, their western the near-freezing open ocean. They were seafarers rather than mountaineers, sailing for hundreds of miles through the deep fjords and passages between the myriads of forest-covered islands that fringe the coast.

There were seven main tribes. In the north lived the Tlingit and the Tsimshian, and on the Queen Charlotte Islands, the Haida. The centre stretch was divided between the Kwakiutl and, inland, the Bella Coola. The south belonged to the Nootka and the Salish. Each tribe had its own distinct language and its own individual social system and culture. But all shared several characteristics. They were aristocratic; they owned slaves who were nearly always prisoners taken during wars; and they all held a view of life which largely equated wealth with importance.

A man's riches were not only material ones – canoes, blankets, stocks of smoked fish and furs, and the fishing and hunting rights that produced such things. They also included the privilege to perform a particular dance, to relate a certain myth, to wear a category of mask and to be called by a particular title; and such rights were considered as much worth fighting over as any tangible object.

A man inherited both kinds of property from his family or that of his wife, and he proclaimed his ancestry, and therefore his entitlements, with his totem pole. The creatures carved on the poles were characters from important family legends. One such might tell of a hunter, wandering far from his village in part of the forest that no man had entered before. There he met a strange creature – a raven, perhaps, or a wolf – who spoke to him with a human voice. Hunter and animal formed an alliance and travelled together in the forest. After many adventures, the animal gave to the man the exclusive right to hunt and fish on its land. When the hunter at last returned to his village, he commemorated the partnership and declared the privileges that came from it, by adopting the animal's image as his crest.

Sometimes the legends are not so clearly concerned with territorial rights, although it is perhaps significant that the animals represented in crests are predominantly predators and hardly ever creatures that the people hunt for food. Nearly always, however, the burden of the myth is that the family formed a special relationship with a creature and, in consequence, have special entitlements. So the ravens, killer whales and thunder-

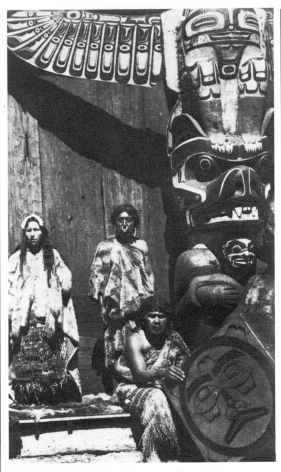

Kwakiutl dancer and box-drummer, about 1915

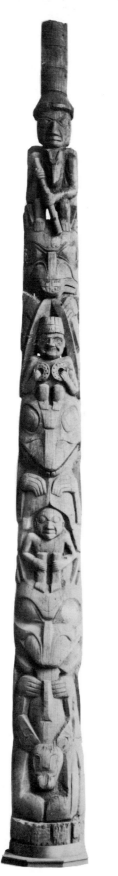

Memorial pole. 19th century. Haida. Ht 11.5m

birds of the American Northwest Coast are cousins to the lions, unicorns and dragons of European heraldry. And just as an ancient European family may, through marriage, have acquired several quarterings to its coat of arms, so an Indian chief might have several crests carved on his totem pole.

Cedar wood is rich in resin, but it cannot withstand indefinitely the gale-driven rain and the blizzards of the long northern winters. The life of a pole standing in the open is seldom as long as a century. Most of the ancient ones still survive because they have been uprooted and taken into museums for preservation. One of the most impressive groups that still remains on its original site stands in the abandoned Haida village of Ninstints on Anthony Island. This tiny isolated fragment of the American continent lies hunched against the storm-racked open ocean to the west, with a bay on its eastern side, partially protected by a small islet. Along the beach on this leeward side, on the edge of the dense forest, a Haida community of several hundred people once had their homes. The houses have now fallen in but a dozen or so poles are still in position, each around ten feet tall, some tilted, some still proudly vertical. They are barely thinner than the trunks that can be glimpsed in the gloom of the forest beyond. It seems as though the elements alone could have been responsible for sculpting the faces that peer out from them. Several were funeral posts and have the remains of a box at their tops which once contained the bones of the chief whose crest was cut in the wood below. Beyond the poles, where the ground is covered with a springy mat of spruce needles and the air heavy with the tang of resin, there are others that have fallen and are being reclaimed by the forest. Bushes grow over their broken faces, birds nest between the pouting lips, and sheets of moss, heavy with water, drape the eyes.

Another ancient survivor, the Hole-in-the-Sky pole, stands in Tsimshian country on the mainland in the village of Kitwancool. Although the pole now stands isolated like the Ninstints poles, it was not originally so, but once formed part of the front of a ceremonial house. A hole cut in its base served as the door. A wolf sprawls around its broken top representing a pack which killed the child of an ancestor. Below this, the chief who erected the pole is shown clinging to the tail of another wolf. Further down, a bear lies disembowelled and a third wolf crouches close to the viscera, perhaps about to eat them. The door-hole itself is circled by small spirit figures guarding the house that once stood behind.

The clan which owned this pole is now widely dispersed and the legends it records are half-forgotten. Yet the right to reproduce a family's crest still commands respect. The pole is easily visible from a public highway, but to photograph it without permission of the owners would be tantamount to theft. This is not simply a device to make money. When we finally traced the head of the family who, by complex genealogical reasoning could be reckoned to be the current owner of the rights and who lived in a village many miles away, he was by no means happy to grant permission on any terms. Indeed, the matter was not settled until several weeks after we left the area.

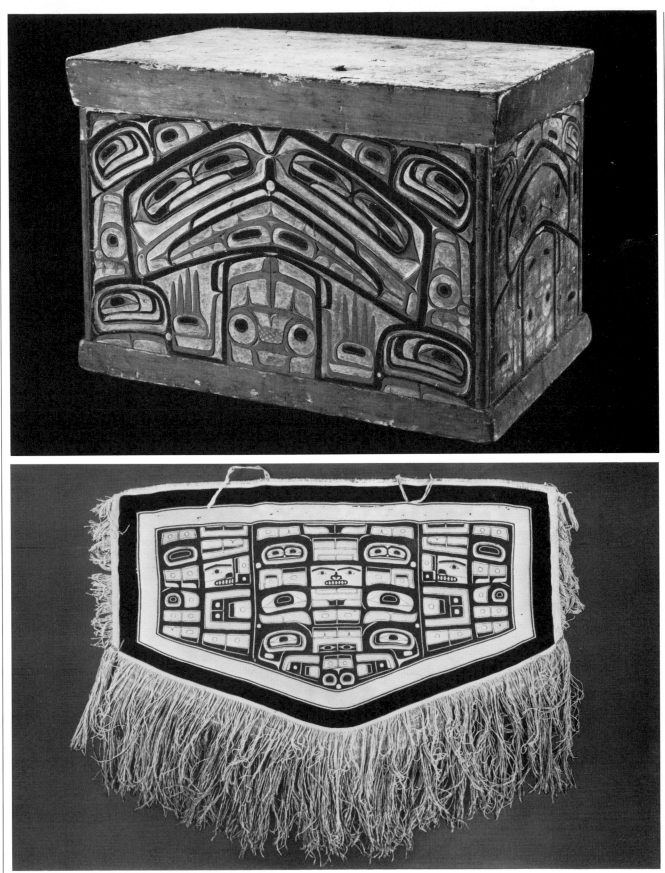

Chief's chest. Painted wood. Tsimshian, collected in 1912. Length 90cm
Chilkat blanket, said to represent a whale in the central panel with a sitting raven on profile in each side panel. Wool. Tsimshian. Length 170cm

31

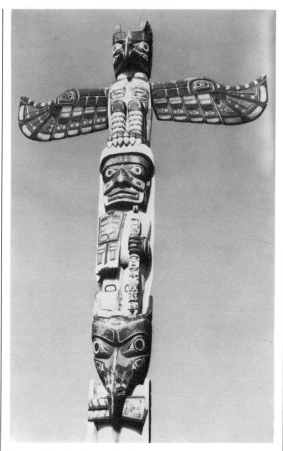
Memorial pole. Alert Bay, Kwakiutl

The Tsimshian carvers, like the Haida, did not greatly change the overall shape of a tree trunk when they turned it into a totem pole. It is as if they had done little more than strip away the bark in order to reveal the images beneath, tightly packed within the constricting cylinder of the trunk. Nor did they paint the carvings, except for a few details, so the grain of the timber, etched into prominence by rain and wind, now forms an elegant counterpoint which heightens the taut sensitivity of the lines cut by chisels.

The tribes farther south, the Kwakiutl and the Bella Coola, carved in a more uninhibitedly sculptural fashion. They joined extra pieces to the poles so that the thunderbirds could spread their wings, and spirits stretch out their arms to welcome the living into their embrace. The southern taste for the flamboyant went even further, for most of the poles were brilliantly painted. Brown faces with green noses purse scarlet lips, beaks are yellow and wings patterned in black and white.

This difference in style between the north and south is reflected in a similar way in much more modest objects such as bowls, dishes, amulets and boxes. The Haida and Tlingit in the north favoured flat designs, freely distorting and stylising an animal's appearance in order to fit it on to the rectangular side of a box or the curving surface of a bracelet. One way of doing so was to 'split' the animal either along its spine or its belly, so that a single bear might appear to be two, sitting in profile, back to back or facing one another. Such highly stylised designs allowed great scope for invention and the artists frequently introduced additional elements to fill up any vacant spaces in their patterns. They might decorate the blank disc of a wide open eye with a small face. Sometimes they indulged in visual puns, turning a bear's claws into birds' beaks or a fin into an animal's head. Joints are conventionally represented by a symbol indistinguishable from that used for a small eye, and so a torso with two shoulder joints can become a face.

With such exuberant invention, the identity of the animals represented can become very obscure. Usually there are precise clues. Two prominent teeth and a rectangular cross-hatched tail among the maze of symbols indicate a beaver; a wide toothless mouth and no tail, a frog; a dorsal fin and a blow-hole, a killer whale. Birds can be identified by their beaks. A raven has a straight one, a hawk's is curved into a hook, and an eagle's is heavy, with a turned-down tip. Even with such clues, however, identification is by no means always easy or certain and many ancient designs can still produce contradictory identifications among experts, both European and tribal.

A particularly extreme form of this geometricisation is found in the Chilkat blanket. These were made by women of a subdivision of the Tlingit tribe and traded all down the coast to be worn as capes on ceremonial occasions. They were woven from the wool of mountain goats on a warp of cedar-bark threads. The designs, in yellow, black, blue and green, appear to be a maze of rectangles with occasional eye-like forms scattered among them. In fact, like nearly all Northwest Coast designs, each represents a creature of

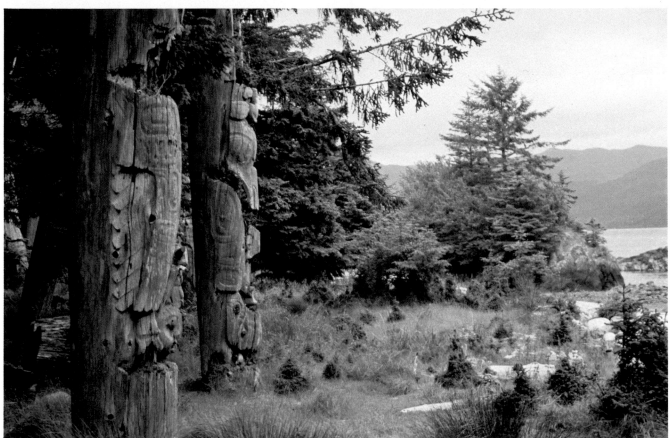

Poles in the ruined Haida village of Ninstints, Anthony Island, British Columbia

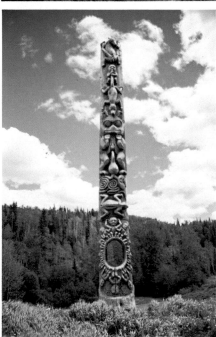

The Hole-in-the-Sky Pole, Tsimshian.
Kitwancool, British Columbia

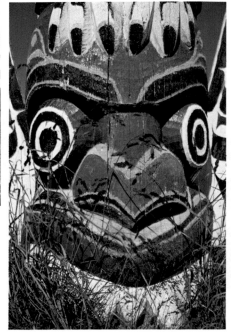

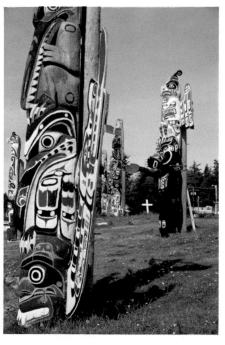

Kwakiutl memorial poles in the burial ground,
Alert Bay

Painted mask,
collected in 1913.
Bella Coola.
Ht 45.6cm

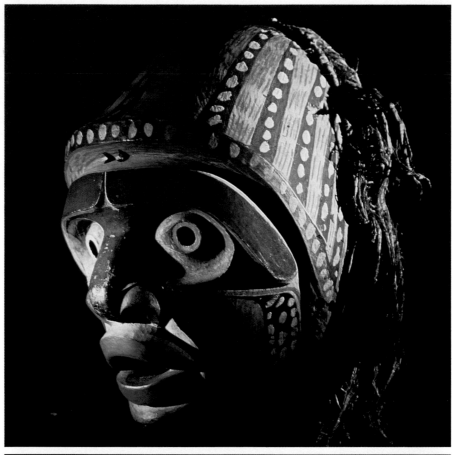

Mask representing a
conceited woman.
Collected on the
Nass River, 1912.
Tsimshian. Ht 23cm

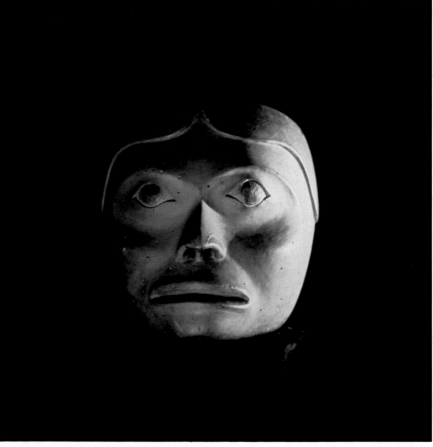

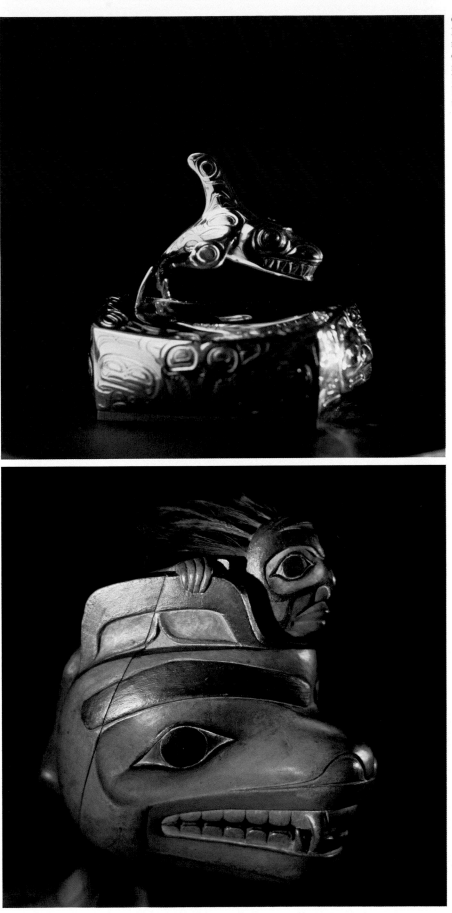

Golden box by Bill Reid, the base modelled in the form of a Haida food dish representing a beaver, the lid bearing a killer whale

Rattle representing a bear with a human figure crouching between its ears. Haida. Ht 26.7cm

Arthur Dick's potlatch, Alert Bay
Crooked Beak of Heaven

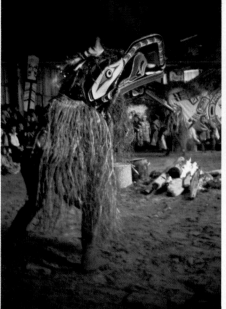

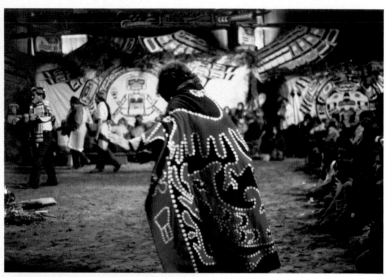

Dancing in button blankets

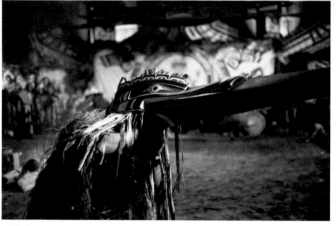

The distribution of gifts

Hohok

Arthur Dick's niece dancing in front of a newly painted screen

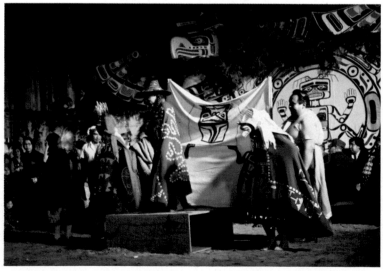

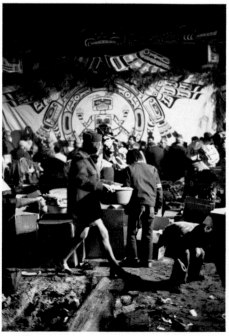

some kind, but one that has been totally fragmented into its component parts so that eyes, paws, ears, tail and flanks may be totally separate from one another and placed on the cape with regard not so much to anatomical logic as geometrical neatness.

As with totem poles, this flat painterly style is replaced further south by a more sculptural three-dimensional one. If a Kwakiutl vessel is to carry the crest of a beaver, its sides are not decorated with two-dimensional symbols, but the whole object is likely to be carved into the shape of the animal, crouching on its four feet, a flat tail at one end and at the other a boldly conceived head, gnawing a stick with long prominent teeth, and its back deeply hollowed to form the bowl.

Another characteristic seems to be correlated with this difference in style. The designs of the Haida and Tsimshian served a predominantly social function, reflecting through heraldry the genealogical relationships of the people. Though this element was also important in Kwakiutl designs, many of their objects also had important religious significance.

A whole segment of the Kwakiutl year was devoted to sacred ritual. Throughout the summer and autumn, the people laboured to build up stocks for the winter – smoked and dried fish, storage boxes full of eulachon oil, clams and mussels that had been steam-cooked and dried, cakes of pressed fruit and berries. When the fogs and rains of the oncoming winter finally forced them to abandon fishing and trapping, they retired to their well-stocked houses and began the *tseyeka*, the supernatural season.

Now people abandoned the names and ranks they had held during normal times and took up new identities in religious societies. Although a man with an important secular rank would have a similarly important position in the sacred society, such privileges were not granted automatically. They had to be attained by initiation. Each society mounted long dance dramas in which the legends and myths of which they were the privileged possessors were re-enacted. Newly initiated men performed in these dramas and by doing so made apparent their newly acquired status.

On such occasions, the huge houses became sacred theatres. Light came from a log fire burning in the centre of the floor, its smoke escaping through a hole in the roof. The people were seated on platforms around the sides. At the end opposite the door, between the two carved house posts that supported the beams, a painted screen was set up and from behind it came the dancers wearing spectacular masks.

One of the most famous and prestigious of the Kwakiutl societies was that of the *hamatsa*. An initiate had to spend four months in the forest, sometimes instructed by senior members of the society, often fasting in solitude. There he eventually became possessed by the Cannibal-Spirit-at-the-North-End-of-the-World, a terrifying creature covered with open bloody mouths across which the wind whistled eerily as it flew shrieking through the skies. It was accompanied by three servants of almost equal horror – a raven which plucked out men's eyeballs, *hohok*, a long-beaked bird which split men's skulls to feast on their brains, and

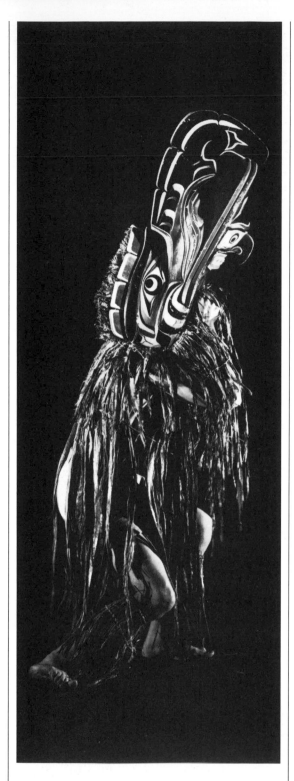

another cannibal, Crooked-Beak-of-Heaven. The initiate at last, by his own courage and with the help of other men in the society, managed to escape the influence of these creatures and return to a human condition. But he was marked for ever by his dreadful encounter with the ancient spirits.

Initiates who had undergone these ordeals re-enacted them in dance. The masked cannibal birds, beaks clacking, postured around the fire. The young spirit-possessed *hamatsa* appeared, wild and distracted, driven frantic by his craving for human flesh. Sometimes, losing control, he rushed into the spectators and bit pieces from onlookers' arms or legs. On occasion, he even consumed dismembered human limbs. Only gradually, with help from his attendants, was he tamed and able to become human again.

The Kwakiutl had a genius for the theatrical. When the *hamatsa* attacked spectators, they were, in fact, accomplices who, for a reward, had agreed to submit to cuts from a knife the *hamatsa* had concealed in his hand. Sometimes the illusion was made even more gruesome by piercing hidden bladders full of blood. In other, secular, dances masked men appeared who represented half-human half-animal characters and wore transformation masks. At the pull of a string, a raven mask split in two down the beak, revealing a human mask behind, or a wolf mask, similarly hinged, sprang apart to change into the beaked head of an eagle. Another type was fitted with interchangeable mouthpieces. The man who wore it held a blanket draped over his arm in front of him. With a bob of his head he could change the mouthpiece and become in turn a fish, a bear, an eagle or a spirit.

The most elaborate tricks were invented. Men hid in the rafters, holding strings with which to animate puppets below and make the audience catch their breath with astonishment. Huge wooden birds flew in the flickering firelight along the length of the house. In one of the most baffling illusions, a girl was taken captive, imprisoned in a wooden box which was then thrown on the fire. As the flames consumed it, the girl's screams for help could be heard coming from it. When all was reduced to ashes, her bones were retrieved and taken away. They were put into another box and, in due course, the girl miraculously reappeared quite unharmed.

The first box had been placed in front of a concealed pit into which the girl had slipped in the half-darkness. The bones had been hidden in the box's false floor and a tube made of kelp stems connected the girl's hiding place to the hearth of the fire so that, when she screamed down it, her cries seemed to come from the centre of the flames.

For all these activities, artists were essential. Masks had to be carved that would give shape to the spirits and the magical animals of legend. Screens had to be painted. Rattles, head-dresses and statues had to be constructed. The accumulated wealth of the people, and the enforced leisure of the winter months, made it possible for particularly gifted men to lavish great care and time on such work. Individual sculptors acquired great reputations. A

Dancer wearing a Crooked Beak of Heaven mask, carved some time before 1940. Painted wood with hanging skirt of shredded cedar bark. Kwakiutl

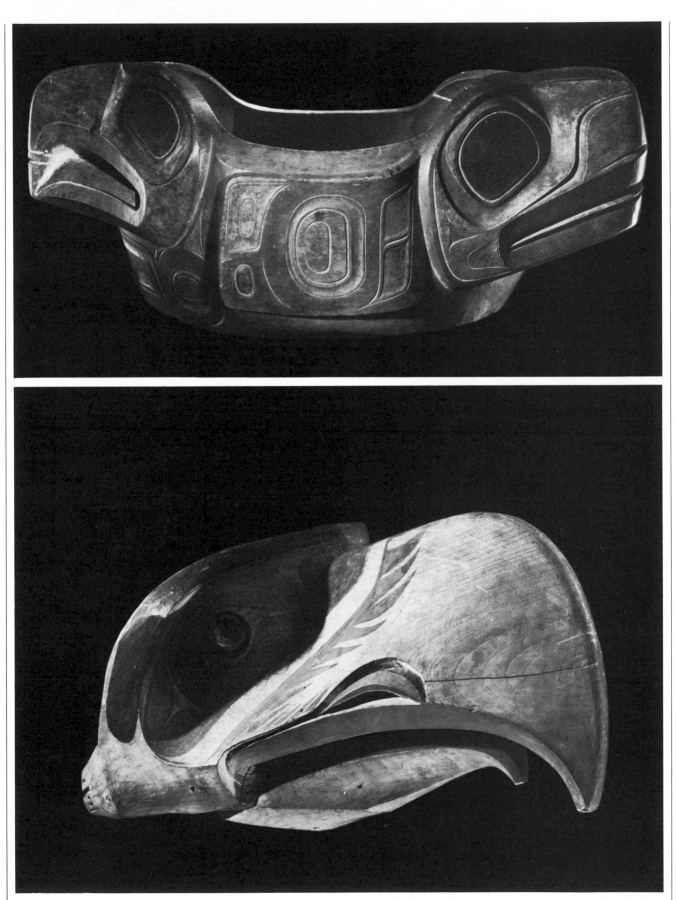

Above: Animal-headed bowl. Wood. Haida. Length 35cm *Below:* Eagle mask, collected 1893. Painted wood. Kwakiutl

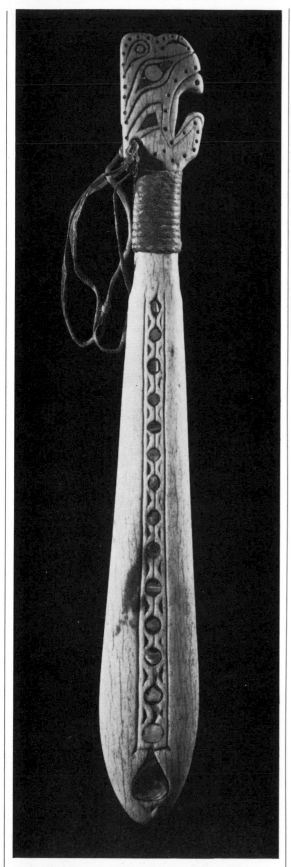

Club collected at Nootka Sound by Captain Cook's expedition in 1778. Whalebone inlaid with abalone shell. Length 59cm

chief would invite one to come and live in his house and publicly commission him to make a new and important carving to join the splendid heirlooms that already belonged to his family.

So the winter passed in long cycles of drama and feasting until, with the spring, the *tseyeka* came to an end and the men left once more to hunt in the forest and fish in the seas and rivers.

We do not know when this elaborate culture began, but it is likely that people first came to the Coast some 7000 years ago, after having travelled, over generations, from Asia across the Bering Straits and down through Alaska. Excavations indicate that their culture was without metal and the tools they used for their carvings were adzes with jadeite blades and chisels made from clam shells and beaver teeth.

The first Europeans to arrive here were Spaniards who, in 1774, sailed north from their long-established settlements in California. Their visit was brief and had little effect on the people. The Spanish ship was hardly likely to impress the Indians greatly for it was not as long as their own great war canoes. In 1778, however, Captain Cook sailed into Nootka Sound on the west coast of Vancouver Island and stayed for a month, repairing his ships, mapping, trading with the Indians, compiling a vocabulary of their language and, with characteristic sympathy and understanding, making copious notes of everything he saw. John Webber, the official artist of the expedition, entered one of the big Nootka houses and began to make a drawing of one of the carved house posts. Interestingly, one of the Indians there immediately covered up the sculpture with a mat to prevent Webber from continuing. Webber cut a brass button from his jacket and gave it to the man as a fee, but he was only allowed to complete his drawing when his coat had been entirely stripped of its buttons. The ownership of a design, and the practice of selling the right to copy it, seems to have been well established even then.

Cook assembled a huge collection of artefacts, many of which are today in the collections of the British Museum. He recorded in his journal that the people were already using iron knives and 'tomyhawks'. What is more, they seemed to have had metal for some time, since they had a word for it and for other metals including copper. Copper occurs naturally in parts of the Canadian hinterland and in Alaska, but where the iron had come from is not certain. It may have been collected from the wreckage of European or more probably oriental ships washed up on the shores. It may have been imported along the long trade routes that stretched from the Coast up north and into Siberia, where iron had been in use since prehistoric times. Whatever its source, however, it was still in extremely short supply and the people eagerly exchanged furs for steel axes.

Cook's ships, on their way home, called at Chinese ports and there discovered that the sea-otter skins from Nootka fetched huge prices. When the news reached Europe, it triggered a rush of ships to the Coast, not only from Britain but also from Spain, France and the eastern seaboard of America. So began a trade in fur that was to dominate life on the Coast for nearly a century.

To begin with, metal was sought above all else by the Indians, but the volume of trade became so huge that eventually the coastal villages became saturated with metal goods and their value was greatly reduced. So the ships brought muskets, rum and blankets, blue glass beads and trinkets of all sorts.

They also brought diseases. The sailors had partial immunity to measles, influenza, tuberculosis and venereal disease, but the Indians had none. Worst of all was smallpox which raged with dreadful speed and ferocity through the villages. It spread up the coast, carried by people fleeing from the stricken settlements who were sometimes already fatally infected or who, in tragic ignorance, took with them the blankets of the dead. The worst smallpox epidemic of all ravaged the Coast in 1862. Within three years, it had killed a third of the population. It is estimated that more than 80,000 people lived on the Coast when the Spanish first visited it. By the end of the nineteenth century, that number had been reduced to about 25,000.

Contact with the Europeans, so disastrous in many ways, brought a great stimulus to the arts. Indeed, in terms of inventiveness and quantity, sculpture and painting reached their most splendid development during the century that followed Cook's visit. The greater availability of metal tools and their improved quality allowed the carvers to work with greater ease and virtuosity. Some authorities believe that there were no totem poles at all before this time, for Cook saw none. Whether or not this is so, it is certain that totem poles were now developed in a spectacular fashion.

There were also new materials for the artists to work with. The Spanish traders coming up from Mexico and California brought abalone shell with a brilliant blue iridescence which the Indians greatly preferred for inlaying in their carvings and jewellery to the more pallid variety from their own waters. Silver dollars and gold guineas were beaten out to make bracelets and nose-rings. Pearl buttons, brought back from China, were sewn in heraldic patterns on trade blankets to make ceremonial cloaks. Paints, traditionally, had been made from natural ochres mixed with chewed salmon eggs, to form a kind of tempera. During the 1880s, European paints were introduced and eagerly seized on, particularly by the Kwakiutl, to make their sculptures still more dramatic.

The Europeans, for their part, took away not just furs but also mementoes of the Coast. Sometime around 1820, the Indians began to provide objects specially for the purpose. The Haida discovered in their territory outcrops of a peculiar kind of carbonaceous shale called argillite which is relatively soft, yet capable of taking a high polish. They carved this material into plates and dishes embellished with figures from their own mythology. In the 1830s they also made carvings showing men with heavy beards and structures from European sailing ships. These may have been made in imitation of the pieces of scrimshaw that visiting sailors carved from whales' teeth and walrus ivory to pass the time on a long voyage.

One of the most gifted of these sculptors was Tahigan, a Haida

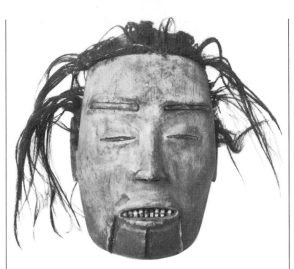

Mask. Wood, fringed with human hair and inlaid with hide. Collected by Captain Cook's expedition at Nootka Sound, 1778. Ht 28cm

chief, born in 1839, who spent his early life at Kiusta on the Queen Charlotte Islands. He carved wooden poles and masks and other traditional objects for his own people. He made superb silver bracelets and a great range of argillite objects for sale to tourists – plates, pipes, platters, caskets and miniature totem poles. His range was immense and his invention unflagging. As well as bringing great authority and assurance to traditional heraldic patterns, he also produced sculptures with vivid narrative themes. When Tahigan was in his forties he took a European name and was baptised Charles Edenshaw. The argillite carvings made by him and many other unknown Haida men, before and after his time, rapidly became highly esteemed and avidly collected by Europeans. They are one of the first and best examples of a tourist art produced by a tribal people entirely for export.

The rapid growth of European trade on the coast also brought changes to one of the most characteristic of all Indian institutions, the potlatch. A man, by inheritance, might have a claim to a rank or title but, before he could assume it, he had to validate his claim by holding a feast called a potlatch. The word originally meant 'to give' and the distribution of gifts was a central element. People were invited from far distant settlements. Each was welcomed and seated in a place appropriate to his rank. During the lavish feast that followed, there were displays of masked dancing at which the host's hereditary regalia were displayed. Food was served in spectacular ceremonial vessels, usually decorated with

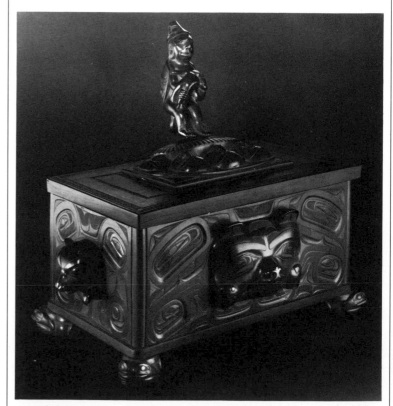

Carved chest showing, on the lid, the origination of mankind from a clam shell, with hawk and beaver on the sides, bears at the ends, and frogs on the corners. Argillite. Attributed to Charles Edenshaw. Length 45cm

the family crest. At the climax, the donor declared his assumption of his new rank and made gifts to all who had attended. Each gift had to be appropriate to the rank of the recipient. An important man had to have an important gift. Equally the greater the rank the host claimed at his potlatch, the more splendidly generous he had to be. His guests, in accepting his gifts, acted as witnesses of his accession to a new rank and acknowledged that he had a proper claim to it.

When Europeans came, many chiefs and their dependants left their villages and traditional territories to settle close by the trading posts. Camped cheek by jowl, fierce rivalries developed between them as they struggled to take the lion's share of the trade with the white men or tried to compel outlying tribes to accept them as middle men. They were vastly richer, too, than any chiefs before them had ever been. They had not just masks, furs and stores of provisions, but the completely new forms of wealth introduced by the Europeans – blankets, which were commonly used as currency, guns, metal tools, trade goods of all kinds and even European money. And as added stimulus to their rivalries, many ancient and prestigious titles had become vacant because of the great number of deaths caused by European diseases. No direct inheritors of many of these ranks were apparent. So if a man had become wealthy through energetic fishing or logging, he might, with an appropriate potlatch, convince others that he was the most worthy claimant of a chiefly title.

The potlatches became fiercely competitive as the chiefs strove to prove their superiority to one another by displays of over-whelming riches. And how better can a man show how much wealth he has than by demonstrating his indifference to it? So a chief invited a rival to his potlatch not merely to receive goods but to witness their waste and even their destruction. Precious eulachon oil was spilled about recklessly from immense ladles. Blankets were torn in pieces or thrown on the fire. The rival chief, if he were not to be shamed in the eyes of his people, would then have to reply with a potlatch of his own in which even greater quantities of goods were destroyed.

Among the most valuable possessions of all were coppers, sheets of copper shaped like shields, sometimes lightly engraved with an emblem, sometimes plain. It may be that coppers were in use before the European period and that they were made from the naturally occurring metal. Chemical analysis, however, has shown that all those tested are made of copper of European origin. They were in themselves of little or no intrinsic value, but they could represent immense sums like bank notes. Every time a copper was exhibited at a potlatch, every time it changed hands either as a gift or as a straightforward sale, its value increased. An old one might be worth as much as 10,000 trade blankets. Such a one would be famous among the villages and have its own name – *Maxtsolem* 'All-others-are-ashamed-to-look-at-it'; *Lopelila*, 'It-empties-a-house-of-blankets'.

Coppers became key weapons in this economic warfare. A chief would offer one for sale to his rival who had to buy it, and for a

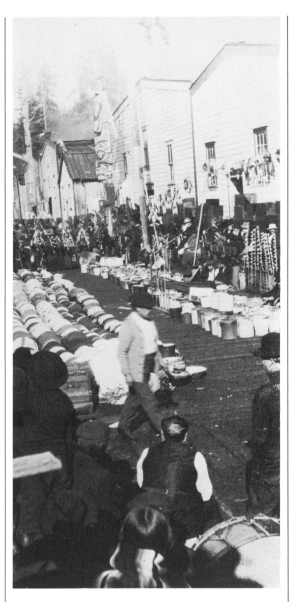

Display of gifts for a Kwakiutl potlatch. Alert Bay, 1903

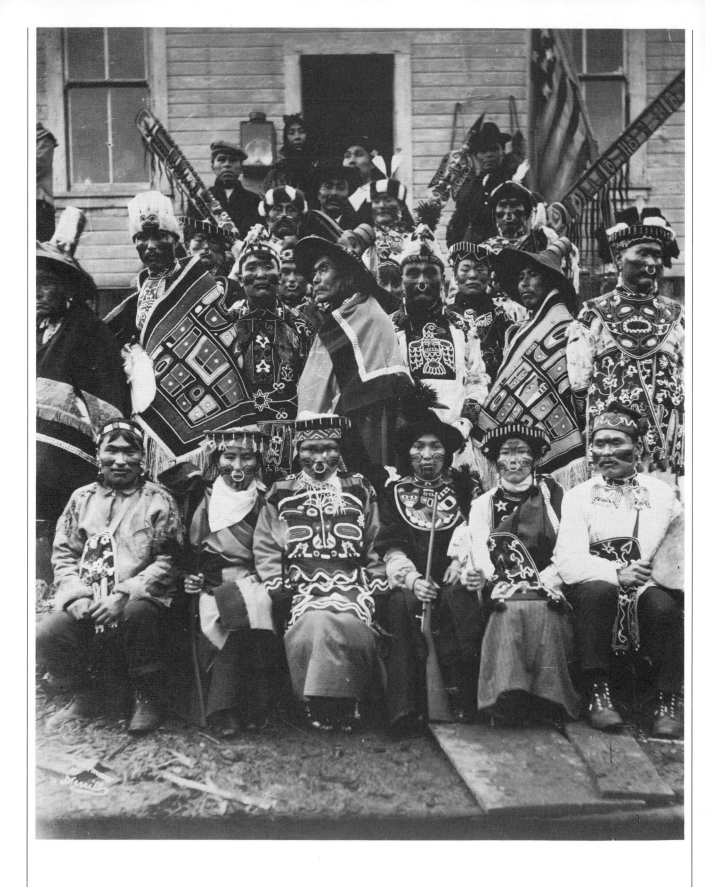

Tlingit people dressed for a potlatch. Yakutat, about 1900

significantly larger price than when it last changed hands, or be humbled. Even more drastically, a copper might be smashed and thrown into the sea, or the fragments handed contemptuously to a rival chief, challenging him to make a gesture of equally profligate extravagance. 'When I was young,' an old Kwakiutl chief is recorded as saying in 1895, 'I saw streams of blood shed in war. But since that time the white men came and stopped up that stream of blood with wealth. Now we fight with our wealth.'

The giving of an important potlatch required the support of a chief's entire family. The labour involved in preparing all the costumes and the food was enormous. He might also need to borrow heavily from his relations if he were to respond successfully to a challenge. So it was not only the chief whose economic future was at stake on such occasions, but that of the whole group. Sometimes the result was the ruin of both rivals.

The Canadian Government decided that such customs had to stop. Missionaries working among the tribes urged that the sacred feasts should be abandoned. Some claimed that the *hamatsa* rituals really did involve cannibalism, though whether this was true, or whether they had been misled by the Indians' theatrical ingenuity, is now hard to tell. Indian customs of all kinds were to be discouraged so that the people might become more quickly integrated with the European community around them. In 1884, the first of a series of laws was passed which eventually became the Indian Act. Among other things, the Act made potlatching illegal.

But the traditions were not easily killed. Potlatching and many of the other sacred rituals continued surreptitiously. In 1921, a group of Kwakiutl people planned a potlatch in a secluded village. The cherished regalia and sacred masks were brought out of concealment and secretly assembled for the occasion. Just after the ceremony finished, the Royal Canadian Mounted Police arrived. Thirty people were arrested and some 800 ceremonial objects were confiscated. The outrage of the people at this suppression was immense and it still burns in the villages of the area over fifty years later.

Since that time, official attitudes towards the Indians and their rights have changed. In 1951, a thoroughly revised version of the Indian Act was published. The clause forbidding potlatches was simply omitted and now the ceremony can be held freely again. The Indians themselves are proud once more to speak an Indian language, to wear their hair long in the Indian fashion, to observe their traditional customs, and the white-skinned North Americans are fascinated by a culture that flourished a thousand years before their ancestors arrived on the continent and which once, so recently, nearly died.

In consequence, there has been a great revival of Indian arts. So much had been lost that recovery was not easy. Bill Holm, an artist and anthropologist working at the University of Washington in Seattle, made a detailed analysis of 400 of the finest old pieces now in museums and discovered the aesthetic rules that had governed the work of traditional sculptors. Bill Reid, an artist of Haida descent, worked closely with Bill Holm in his research.

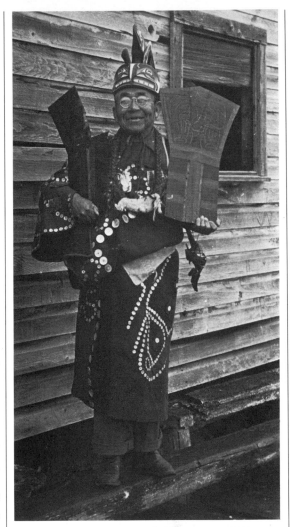

Kwakiutl Chief Willie Seaweed, with coppers, 1955

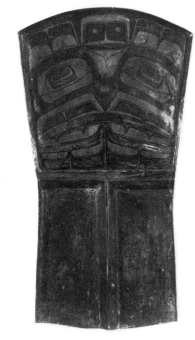

Copper painted with totemic design. Tsimshian. Ht 76cm

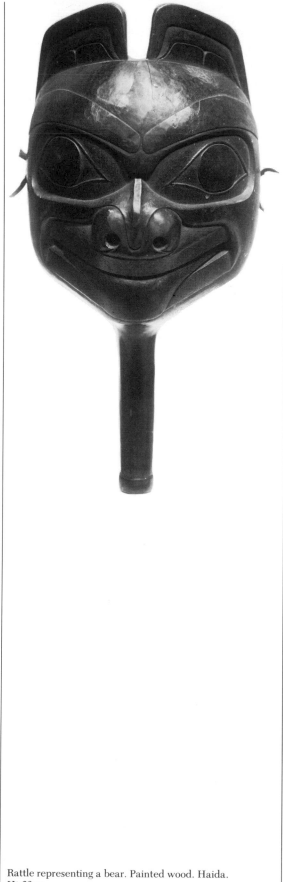

Reid, with the aid of these findings, was able to breathe new life into the Haida artistic tradition and create designs of splendour and conviction which he used in his prints and jewellery. In Victoria on Vancouver Island Henry Hunt, a great Kwakiutl carver from a long line of artists, makes masks and, particularly, totem poles. He uses modern steel chisels, but strikes them with an ancient stone hammer. He believes that a stone maul, because of the way its weight is distributed, gives the carver a control that cannot be matched by European-style mallets. Farther north, in Tsimshian country, the village of 'Ksan had been founded where many traditional skills have been revived. The complex technique of weaving Chilkat blankets seemed to have been totally lost. But the artists of 'Ksan heard of an enthusiastic amateur weaver in the United States who had discovered how these blankets had been made by the simple, if drastic, expedient of unravelling one, and later found a tiny group of Tlingit women who still practised the art. Now several weavers at 'Ksan have the skill. Earl Muldon

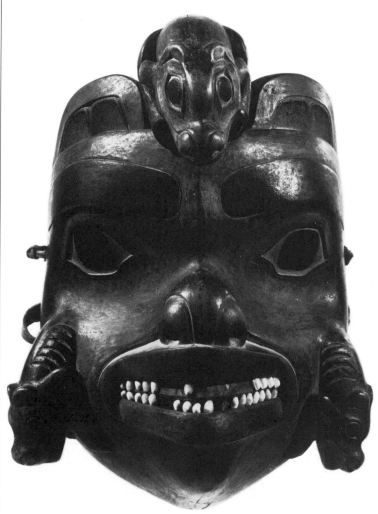

Rattle representing a bear. Painted wood. Haida. Ht 23cm

42

Mask of a bear with three cubs, collected 1868. Painted wood. Tlingit. Ht 26cm

carves masks and silver bracelets. Walter Harris, by hereditary right a Tsimshian chief and once a building contractor in a coastal town, now designs and carves totem poles. They are in great demand by Californian millionaires for their estates, and Canadian municipalities want them for their parks. Crucially, Indian families in the neighbourhood want once more to commemorate their myths and their lineage by putting up poles and are proud to commission Walter Harris to make them.

And potlatching, once again, has become a recognised and admired way by which a man may mark his progress through life. Alert Bay is the home of the Nimpkish Band of the Kwakiutl tribe. The area is the only place on the Northwest Coast where Kwakiutl tradition has remained alive and unbroken even throughout the period when it was officially proscribed. The suppressed potlatch of 1921 was held on an island not far from the town and many people there still remember the occasion very well. Perhaps because of that, potlatching is now practised in Alert Bay with particular fervour.

The vitality of the tradition is obvious to any visitor to the town. The burial ground contains many memorial poles superbly carved and brilliantly painted, some of them by sculptors of a previous generation whose masks are now prized by museums all over the world. Other poles stand beside private houses that line the hillside above the harbour. Outside the town, in the grounds of the tribal reserve, the people have built a huge ceremonial house and painted its façade with a bold traditional design. In front stands an immense totem pole over a hundred feet high which, the people say, is the tallest in existence and which they put up only a few years ago.

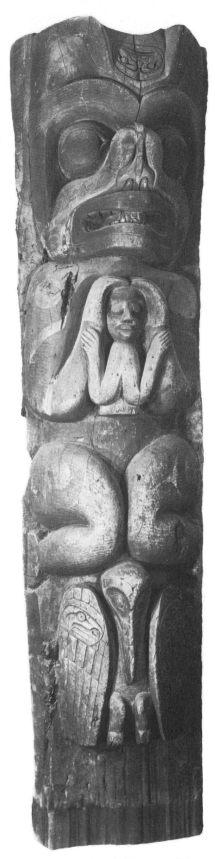

Doorpost representing a bear holding a small figure in its fore-paws with a raven beneath. Wood with traces of red, brown and black paint. Kwakiutl, collected 1899. Ht 250cm

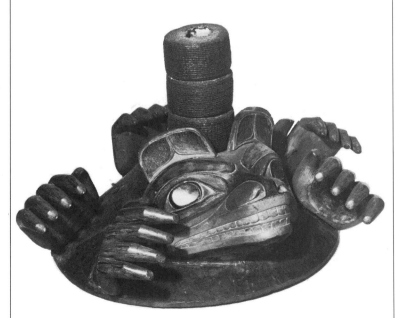

Clan hat. Wood painted red, black and green. Tsimshian

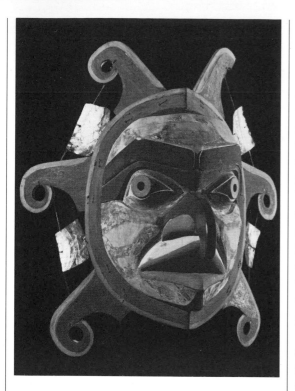

The community is a wealthy one, based as it always has been on fish. Powerful ocean-going fishing boats, fitted with the most modern tackle and navigational equipment, lie in the harbour. One of them belongs to Arthur Dick, head of one of the town's senior families and one of the most skilled fishermen. He decided, with the support of his family, that the time had come for him to give a potlatch. Preparations for it went on for weeks. Cargo ships, calling at the harbour, brought in crate after crate which were quietly taken up to the Dick house and stored away in a back room. Days before the appointed date, his wife and daughters began preparing food for the feast and refurbishing the costumes and regalia that would be needed for the dances. Arthur himself went on a long voyage around outlying settlements telling friends and relatives of the coming celebration and bringing back on his boat those who had no other means of getting there. In the village there was much speculation as to what hereditary dances would be performed, what regalia displayed, what titles and privileges Arthur would assume, and how great the gifts would be.

Ron Hamilton, a Nootka artist and a friend of the Dicks, arrived a few days before the festivities and was promptly commissioned to paint a screen for one of the dances. He did the work secretly in the Dick house, for the beauty of his designs must come as a surprise to the guests.

The rituals began in the early evening. The inside of the big house had been lavishly decorated. At each end, painted screens had been hung between the carved houseposts. Hemlock and cedar branches were draped along the walls and the rafters. A great fire burned in the centre. At the end opposite the door, two dozen old men, some from far-distant villages, were seated on both sides of a long log drum, with wooden beaters in their hands.

The ceremonials were prefaced by a long series of songs, mourning those in the family who had died since the last potlatch had been held by the Dicks, four years earlier. It was a time of great solemnity. As the old men sang the dirges the women of the family sat in front of the log drum, wrapped in their button-decorated scarlet capes. When the last song was finished, there was a long break in the proceedings.

More and more guests arrived until the house was crammed with an expectant audience. The old men took their places again beside the drum and beat a long and ominous tattoo to announce the recommencement of the rituals. Whistles and calls came from behind the screen and suddenly Arthur's son came prancing out, dressed as a *hamatsa* initiate, a ring of cedar bark over his naked chest and wearing a kilt of cedar bark. Stepping high, arms outstretched and quivering, he circled the dancing floor. He rubbed his stomach, calling of his hunger for human flesh. He ran his fingers through his hair to show that he wished to wash it in human blood. The long rituals and stern initiations of the *hamatsa* society may no longer be observed, but the prestige of belonging to the society remains. This was the first time that Arthur's son had danced as a *hamatsa* and he was the first of the family this evening to indicate that he was assuming a new rank.

Mask representing the sun. Alder wood with green paint and abalone shell plaques. Kwakiutl, collected 1911

The three cannibal birds, attendants of the Spirit-from-the-North-End-of-the-World, appeared. A long skirt of shredded cedar bark hung from the bottom of each mask, concealing the body of the dancer. In front of each, an attendant walked, shaking a rattle and helping the dancer to find his way. The mask of Crooked-Beak-of-Heaven was particularly magnificent. It had been carved twenty years before by Willie Seaweed, and was one of the most famous of the Dicks' ceremonial possessions.

One by one, the dances continued. Ron Hamilton's screen was produced in order that one of Arthur's grandchildren might dance in front of it, a right that had come to the Dick family when one of Arthur's forebears had married a Nootka woman. The women, still wearing their resplendent cloaks, danced in procession around the floor. Masks and regalia were displayed. The children performed a special dance of their own. Some time after midnight an ancient copper was brought in, brandished in a dance and then placed on the ground beside the fire for all to see. It had been promised to Arthur by the family of his son's wife as part of the marriage settlement and its transfer of ownership was now being publicly made for all to see.

After hours of dancing, a high-ranking chief who had led the drumming rose to his feet. He praised Arthur for his work in the community and for his respect for the traditional ways. A mask of a forest spirit, the *tsonoqua*, was produced. This was a mask that might only be worn by a chief, he said, and he presented it to Arthur. As Arthur put it on, the old chief loudly called his new

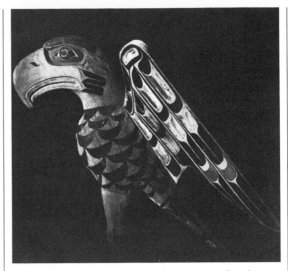

Figure of an eagle from the top of a mast. Wood with wings carved from separate attached pieces, painted black, red, green and yellow on a white ground. Kwakiutl. Ht 89cm

Arthur Dick, wearing his ceremonial button blanket and holding his newly bestowed chief's mask, being presented with a copper

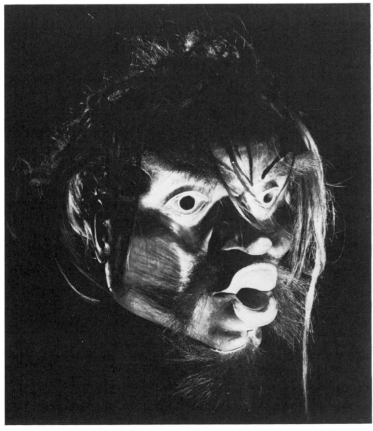

Mask of the *tsonoqua* spirit. Painted wood with fur. Kwakiutl

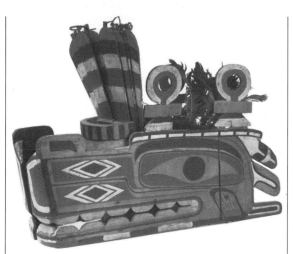

Transformation mask representing, closed, a wolf.
Painted wood. Nootka. Ht 41cm

name and rank. Finally, from the rooms behind the screen, the gifts were brought out in crates. There were pots and pans, plastic mugs, scarves, cutlery, knitted hats, tea towels and radio sets. Arthur's close relatives worked their way around the audience, making sure that appropriate gifts were made and that everyone received something; and Arthur followed behind, handing out dollar bills.

There were calculating eyes in the audience. Everyone had seen that Arthur owned splendid regalia and masks, that his family had the rights to many important songs and dances and, at the very least, he had given away that night several thousand dollars. And that was as it should be, if a man is to be recognised as a chief on the Northwest Coast.

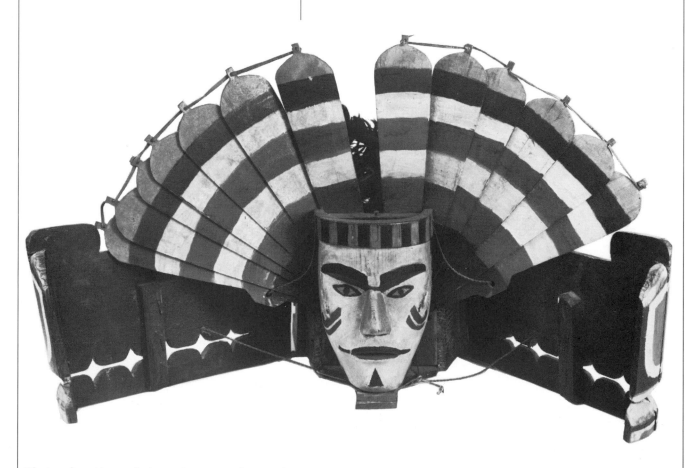

The transformation mask, shown above, opened to reveal the face of the sun

Sweat of the Sun

Sweat of the Sun

Sweat of the Sun

Sweat of the Sun

Sweat of the Sun

Sweat of the Sun













Sweat of the Sun

In July 1520 an astonishing collection of jewels and gold arrived at the court of King Charles V of Spain. It had belonged to Montezuma, Lord of the Aztecs, and had been sent to Europe by the Spaniard Hernando Cortés, who at that very moment was taking possession of Montezuma's land, Mexico. Charles V put the treasure on display in Brussels where he was holding court. Among the many who went to see it was the German painter, Albrecht Dürer. He described some of these extraordinary objects in his journal: 'A sun all of gold a whole fathom wide; a moon all of silver of equal size; and two rooms of rare accoutrements, of all manner of their weapons, armour, bows and arrows, wonderful arms, strange garments, bed hangings and all manner of wonderful things for many uses, all much fairer to behold than any marvel.'

Everyone who visited the exhibition was astonished that the New World, where hitherto only savages had been found, should contain people whose skills clearly rivalled those of the greatest craftsmen of Europe. Dürer's reactions, however, went farther than admiration of technical ability. 'In all the days of my life, I have seen nothing that so rejoiced my heart as these things. For I saw among them strange and exquisitely worked objects and marvelled at the subtle genius of the men in distant lands. The things I saw there I have no words to express.'

That passage may well be the first record of a European looking at the creations of an exotic society and finding them, not barbarous, grotesque or even skilfully made, but aesthetically moving.

Cortés sent a letter with the treasure, listing the objects. When it was brought ashore in Seville and unpacked, the royal clerks also compiled an inventory. With the help of these two lists, it is possible to identify some of the pieces with reasonable certainty.

In the British Museum's unrivalled collection of Aztec mosaics there is a human skull covered with broad horizontal bands of lignite and turquoise. Its teeth grin white. Its bulging eyes are of burnished pyrites, ringed with white shell. At the back, the cranium has been cut away and the edge of the bone lined with leather and fitted with straps so that it can be worn as part of a costume. The glittering splendour of the stones which cover it and the grim reality of the human bones beneath make it an object of startling and sophisticated horror. The British Museum acquired the skull

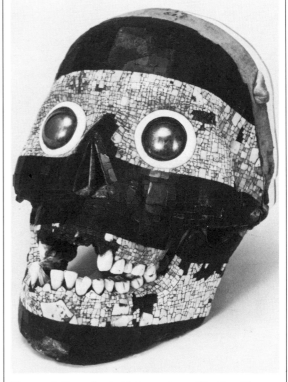

Human skull, overlaid with turquoise and lignite with eyes of polished pyrites and shell. Probably part of the treasure presented to Cortés by Montezuma. Aztec. Ht 20cm

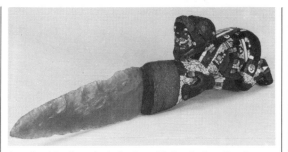

Sacrificial knife with chalcedony blade, the handle of wood, covered with turquoise, malachite and shell mosaic, representing a crouching man wearing an eagle head-dress. Aztec. Length 32cm

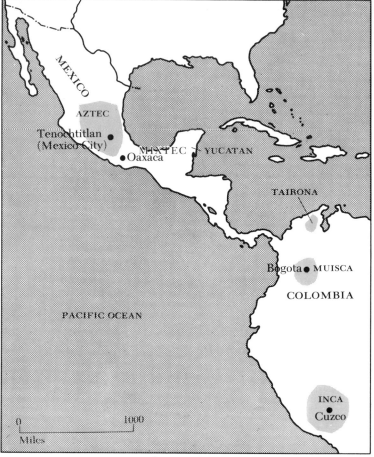

The people of Pre-Conquest Middle and South America

in the nineteenth century from a Bruges collection. Local tradition maintained that it had been in local hands for several centuries. Perhaps it had been part of the original treasure that King Charles had given to one of the local noblemen. He certainly gave away many other pieces. He sent the Pope an articulated silver fish, inlaid with gold, which was later seen by Benvenuto Cellini. Cellini, who was regarded by his contemporaries as the greatest of all jewellers and possessed of almost supernatural skills, was reported to have declared that he did not himself know how to make such a piece. That fish has now disappeared.

King Charles also gave a huge head-dress of iridescent green feathers to his young son, Archduke Ferdinand of Tyrol. This remained for centuries in Ambras Castle near Innsbruck, occasionally worn, it is said, by the ducal children as fancy dress. At some time in the eighteenth century, a golden bird's head, that had been fixed in the centre of the brow, came off and was lost. Not until the nineteenth century was the head-dress rescued and taken to the Vienna Ethnographical Museum. Miraculously, it is still in good condition. The feathers, two feet long, which come from the tail of the quetzal bird, retain their shimmer, bronze in one light, electric green in another. Bands of blue and red feathers run along the bottom mingled with lines of golden discs, crescents and triangles. Each tiny plate is meticulously made with a perfor-

ated flange so that it can be fastened to the feathers beneath.

The Vienna Museum has another outstandingly beautiful feather piece that, if it was not part of the original treasure sent by Cortés, must certainly have arrived in Europe very soon after it. It is a ceremonial shield, a disc of pink feathers from the roseate spoonbill in which is set a design of a plumed coyote, its outlines picked out with ribbon-shaped plates of gold. These tiny pieces and those in the head-dress are the only gold objects that certainly survive from the whole immense treasure. The sun disc, six feet across, singled out by Dürer and surely the most spectacular piece in the collection, together with all the other gold pieces, was melted down for bullion.

Gold, at this time, had an almost supernatural appeal to Europeans. The alchemists had noted that, alone among metals, it neither tarnished nor decayed. So it symbolised incorruptibility and eternal life. Any potion designed to ward off old age had to contain it in some form. Even drinking from golden vessels was thought to have a beneficial effect. The elixir of life, whatever it might be, must assuredly be based upon gold. And the aim of alchemy was to discover a method whereby base metals might be transmuted into this most precious and perfect of substances.

So the quest for gold became an obsession of the age, and it was this that drove Cortés with some 500 men in eleven ships to leave the Spanish settlement in Cuba, in February 1519, and sail west across the Caribbean to explore the mainland of Middle America. Two Spanish expeditions had already sailed these waters and landed on the continent, but neither had managed to penetrate far inland. Both had been attacked by the people they encountered and had had to fight their way back to their ships with the loss of many lives. Cortés and his party went ashore several times as they voyaged round the Yucatan peninsula. They sailed further up the coast of Mexico and came to the tiny offshore islet of San Juan de Ulua, discovered and named by one of their Spanish predecessors. It provided good shelter and they anchored.

Indians came out from the mainland in two canoes and told the Spaniards that they wished for peace. Through his interpreter, Cortés learned that they were servants of Montezuma, King of the Aztecs, who commanded an army of many thousands and lived in a city several days' march across the mountains. Cortés realised that he had entered not just the territory of a small tribe but an empire. Just how big and sophisticated it was, he then could have had no idea.

The Aztec capital, Tenochtitlan, was built on an island in a wide shallow lake. It was splendidly laid out. A rectangular grid of canals, carrying a busy traffic of canoes, ran between gleaming white buildings. There were spacious plazas and temples with brilliantly painted walls standing on top of pyramids that rivalled in size those of ancient Egypt. The population of the city was between 150,000 and 200,000, larger than most, if not all, European cities of the time. The people walking in the broad straight streets were elegantly dressed. Ordinary citizens wore white cloaks and warriors and noblemen were resplendently costumed

The restored temple and pyramid of Santa Cecilia. Aztec. Mexico City

with golden jewellery and head-dresses and capes of brilliantly coloured feathers.

The Emperor Montezuma, or to spell his name as it was pronounced, Motecuzoma, had his palace in the centre of the city, close to the temples, where he lived with his wives and councillors. His court delighted in poetry, music and dancing. He maintained a large botanic garden and a zoo in which he kept examples of animals from all over his territories. His aviaries alone required 600 keepers to care for them. His empire stretched across the peninsula from the Caribbean to the Pacific. His scribes practised a form of picture writing that was primarily figurative but which could also be used phonetically. His officials, therefore, were able to administer and tax the 489 cities that owed him allegiance and paid him tribute. The main roads through his territories had post houses every five miles staffed with runners who operated so efficiently that fish caught in the Caribbean could be delivered to the palace, 200 miles away, within twenty-four hours.

In the midst of all this splendour and sophistication stood places of the greatest horror. The Aztecs believed that after the sun had sunk below the rim of the world, it had to struggle with the god of the night before it could reappear the following day. To ensure its victory and prevent eternal darkness overtaking the world, the sun had to be nourished with human blood. So every day men were taken up the pyramid steps to the temples. The priests, black-robed, their long hair matted with blood and stinking of decaying flesh, awaited them. Each victim was stretched over the sacrificial stone. The priest sliced open his chest with an obsidian knife and lifted the heart, still palpitating, up towards the sun. The demand for victims was never-ending. Some were men who had been sent as tribute by vassal states, others were prisoners taken in battle, and the Aztecs maintained a continuous state of war with some of their neighbours to ensure that the supply never ceased. On important occasions, the scale of sacrifices was such that the queue of men waiting to be led up the pyramid steps to the temple stretched for over a mile through the city.

The Aztecs were relatively recent arrivals in the Valley of Mexico. Only 200 years earlier, they had come down from the mountains in the north-west, an impoverished and semi-nomadic group, to settle on their island in the lake. The island was then so swampy and ill-favoured that no one else wanted it. Within the next century, by intrigue and battle, they became masters of the valley. They took over much of the culture and technology of their immediate predecessors, the Toltecs. They also adopted some of the Toltec gods and in particular their divine hero, Quetzalcoatl.

Quetzalcoatl, a pale-faced god, was said to have fled from the country eastwards into the Caribbean when the Aztecs arrived, but it was prophesied that eventually he would return and reclaim the throne. The date of this return had been predicted with precision. It would be in the spring of the Aztec year 'One Reed', which in their calendar recurred every fifty-two years. One such year was, in European notation, 1519.

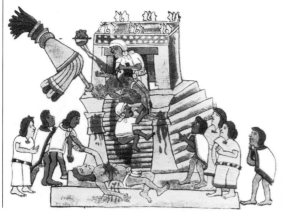

Human sacrifice, from a Mexican manuscript

As that year approached, Montezuma became deeply troubled. For a long time past, there had been disturbing omens – a comet like a golden maize head had appeared in the sky; thunderbolts had fallen; a temple in Tenochtitlan had burst spontaneously into flames. And then he received reports from his agents in his eastern territories that moving islands had materialised in seas there. Now, in the spring of Year One Reed, messengers arrived to tell him that some of these islands had appeared again and pale-faced beings had come ashore from them. Some were seated on the backs of hornless deer. They carried sticks that spat fire with a terrifying noise and other bigger objects which, when pointed at a tree, made it explode into fragments. The messengers produced paintings by picture-writers showing the appearance of these personages, the clothes they wore, the objects they carried and the creatures they rode.

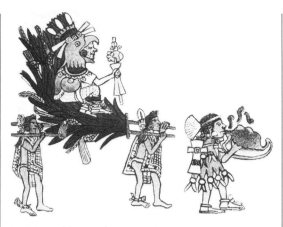

An Aztec nobleman, from a Mexican manuscript

Montezuma had little doubt that this was indeed Quetzalcoatl who had landed on exactly the date and from the direction that the legend had said he would. Immediately, he commanded his jewellers to prepare special regalia. He ordered sacred objects that had never before left the temple to be gathered together – a mask made from a human skull covered with turquoise; a golden image of the sun; and the huge head-dress made from the feathers of the quetzal, the bird that was sacred to Quetzalcoatl. Then he dispatched them and many more sacred objects as gifts to welcome the returning god.

One of Cortés' companions, Bernal Diaz de Castillo, wrote in his old age a long account of the campaign and described the arrival of these gifts at Cortés' camp in the sand dunes of the coast. 'When these people arrived and came before our captain, they first of all kissed the earth and then purified him and all the

Double-headed serpent, probably worn as a chest ornament. Wood covered with turquoise mosaic. Probably part of the treasure presented by Montezuma to Cortés. Aztec. Length 44cm

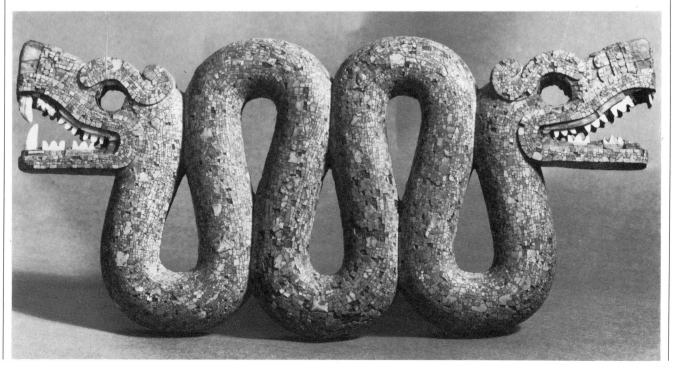

soldiers who were standing around him, with incense which they brought in braziers of pottery. Cortés received them affectionately and seated them near himself . . . After welcoming us to the country and after many courteous speeches had passed, [the chief] ordered the presents which he had brought to be displayed, and they were placed on mats over which were spread cotton cloths. The first article presented was a wheel like a sun, as big as a cartwheel, with many sorts of pictures on it, the whole of fine gold, and a wonderful thing to behold, which those who afterwards weighed it said was worth more than ten thousand dollars. Then another wheel was presented of greater size made of silver of great brilliancy in imitation of the moon with other figures shown on it, and this was of great value as it was very heavy. . . . Then were brought twenty golden ducks, beautifully worked and very natural looking, and some [ornaments] like dogs, and many articles of gold worked in the shape of tigers and lions and monkeys, and ten collars beautifully worked and other neck-laces; and twelve arrows and a bow with its string, and two rods like staffs of justice five palms long, all in beautiful hollow work of fine gold. Then there were presented crests of gold and plumes of rich green feathers, and others of silver and fans of the same materials, and deer copied in hollow gold and many other things that I cannot remember for it all happened so many years ago.'

An Aztec account of a similar presentation made a few weeks later also survives. 'When they were given these presents, the Spaniards burst into smiles; their eyes shone with pleasure; they were delighted by them. They picked up the gold and fingered it like monkeys; they seemed to be transported by joy as if their hearts were illumined and made new. The truth is that they longed and lusted for gold. Their bodies swelled with greed and their hunger was ravenous; they hungered like pigs for that gold. They snatched at the golden ensigns, waved them from side to side and examined every inch of them.'

Cortés was convinced that he had at last found the golden kingdom for which he was seeking and he made preparations for a long campaign. He built a settlement among the dunes which he called *Villa Rica de la Vera Cruz*, Rich Town of the True Cross. He explored further up the coast and discovered that the people there were only too anxious to see the overthrow of the Aztecs who oppressed them so mercilessly and claimed regular tributes of prisoners for sacrifice in the temples of Tenochtitlan. These people, he calculated, could become his allies. His plans made, he packed up the entire treasure that Montezuma had sent him and dispatched it in one of his ships back to the King of Spain. Then he destroyed the rest of his fleet to prevent any thought of defection among his party and set out for Tenochtitlan.

His astonishing campaign has been described many times. It is a story of great bravery and of massacres, deceit and savagery. It ended after three years with the entire Aztec Empire in Spanish hands, Tenochtitlan razed to the ground and the country stripped clean of its gold.

Sources of gold ore are rare in the Valley of Mexico. Most of the

Facing: Pendant representing Mictlantecuchtli, Lord of the Dead. Gold. Mixtec from Tomb 7 Oaxaca. 15th century. Ht 11.5cm

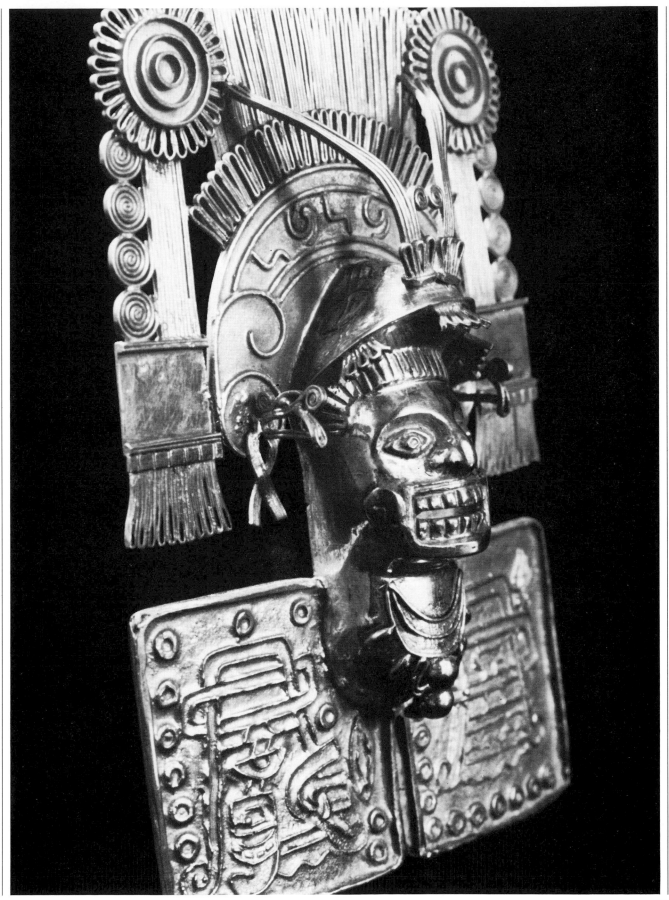

53

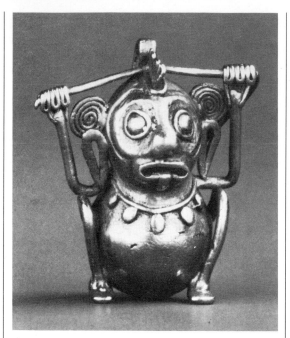

Golden bell in the form of a monkey. 16th century
Mixtec. Ht 2.7cm

metal came to the capital as tribute from people in outlying parts of the empire, or was traded up from farther south. Perhaps the most talented craftsmen in ancient Mexico were the Mixtec who lived around the valley of Oaxaca south-east of the lake. The Mixtec carved jade, made exquisite painted pottery and feather-work, and worked gold with a skill that was unexcelled in the whole of pre-conquest America.

The number of their gold pieces that survive today is tiny. Montezuma's official tribute lists showed the Spaniards exactly which parts of the empire had supplies of gold and they followed up the clues ruthlessly. The only objects they failed to discover were those that had been hidden below ground in graves, and it was from the few of those that remained unplundered into the age of scientific excavation that most of our knowledge of Mixtec goldwork has come. The greatest single discovery was made in 1932 when the archaeologist Alfonso Caso excavated a cemetery in the sacred Mixtec city of Monte Alban, near the present town of Oaxaca. In one tomb lay nine skeletons and, strewn in the dust around the bones, the jewels with which the corpses had been decked – turquoise, onyx, rock crystal and gold. The most spectacular single piece is a pendant, four and a half inches high, of Mictlantecuchtli, the Lord of the Dead. The god wears a huge head-dress and across his mouth a rectangular mask shaped like grinning jaws. The base consists of two square plaques inscribed in relief with glyphs that date the piece with some degree of certainty to the fifteenth century.

The Mixtec goldsmiths seem to have taken a particular delight in making jewels with moving parts. A tiny skull pendant found near Oaxaca has a lower jaw so delicately balanced by little bells hanging from it that, if it is worn, the jaw is in continual movement. A labret, worn in a hole pierced in the lower lip, is in the form of a serpent from whose fanged jaws hangs a long quivering tongue.

Although so little of the work of the Mixtec goldsmiths survives, we have a highly detailed knowledge of their techniques. Soon after the conquest a friar, Bernardino de Sahagun, came to assist with conversion of the Mexicans to Christianity. He founded a missionary college and after some years began to compile a record of the beliefs, practices and everyday life of the people as it had been before the Spaniards arrived. He trained his young pupils to become interrogators and recorded their findings in Nahuatl, the Aztec language, written phonetically with a Roman script. The accounts were illustrated with small vignettes which combine the formal semi-symbolic style of the traditional picture-books with European devices of perspective and portraiture. The finished manuscript, the result of eleven years' work, is entitled *Historia General de las Cosas de la Nueva España* – The General History of the Things of New Spain – and is today in the Medici Library in Florence. It is, in effect, the first thorough-going ethnography ever compiled and among its chapters are several dealing with gold working.

Gold was collected as tiny particles from river beds, either by panning or by building stone riffles across a stream so that the

heavy metal particles carried down by the current accumulated in front of them. The smiths did not have bellows, but they blew through reeds into their charcoal furnaces and so raised the temperature high enough to melt the particles and produce solid metal.

They were masters of most metallurgical techniques. Beating gold into sheets with stone implements was a specialised trade. They knew that after a great deal of hammering, the metal becomes brittle and the hammer bounces away without thinning it any further. But they also understood how to restore it to its former malleability and strength by reheating it, a technique called annealing. The process is far from simple, for, to be effective, gold has to be taken up to a temperature very close to its melting point. If the sheet is to be prevented from collapsing into a puddle of liquid metal, it has to be withdrawn at just the right moment and this requires a most accurate judgment of its colour within the furnace.

Other craftsmen specialised in casting. A model was made in wax around a core of clay mixed with carbon. This was covered with an investment of clay. Heating then baked the clay and allowed the wax to be poured off as a liquid or dispersed it as vapour. Molten gold was then poured into the mould to fill the space that had been occupied by wax. The Mixtec exploited this process, known as 'lost wax' casting, to perfection. Sometimes jewels with moving parts were cast in stages. A tongue was made first and then the jaws between which it would fit were modelled in wax and cast in a second firing. Jewels which combined gold and silver were also produced in two stages. Since silver has the higher melting point, that part was cast first and the gold section then cast on to join it.

As gold was in short supply, the Mixtec usually made the most economical use of it, their castings being firm and strong but hardly ever unduly thick. They eked out their gold by mixing it with copper, an alloy that the Spaniards called *tumbaga*. It was also easier to work in this form, for the melting point of the alloy is substantially lower than either metal when pure. *Tumbaga* is a dull red colour, but the Mixtec had a method of turning it yellow by heating it and rubbing it with what they called 'gold medicine'. This was a solution of minerals which dissolved the copper from the surface leaving a spongy film of pure gold which could be consolidated by burnishing. In such a way *tumbaga* objects containing up to ninety per cent of copper could be made to glisten a convincing yellow.

The Mixtec acquired their gold-working techniques comparatively late, in the twelfth century, but it is not known from whom they learned them. The source is likely to have been further south. Certainly the richest supply of gold lay there, in the rivers of the Andes. Gold had been worked in this area as long ago as the second millennium BC and it seems almost certain that it was here that the techniques of metal working were discovered. The Incas who came to power in the northern Andes during the fourteenth century inherited a tradition of metallurgy that had already mas-

Pendant in the form of a skull with movable jaws hung with bells. Gold. Mixtec. Ht 8.8cm

tered the methods of hammering and annealing, soldering, casting and alloying; and they used gold with a lavishness that has never been equalled by any other society. They called gold Sweat of the Sun, and silver Tears of the Moon.

Gold was a state monopoly. Only the priests and nobility might own it. The Inca emperor ate and drank from golden vessels and rode in a huge litter of gold studded with emeralds that needed twenty-five men to carry it. Water, in his palace, flowed through golden pipes and splashed into golden bowls. The stone walls of the Coricancha, the Temple of the Sun in Cuzco, were sheathed with gold plates. Inside, a huge golden disc represented the sun and on either side of it sat the mummified bodies of past Inca rulers, each encased in gold and laden with golden regalia. At the time of the spring sowing, a courtyard of the temple was planted with tall stems of maize made from silver and gold. Among them stood life-size golden llamas tended by golden shepherds. Elsewhere the craftsmen had built complete gardens – beds of flowers and trees in which there perched birds and butterflies, lizards and snakes, all fashioned from gold and decorated with emeralds and other precious stones.

This civilisation, too, was to fall to the Spaniards. Eleven years after Cortés had invaded Mexico, another expedition, led by Francisco Pizarro, marched into the Inca empire. In some ways, the two campaigns resembled one another. In both, a tiny group of determined men invaded an immense empire ruled autocratically by a god-king, and gained control by the simple device of seizing the ruler himself. Pizarro with his tiny band of only 170 men

Head of a spatula representing a monkey and a bird. Gold. 4th-9th century. Mochica culture, Peru. Ht of whole object 16cm

Figure of a woman. Gold. 16th century. Inca. Ht 6.1cm

arranged to meet the Emperor Atahualpa in the Inca town of Cajamarca. There the Spaniards laid an ambush for him.

Atahualpa arrived with an army of 40,000 warriors and walked straight into the trap. The Spaniards, armed with steel swords, crossbows and cannon, and supported by cavalry, fighting in the enclosed space of the walled town square, totally routed the Incas. In half an hour, some 4000 Indians were slaughtered. The Spaniards did not lose a single man. And Pizarro, personally, took Atahualpa prisoner.

In his captivity, the Inca shrewdly noted that the Spaniards became greatly excited whenever they found any of the yellow metal that he owned in such quantities. He saw in this obsession of his captors a chance of buying his freedom. He offered to fill the room in which he was imprisoned with gold. It measured twenty-two feet by seventeen feet and he said he would fill it to a level eight and a half feet above the floor. He would fill another similar room with silver twice over and complete both actions within two months. All this he would do if he were allowed thereafter to go free. The offer was an astounding one. Pizarro accepted. He had nothing to lose. How better to collect the treasure for which he had come to Peru than to get the people themselves to gather it for him?

So Atahualpa's orders went out and the work of collection began. Soon processions of carriers were arriving every day at Cajamarca to tip loads of golden plates, vessels and figures of gods into the room. After several weeks, the Spaniards complained that the work was not proceeding quickly enough. Atahualpa suggested that, in that case, the Spaniards should go to Cuzco, 600 miles away, and supervise the gathering of the gold themselves. Three Spaniards went and, protected by Atahualpa's instructions, wrenched the plates from the walls of the Coricancha with copper crowbars. They gathered 700 plates, each weighing four and a half pounds, from this one source alone.

The collection nonetheless took much longer than Atahualpa had predicted and the Spaniards did not deem it complete until over six months later. Then nine forges were built in the square. Into them, to be melted down, went eleven tons of golden objects. A fifth was sent back to the Royal Treasury in Spain. The rest was divided between the conquistadors. Pizarro, in addition to taking much the largest share, also kept Atahualpa's jewel-laden litter. And Atahualpa himself, having kept his word, was taken out into the square and there strangled to death.

Since so much of the Inca gold and silver went back to Spain as bullion, it did not create the sensation that Montezuma's treasure had made. A few pieces were so spectacular that even the conquistadors spared them from the furnaces in order to send them back to Spain undamaged. But they did not last long. Charles V issued an edict that all gold and silver received from his territories in Peru had to be melted down in the Royal Mints of Seville, Toledo or Segovia. So it is that, apart from written sources, our knowledge of the greatest of all golden treasures of the New World rests only on a few pieces that were either hidden or lost

Figure of a man. Gold. Inca. Ht 6cm

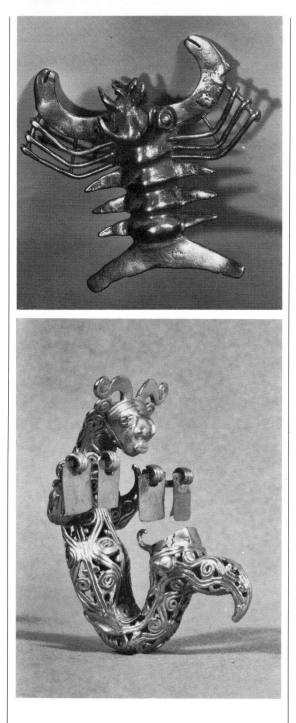

Crayfish pendant. Gold. Excavated at Bugabita, Costa Rica, in 1859. Length 8cm

Pendant in the form of a monster with a human head, the body of a snake, and a tail shaped like bird's beak. Gold. Panama. Ht 6.1cm

among the ruins in the wake of the pillaging Spaniards. There remain only some cups and jars, a few figures of llamas and some standing human figures no more than an inch or two high.

In the lands between the two great empires of the New World, in present-day Colombia and Panama, the people lived in confederations of small towns. Although their daily lives were simpler and less sophisticated than those living in the great Inca cities, their smiths were highly skilled and produced pieces that rival the finest work in the Americas.

The Spaniards had had relatively little difficulty in stripping the Inca empire of its gold. Since only priests and aristocrats were permitted to own it, the Spaniards knew exactly where to concentrate their search and their extortions. Furthermore, the Inca administrators had perfected very efficient methods of collecting tribute of gold from all over the empire. The Spanish took over the system and forced the people to continue it.

But in the chiefdoms of Colombia, any man might own gold. So the conquistadors had to compel not just a small and privileged section of society to surrender their accumulated wealth but to force an entire population to do so, household by household. In spite of the most brutal tortures, many of the people of Colombia and Panama managed to keep their golden jewels and, as had been their custom for centuries, to take them with them to their graves.

The Spaniards, of course, had no compunction in digging up cemeteries, if they could find them. Bernal Diaz, in his description of the Mexican campaign, wrote of a soldier named Figueroa, who instead of fighting against the Mixtec found it much more profitable to spend his time rifling their tombs. Figueroa is the first grave-robber of the New World known by name. The practice has never stopped since and today there are tens of thousands of *guaceros*, as they are called all over South America, who regard the gold in graves as a crop which is theirs for the reaping by traditional right.

The *guaceros* are highly skilled in finding sites. The slightest change in the colour of the surface soil or the pattern of the vegetation may give them a clue. They use long probes to feel for the presence of a hollow chamber, and metal blades curved in the shape of a half cylinder mounted on poles to bring up samples from depths of many feet which might provide evidence of ancient disturbance.

The operations of the *guaceros*, almost everywhere, are technically illegal but frequently they are far from surreptitious. If the site is in a settled area and has an owner, the *guaceros* may take a formal lease on it for a fixed period and agree to pay, in addition to a fee, a share of the profits. The depths of the burials vary from district to district but often they are only a few feet below the surface. Soil has usually seeped into the chamber or the pottery urn in which the corpse had been placed. The urn may be shattered by the weight of the earth above and the bones have turned into powder, but the golden ornaments survive. A spit, a rub on

the sleeve and the yellow metal shines bright through the encrustations of centuries.

A plundered cemetery is a sad sight. The sides of the pits fall in leaving each grave looking like a shell-hole and the whole area a battlefield. Human bones, stone axeheads and fragments of pottery are strewn across the ground. Unless objects are saleable the *guacero* has no interest in them. So they are left as litter, pathetic memorials to lost knowledge.

In such a vast and empty country as South America, the chance of preventing such activities by police control is negligible. And there are a thousand full-time *guaceros* for every archaeologist. The gold pieces that come from these illicit digs cannot have the data that proper archaeological excavation could have given them. As a result, they can seldom be dated with certainty. Even the precise site where they were found may be unknown except in the vaguest terms. The jewel may have passed through many hands before it finally reached a museum and even if the *guacero* who dug it up is identified, he may not wish to reveal the exact location of his find. Worse still, he may invent a totally false story in order to make sure that no one else will visit the cemetery and prevent him from gathering more.

Gold was worked by nearly all the tribes living between the northern edge of the Inca empire and the southern frontiers of the Aztec territories. The variety of styles is huge. Every few years or so, objects are found that have a quite new style and which suggest that yet another ancient tribal culture is waiting to be identified, excavated and described.

In some areas, the graves contain magnificent vessels – flasks, beakers and bottles. But most pieces are for personal adornment – pendants; labrets, ornaments which fit in a hole in the lower lip; pins for the hair; and bars, rings, and half-moons of gold cast as fine as lace, to hang from a pierced nose. Some pieces are hollow-cast, others solid and heavy. Tribes in the north often made pieces with tiny hooks on the front so that they could be hung with thin tinkling plates of gold.

Animals are a frequent source of inspiration – crayfish, bats, insects and jaguars, toucans and turtles. There are great pendants of birds with spread wings, eagles or king vultures, and necklaces of golden frogs. There are human figures with animal heads and extraordinary creatures, multiple-headed or sprouting cog-shaped tails, that are like nothing known on earth.

Among the most technically accomplished pieces are pendants in the shape of a stocky, muscular warrior, standing astride, arms akimbo, a tiny labret in his lip and scowling truculently from beneath a huge and delicately detailed head-dress. These were made by the Tairona people who, at the time of the Spanish conquest, lived in the lowlands of northern Colombia. Their towns were neatly built from stone and linked by carefully constructed roads paved with stone slabs. They made beautiful golden jewellery and they became a prime target for plunder. The Tairona rebelled again and again, and it was not until the year 1600, after three months of almost continuous fighting, that they were finally

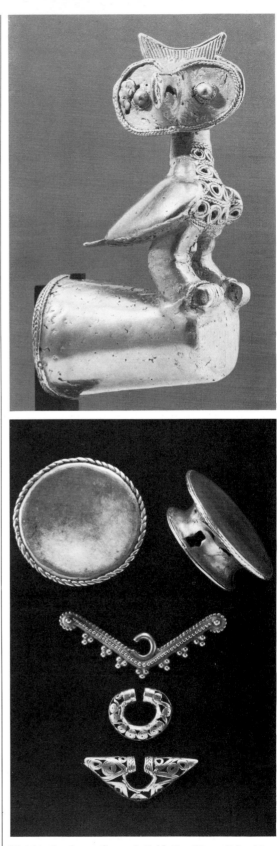

Finial in the shape of an owl. Gold. Sinu River, Colombia. Length 12cm

Ear and nose ornaments. Gold. Quimbaya culture, Colombia. Diameter of ear-plug 5.9cm

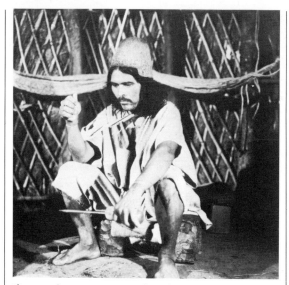

Ika man chewing coca, seated inside the ritual house

subdued. The Spaniards burnt their villages and executed their leaders in the most sadistic fashion.

So the Tairona, as a group, were destroyed. Remnants of the tribe fled into the mountains of the Sierra Nevada de Santa Marta. About 3000 of their descendants, known today as the Ika, live in small villages scattered through the high valleys.

The Ika do not welcome strangers. They ask nothing more than to be left alone. Their dress is still strictly traditional – long-sleeved cloaks over baggy trousers with dome-shaped hats, all made from white cloth that they weave from cactus fibre. The men always carry a *mochilla*, a striped woven shoulder bag. Their black hair is long and hangs down to their shoulders and they go barefoot.

Christian missionaries have lived among them but they have eventually had to retreat, having made no converts. The Ika's own religion remains powerful, dominating their lives and enmeshing them in its symbolism. Their priests, the *mamas*, are celibate and live in their own settlements. Young boys are sent from the villages to join them as novitiates and they must undergo a long training before they become fully qualified. Each village has a sacred enclosure which is, as far as possible, planted with an example of every bush and flower that grows in Ika country, so that it symbolises the whole world. Standing within it are two dome-shaped, windowless houses, their walls shaggy with thatch. One is reserved for men, the other for women. A path of pebbles, shaped like a phallus, leads to the door of the men's house. Long sticks project from the hole in the apex of the roof which serves as a chimney. These, the people say, are the means by which they communicate with the spirits in the sky. Inside, the men sit around the fire, talking softly among themselves. Some weave cloth on vertical looms. Others dry and toast the leaves of the coca bush, which grows abundantly on the mountain slopes.

Every man – though no woman – chews coca. The dried leaves, which the men carry in their *mochillas*, when chewed with a little lime, produce a numbing soporific effect. The lime, made from powdered seashells, is kept in a bottle-shaped calabash called a *poporo* and extracted with a stick. The men are never without their *poporos*. Habitually they beat the lime inside with repeated rhythmic tapping of the stick and they take pride in taking out the moistened lime with the stick and building it up into a thick yellowing collar around the *poporo* mouth. This is as much an act of worship as that of a Tibetan Buddhist when he spins a prayer wheel, for the *poporo* is identified with the most important deity of all, the mother goddess from whom all fertility comes. It is she who can bring solace, through the lime and the coca. Rubbing the lime stick in the *poporo* is symbolic copulation with her. Night after night and sometimes for days and nights on end, the men sit in their ritual house, debating in low voices, sometimes chanting the sacred legends and always chewing coca, drifting in and out of narcotic trance.

Golden *poporos* have been discovered in ancient graves. The Ika say that they have no such things now. The Spaniards robbed

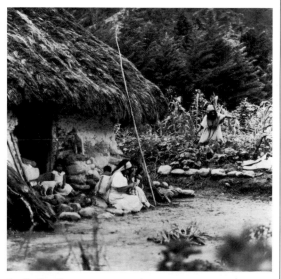

An Ika family

60

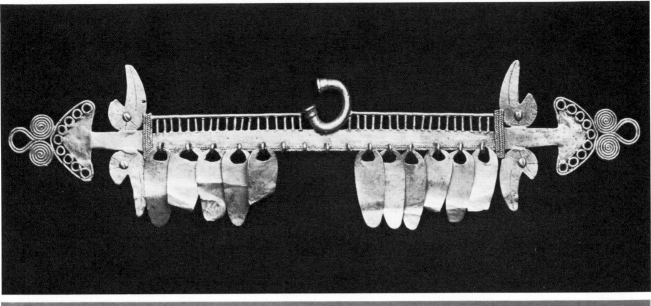

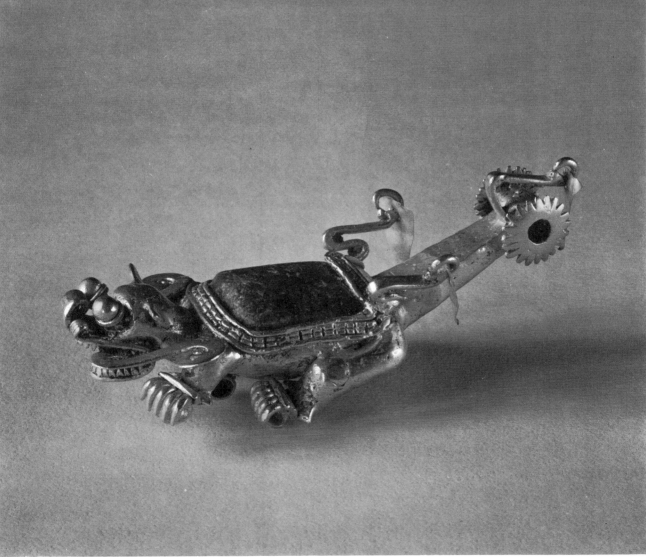

Nose ornament. Gold. Sinu River, Colombia. Length 23cm
Pendant in the form of a fantastic animal. Gold with an emerald inlaid in the back. Coclé culture, Panama. Length 11.5cm

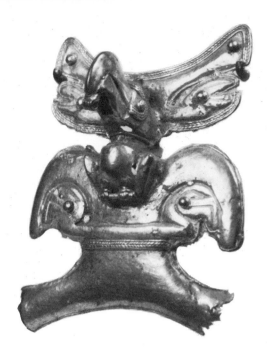

them of all their gold centuries ago. But occasionally, all the Ika villages over a wide area are unexpectedly found empty. The people have left and travelled to a secluded valley away in the high mountains, summoned by the *mamas*. Sentinels are posted to make sure that no strangers are allowed to approach undetected. Then the people hold great ceremonials and then, it is said, the *mamas* themselves appear in front of the people, dancing in magnificent masks of gold. If that is true, it has never been witnessed by outsiders.

The Spaniards never ceased to believe that, in spite of the vast amount of gold they collected, they had failed to find the biggest treasure of all. Many were convinced that the Incas had managed to hide their most sacred and valuable pieces in a secret city. They

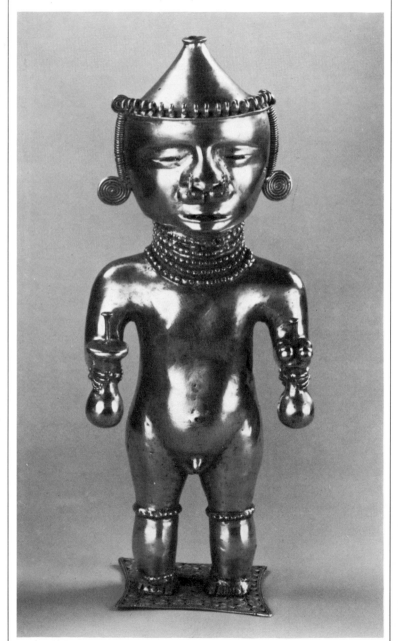

Flask in the form of a man holding two poporos. Gold. Quimbaya culture, Colombia. Ht 26.1cm

Pendant in shape of a fantastic bird. Gold. Tairona. Ht 5cm

heard stories of the Chain of Huascar, a multi-coloured cable of wool, two hundred feet long, covered with plates of gold, which was so heavy that it took two hundred dancers to carry it. But they never found it. And no legend was more seductive than that of El Dorado.

The words, in Spanish, mean simply the Golden One, and although as the years passed it came to mean to many people a hidden city, it applied originally to a man, the Golden Man, the chief of the Muiscas.

The Muiscas, whom the Spaniards called Chibchas, lived in the bleak rolling hills, 9000 feet up, around Bogota, the present-day capital of Colombia. They were an agricultural people, living in large villages and cultivating many crops including potatoes. And they were rich. The sole known American source of emeralds lay in their territory, five days march from Bogota in the lower forested country to the north. All the emeralds used in the ancient jewellery found a thousand miles away in southern Peru came from Muisca territory. The Muisca also produced a commodity that was even more valuable and widely sought after – salt. A huge deposit, still being mined today, lies within one of their mountains and people came from all the surrounding tribes seeking it.

In exchange for these goods the traders brought gold, for the Muiscas had none of their own. So the Muisca chiefs, too, were able to wear golden crowns and regalia and be carried in golden litters. Before them, their attendants carried banners of cloth sewn with innumerable tiny golden plates like stars, and sheets of beaten gold hung clanking beside the entrance to their houses. The people also used the metal to make *tunjos*, flat cut-out figures

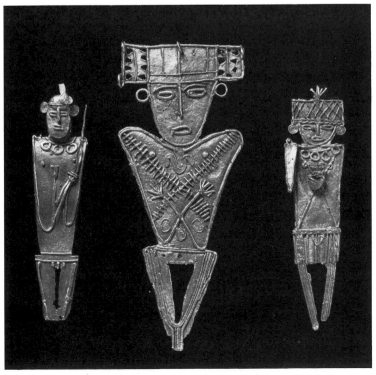

Votive figurines, *tunjos*. Tumbaga. Muisca. Ht of largest 13cm

Lake Guatavita, showing the notch cut in the rim by Antonio de Sepulveda

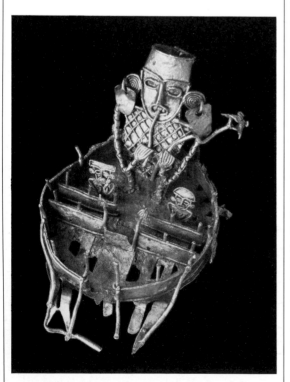

Figure of a chief, perhaps on a raft, with two attendants. Gold. Muisca. Ht 5.5cm

on which the details of the costume and jewellery are indicated by thin wire-like filaments, like icing on a gingerbread man.

The Muiscas worshipped the sun and their greatest ceremony, the one in which the Golden Man appeared, took place on a strange circular lake, Guatavita. It lies thirty miles north-east of Bogota in a steep-sided depression, three-quarters of a mile across, which at first sight looks like a volcanic crater. But there is no lava or volcanic ash to be found here. Some authorities have suggested that this giant pit was produced by the impact of a meteorite, but the surrounding slopes show few of the features associated with such craters. It may have been produced by subsidence, perhaps caused by the subterranean leaching away of a salt deposit.

The dynasty of chiefs who performed the Golden Man ritual was overthrown by a rival Muisca clan some twenty years before the Spaniards reached the lake, so no first-hand account of the ceremony survives, but its broad details are still clear. The paramount chief claimed direct descent from the sun. When he took office or, according to other accounts, every year, he, together with all his people, travelled up to the lake bringing with them a great treasure. Before dawn, the chief was stripped naked and his body covered with a sticky resin. Then he was sprayed with gold dust from head to foot so that he became, in a literal sense, El Dorado. In the early morning light, holding a basket loaded with emeralds and gold, he led his priests in procession down a causeway to the lake. There a raft awaited him and he and his priests were rowed out to the exact centre of the lake, which had been marked by two long cables stretched at right angles to one another from shore to shore. As the first rays of the rising sun slanted down over the hills surrounding the lake and glinted on his body, he emptied his baskets of treasure into the lake. All the people on the shores threw in their own golden offerings and the chief dived into the black waters. The god of the sun had come down to earth. The gold from his body washed off and drifted down to the bottom and he emerged, a god who had once more assumed human form.

The truth of this story is corroborated by two gold pieces which seem to represent El Dorado. One, now in Berlin, was collected at the end of the nineteenth century. The second was found in a cave not far from the lake. It represents the chief on his raft. His nine attendants stand on elaborate decking, holding banners and a staff. The Golden Man himself, because of his importance, is represented as three times the size of the ordinary mortals with him. His head-dress is hung with dangling plates of gold and there are more on what appears to be a golden cape around his shoulders.

The Spaniards reached the lake in 1539 and soon realised that vast treasure must have accumulated on its bed. But how could it be recovered?

The first major attempt was made by Hernan de Quesada, a brother of one of the founders of Bogota. At the beginning of the dry season of 1545, he stationed a chain of Muisca men, standing a

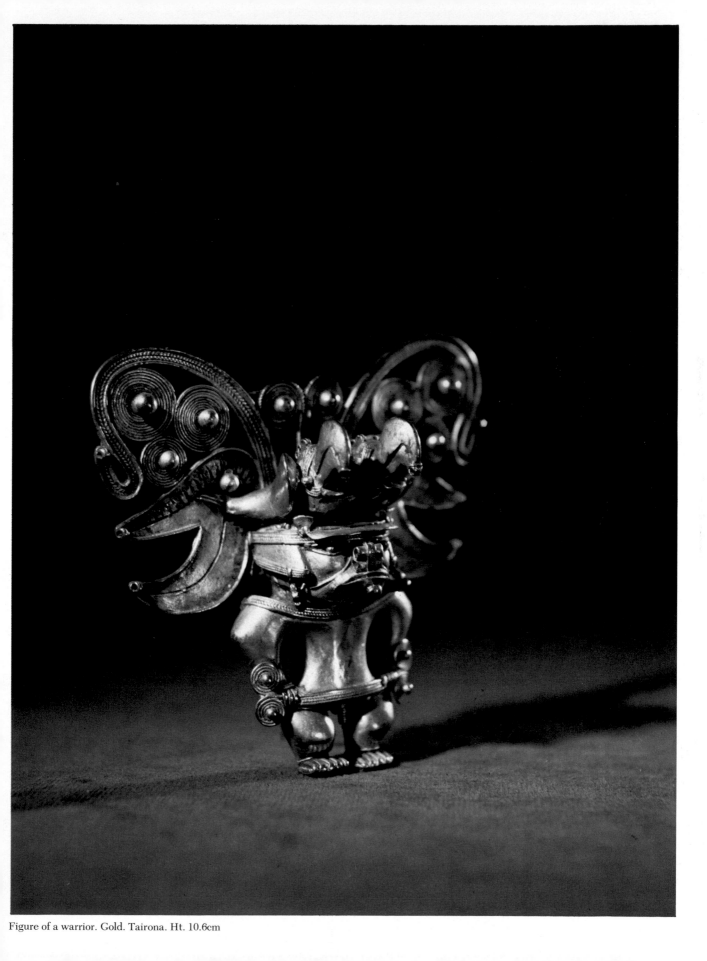

Figure of a warrior. Gold. Tairona. Ht. 10.6cm

The raft of El Dorado. Gold. Muisca from Cundinamarca, Colombia. Length 19.5cm

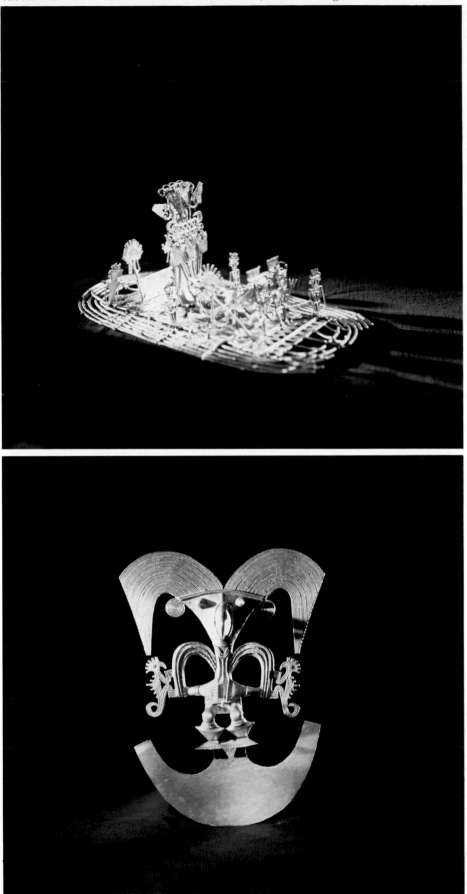

Pendant. Gold. Quimbaya culture from Popoyan, Colombia. Ht. 16.5cm

Nose ornament. Gold. Tairona. Length 6.7cm

Double-headed animal pendant. Gold. Tairona. Length 5.6cm

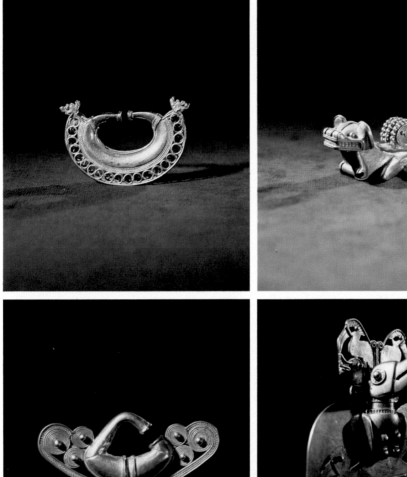

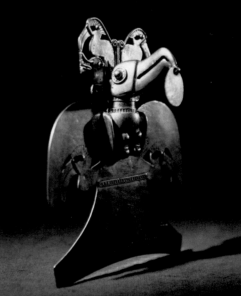

Nose ornament. Gold. Tairona. Ht. 5.4cm

Pectoral ornament in the form of a bird. Tairona. Gold. Ht. 13.6cm

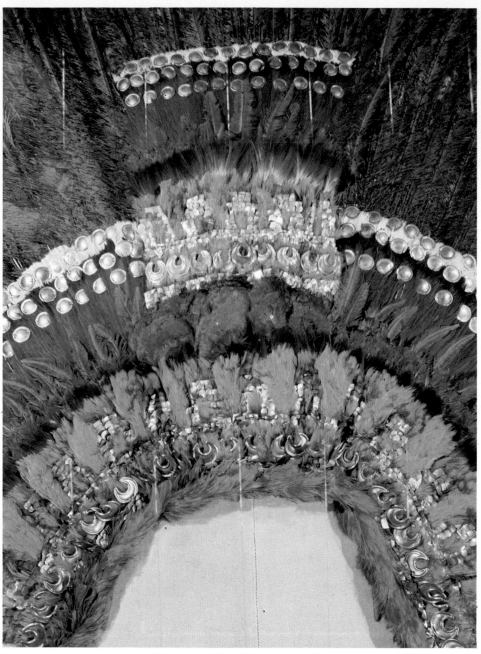

Detail of Montezuma's head-dress. Quetzal feathers with gold plaques. Mixtec

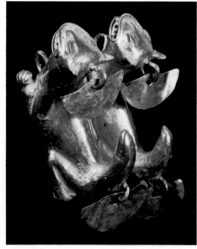

Pendant of two golden jaguars. Coclé culture, Panama. Ht 5.5cm

yard apart, up from the shore to the crater rim 400 feet above. They dipped calabashes into the lake, passed them up the chain and tipped them out on the other side of the rim. They worked for week after week. Eventually, the lake's level dropped sufficiently to allow Quesada to search in the mud. He found enough *tunjos* to confirm the truth of the legend, but the work was extremely laborious and when the first rain storm of the wet season broke, it undid the labour of months. Quesada abandoned the attempt.

Nothing further was done for over thirty years. Then Antonio de Sepulveda, a Spanish wine merchant from Bogota, was granted the exclusive right to the contents of the lake by the Spanish Crown in return for a fifth of all the objects he might recover. He built houses for Muisca labourers beside the crater and set them to work cutting a mammoth slice through the lowest part of the rim. The work involved was immense, but labourers were abundant and cheap. One account says that he employed 8000 men. Eventually the cut was completed. Water poured through it and once more the level fell. Sepulveda began gathering golden images. He found an emerald 'as large as an egg', but then there was a landslip in the side of the cut. Several labourers were buried and killed. The channel was blocked. The rest of the workers rebelled and Sepulveda had to retreat to Bogota. He died soon afterwards.

Many subsequent attempts have been made. In 1900, an English company calling itself Contractors Limited was formed to try and raise the treasure. Their plan was a novel one. They aimed to drive a tunnel into the mountainside outside the crater and below the water level so that the lake would empty like a wash basin when its plug is pulled out. Great quantities of tunnelling equipment and explosives were taken up to the lake on pack mules and work began. After eight months, the lake's bed was punctured and water began to gush out.

What exactly happened thereafter is not clear. It seems that a few *tunjos* were gathered close to the shore, but farther out the expedition discovered to their dismay that the mud on the lake bed was twenty-five to thirty feet deep. Any heavy objects must have sunk deep into it. While the expedition were pondering how to deal with this, the blazing sun baked the mud as hard as concrete. It was decided to return to Bogota for different excavating equipment, but before it could be obtained, the drainage tunnel became blocked and the lake began to fill with water again.

And then the money ran out. In order to raise more and continue the attempt, Contractors Limited returned to London with the few pieces they had obtained from the lake and put them up for sale at Sotheby's. This they hoped would not only produce additional funds but might encourage others to invest in the project. Looking at the catalogue now, it seems unlikely that many of the objects did in fact come from the lake, for a large proportion of them do not seem to be of Muisca work. Whether that was so or not, the company never made another attempt.

Later expeditions have retrieved more objects from the margins. Some have employed sophisticated grabs, some have worked

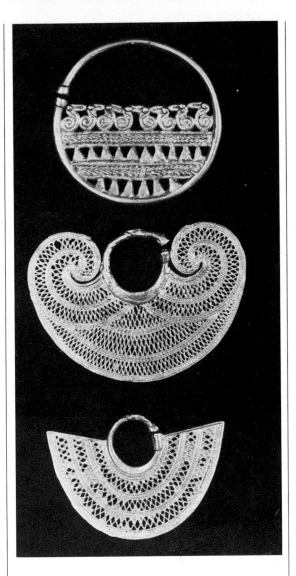

Nose ornaments. Gold. Sinu River, Colombia

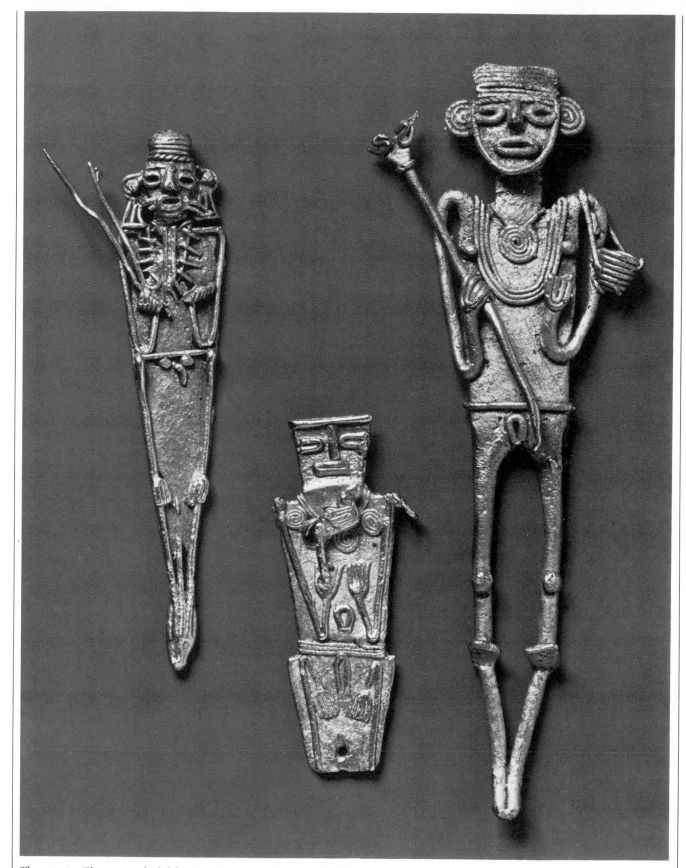

Three *tunjos*. The man on the left kneels with elbows on knees and holds a spear and a spear-thrower. The central figure of a woman also kneels. The woman on the right has a basket on her shoulder and carries a ritual staff surmounted by two birds. Gold. Muisca. Ht of tallest 11.8cm

with divers, but no one so far has managed to reach the centre of the lake where the tribute given to the sun by the Golden Man must lie. That is something to be grateful for. If the treasure had been raised at any time other than in the last twenty years or so, it would surely have met with the same fate as all the rest of the gold of the New World. Even as late as the nineteenth century, the Bank of England was importing, in the normal course of its business, several hundred pounds in weight of Pre-Colombian gold and melting it down. Four hundred years have had to pass before the people of the Western world learned to share Dürer's delight and find more in these objects than the yellow metal of which they are made.

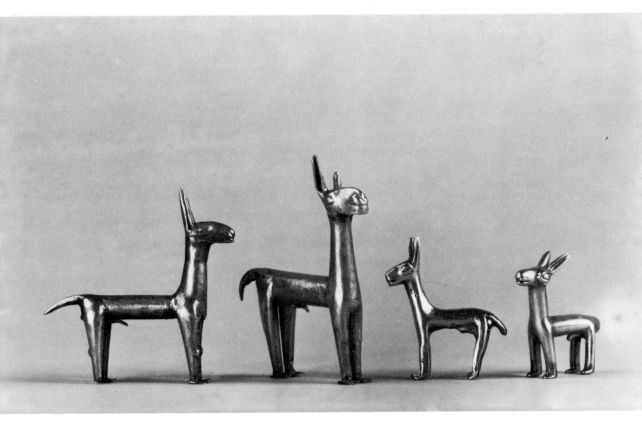

Llamas. Gold. Inca. Ht of tallest 6.2cm

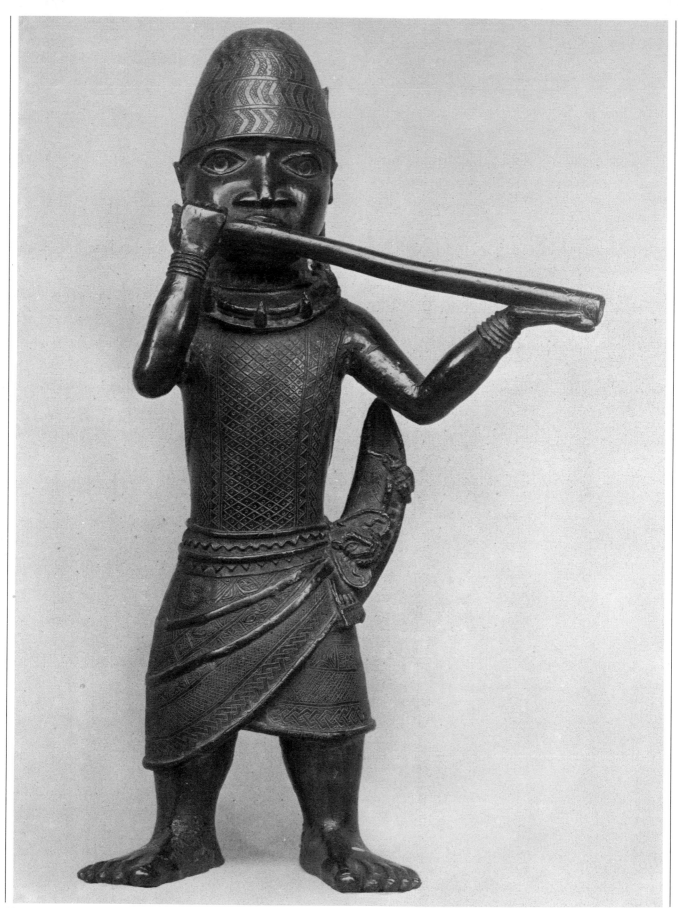

68

Kingdoms of Bronze

Early in 1897, a consignment of official loot arrived in London. It had been sent from West Africa by a British punitive expedition returning from the very frontier of the Empire. It included carved ivory tusks, agate and coral regalia, wooden carvings, elaborate iron swords and staffs, ivory masks and bracelets, and, most numerous of all, bronzes – bells, plaques, stools, sceptres, standing figures and portrait heads. In all, there were over four thousand separate pieces. In terms both of sheer quantity and aesthetic merit, it was the greatest collection of works of art ever to come out of Africa south of the Sahara. The expedition had taken it all from the palace of the King of Benin.

The King, or Oba, of Benin had long been a source of trouble to British colonial administrators on the West African coast. They were intent on imposing British law and organising trade. There was great wealth to be extracted from the lands around the delta of the Niger River. The people could supply rubber and ivory, incense gums and gum arabic, and particularly the palm kernels and palm oil needed by factories in Liverpool and elsewhere in Britain to make candles and soap. But the kingdom of Benin was still independent and the Oba, who had total power over his subjects, often closed his frontiers to trade of any kind. His people, the Bini, were relatively few in number compared with other tribes in the area, but they were extremely warlike and they controlled a tract of country west of the Niger over a hundred miles across. To them the Oba was both king and god. He seldom left his huge palace. He had a great number of wives, eunuchs and slaves; and he practised human sacrifice on an appalling scale. During the late 1800s, European visitors had not been welcome at Benin, but in 1892 Captain Henry Gallwey, the British Vice-Consul at Sapele on the Benin River forty miles to the south, had succeeded in reaching the city and persuading the Oba to make an agreement. One clause specified that human sacrifice would cease; another guaranteed that the frontiers would remain open to trade. Since that time, however, trade had again stopped. British officials had made several attempts to return to the city and resolve matters, but each time they had been met by armed warriors and, rather than risk a fight, they had turned back.

At the end of 1896 the Consul-General in Calabar went on leave and a young and inexperienced officer, Vice-Consul James Phillips, took over control of the Niger River Protectorate. He

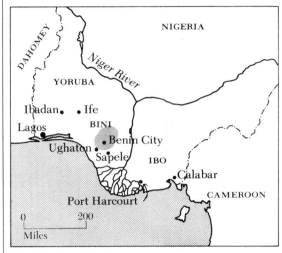

The Kingdom of Benin

Facing
Figure of the Oba's hornblower. Bronze. Middle period. Benin. Ht 62cm

decided that the Oba had to be reprimanded and that he would visit the city and do so. The local chiefs strongly advised him not to go at this particular time. The beginning of the new year in Benin, they said, was the time when the Oba held a long series of ceremonials to renew the fertility of the land. He would certainly sacrifice many men. It was not the moment for a European to go to the city. But Phillips was not to be dissuaded. He dispatched messengers with gifts to the Oba, to say that he proposed to visit him; and on 2 January 1897, he set out in boats from Sapele with nine European companions and 280 locally recruited porters.

As they sailed along the mangrove-lined creeks, they met their messengers returning from Benin. The Oba had replied that the Vice-Consul should not come to the city at this time, but wait for two months until the ceremonies were over. He might then make a visit provided he was unaccompanied by any other European. Phillips decided to ignore the message. The expedition sailed on and landed at Ughoton. This settlement, then inaccurately called Gwatto by the British, was the frontier village where traders waited for goods to be brought down by the Bini chiefs delegated by the Oba to supervise trade with the kingdom. Bini men were in the village when the expedition arrived and they washed the Europeans' feet, the traditional way of giving them the 'freedom of the country'.

In view of the warnings he had received, Phillips went to some trouble to make it clear that his intentions were peaceful. He had brought with him a drum and fife band in order to impress the Oba's court with military music. Now he decided that their uniforms might be misinterpreted and that they should therefore return to Sapele by canoe. He also gave instructions that all firearms had to be kept concealed. Since the Europeans, when walking in this humid heat, wore only light shirts, this could only be done by packing their revolvers in the trek boxes.

Meanwhile, in Benin, the powerful chiefs who surrounded the Oba were outraged to learn that the British were persisting in coming to their city at a time of such ritual importance and against the declared wishes of the Oba. Without his knowledge, they dispatched a war party.

The British set out from Ughoton early the next morning, 4 January. The path to Benin ran through dense forest. It was so narrow that the column had to walk in single file. At its head marched an orderly in blue uniform carrying the Consul-General's flag. Phillips himself walked close behind, and at eleven o'clock he led his party straight into an ambush.

The Bini attacked with muskets and swords. Without soldiers, and with their few firearms out of reach, the expedition was virtually defenceless. Phillips, seven of his European companions and some 240 carriers were slaughtered. Only two of the white men escaped. The Bini warriors hunted them through the forest, but after five days, wounded and exhausted, they managed to get back to the creek and raise the alarm.

Two days after that, on 11 January, the news of the massacre was in London. The British Empire mobilised retribution with

astonishing speed. An admiral was summoned from Simons Town in South Africa to take command. He brought with him a force of 700 men. Another contingent was sent from Sierra Leone. A ship was dispatched from the Mediterranean with still more troops. Twenty-nine days after the massacre had taken place, a Punitive Expedition of 1200 men was marching on Benin.

The expedition brushed aside several attempts at an ambush. Warriors fired at them from tree platforms and there was a major skirmish half a mile from the city walls. The Bini stood little chance against the British who were armed not only with modern rifles but Maxim guns. They also had rockets and when two dropped from the sky and exploded in the middle of one of the crowded courtyards of the palace, Bini resistance broke and the Oba and his people fled into the forest.

When the British entered the largely abandoned city, they found a dreadful sight. The Oba, greatly alarmed at the action of his chiefs in ambushing Phillips's party, had believed that the only chance he had of staving off the revenge of the British was to make even more human sacrifices than his ceremonials normally required. Several bodies were still nailed to the branches of cotton trees on which they had been crucified. Hundreds of corpses had been thrown into great pits beside the shrines on which they had been sacrificed. From one of them, the expedition doctor dragged a man, still alive, who had been one of Phillips's porters. Everywhere there were the remains of decomposing corpses and the ground was so soaked with human blood that the expedition had difficulty in finding a site for its camp that was free from the stench.

Members of the Punitive Expedition seated in one of the courtyards of Benin Palace, 1897

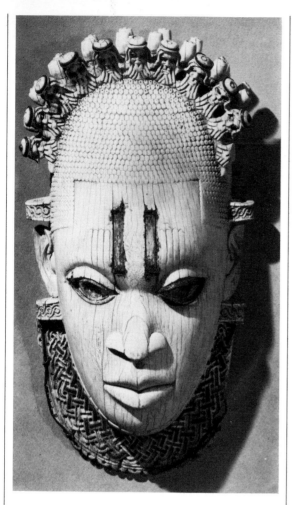

Half the city was occupied by the great rambling palace, a maze of single-storeyed apartments and courtyards, surrounded by a twenty-foot-high mud wall. Thirteen of the largest courts held shrines devoted to the worship of former Obas. On benches of dried mud built against the walls stood great numbers of bronzes coated with coagulated blood. Some were in the shape of human heads and served to support immense elephant tusks. In the Oba's bed chamber, the visitors found a chest full of exquisitely carved ivory bracelets and masks. And in a store room, thick with the accumulated dirt of centuries, they discovered over a thousand bronze plaques bearing figures of kings and soldiers and scenes of war and sacrifice.

The victors gathered all these treasures into one of the courtyards and were photographed sitting among them. Parts of the city were demolished so that defences could be built in case the Bini launched a counter attack. On the third day of the occupation, a fire started about half a mile from the palace and damaged it and a large part of the town. Some wooden sculptures or ivories may have been burnt, but the bulk of the treasure, having been collected together, was saved.

On 22 February, the main expedition left the city, taking the treasure with them as booty. Many of the Europeans kept bronzes and ivories as personal mementoes, but much of it was claimed by the British government as spoils of war and the Foreign Office decided that this should be put up for sale to defray the costs of the expedition.

In London, the bronzes caused a sensation. Europe had become accustomed to the extraordinary fetishes of Africa, though people had not yet perceived their qualities. But among these bronzes were some that had been cast with consummate technical skill and modelled in a naturalistic style of such delicate refinement that they could stand comparison with the sculptures of Europe's own classical antiquity. They seemed the more astonishing, perhaps, in that they had been found in surroundings of such horror. Clearly they were of great interest to scholarship. The sale was attended by buyers not only from Britain, but from European institutions, and within the next year or so, either directly or through dealers, large numbers of bronzes went to museums in Dresden, Leipzig, Hamburg, Vienna, Berlin, Leiden and across the Atlantic to Philadelphia and Chicago. But the British Museum, in spite of the lack of financial help from the government, eventually secured the biggest collection of all.

This great mass of material had all come from the palace itself. No similar objects had been found elsewhere in the town or the kingdom. Bronze, in fact, was a royal prerogative. All objects made of it belonged to the Oba, with the exception of a few small medallions that he himself had given to one or two specially privileged chiefs. Bronze-smiths were forbidden to work for anyone but the Oba on pain of death. The Oba also had a right to ivory. When Bini hunters killed an elephant, one of its tusks had to be taken to the palace where there were carvers to fashion it into whatever the Oba wished. Consequently the scenes and figures

Mask, probably worn on the hip. The head-dress is composed of stylised Portuguese heads. Ivory. Early period after 1500 AD, Benin. Ht 25cm

portrayed in the treasure give little idea of the lives of ordinary
Bini people. But about the palace, its inhabitants and their cus-
toms and beliefs, they give very vivid evidence indeed.

One bronze plaque shows the palace entrance guarded by
soldiers carrying shields. The roof is supported by pillars which
are decorated with plaques from top to bottom. Above rises a
tower roofed with wooden shingles down which sprawls a huge
bronze python. The head segments of several such snakes, were
brought back by the expedition and one was in place when they
occupied the palace. Other pieces show that the towers were
topped by great bronze birds with outstretched wings.

The Oba himself is portrayed many times. Because he was a
god-king, when he walked in the open air he had to be guarded
from the sun's rays and attendants held shields above his head.
His arms had to be supported by chiefs and he was preceded by a
courtier carrying a box of cola nuts which the Oba distributed to
his people as ritual gifts of great magical power. Leopards appear
frequently. Being powerful and cunning, they are the symbols of
kingship and several plaques show the Oba swinging them by the
tail, a mysterious image which may represent metaphorically the
stature of his kingly power. He also appears with mud-fish instead
of legs. In Benin today, it is said that this is the representation of
an Oba who was paralysed and who explained his inability to
walk, so incomprehensible in a being supposed to have divine
powers, by claiming to be an incarnation of Olokun the sea god,
with fish for legs. It is at least as probable that the mud-fish, which
is often shown elsewhere, is another symbol of power that the Oba
may assume in his divine aspect.

There are scenes of daily life of the courtiers – hunters seeking
birds and leopards in the forest; musicians playing drums, rattles,
ivory bells and trumpets; and warriors. The Bini army had a
formidable reputation. One Oba in the seventeenth century was
said to be able to raise 100,000 soldiers within twenty-four hours,
and the empire at its height stretched from modern Dahomey in
the west to near Port Harcourt on the eastern side of the Niger

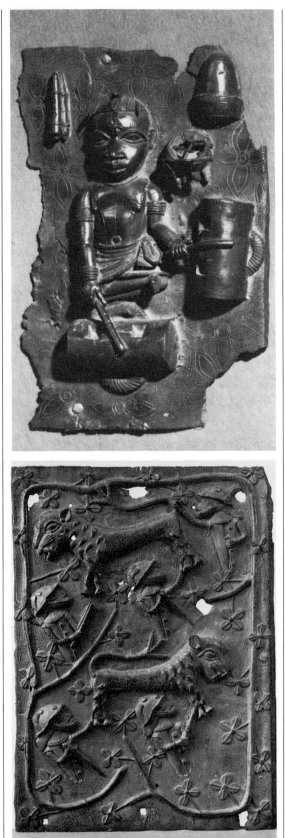

delta, a distance of some 400 miles. One of the Bini's traditional adversaries in the east were the Ibo. They appear on the plaques as prisoners, identifiable by their facial marks. One, held by his Bini captors, has a huge wound sliced across his chest.

Some of these bronze plaques such as one showing the sacrifice of a bull, are of great technical accomplishment, the figures standing clear and attached to their background in only two or three places. But perhaps the most breathtakingly beautiful of all the bronzes are the heads of queens that were made at the command of the Obas for shrines set up for their mothers. They are a little less than life-size. They wear horn-shaped head-dresses or coiffures. They are not, seemingly, portraits of individuals, but idealised representations of a queen, with all the qualities of perfection and serenity that such a semi-divine being should have.

When all these varied pieces were examined by European experts, some maintained that Africans could not possibly have developed such high skills for themselves. They must have been taught by visitors from a more technologically sophisticated society. And some of the bronzes themselves showed obvious candidates for such a role – the Portuguese.

A Portuguese traveller, d'Aveiro, had been the first European to reach Benin, arriving there in 1485. He made several visits and created such a good impression that the Oba sent the chief of Ughoton and another man back with d'Aveiro as envoys to the Lisbon court so that they might learn more about white men.

The Portuguese had been lured down the West African coast by

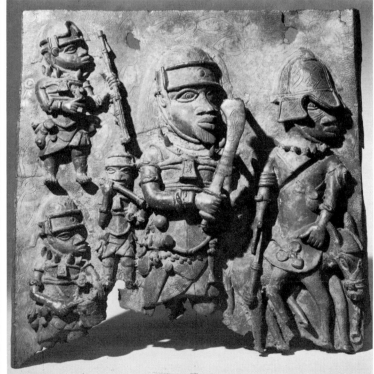

Bronze plaques. Middle period. Benin
Top: drummer Ht 42.5cm
Left: a leopard hunt. Ht 53.5cm
Right: a Benin warrior attacking a mounted Ibo who has a deep wound across his chest. Ht 40cm

74

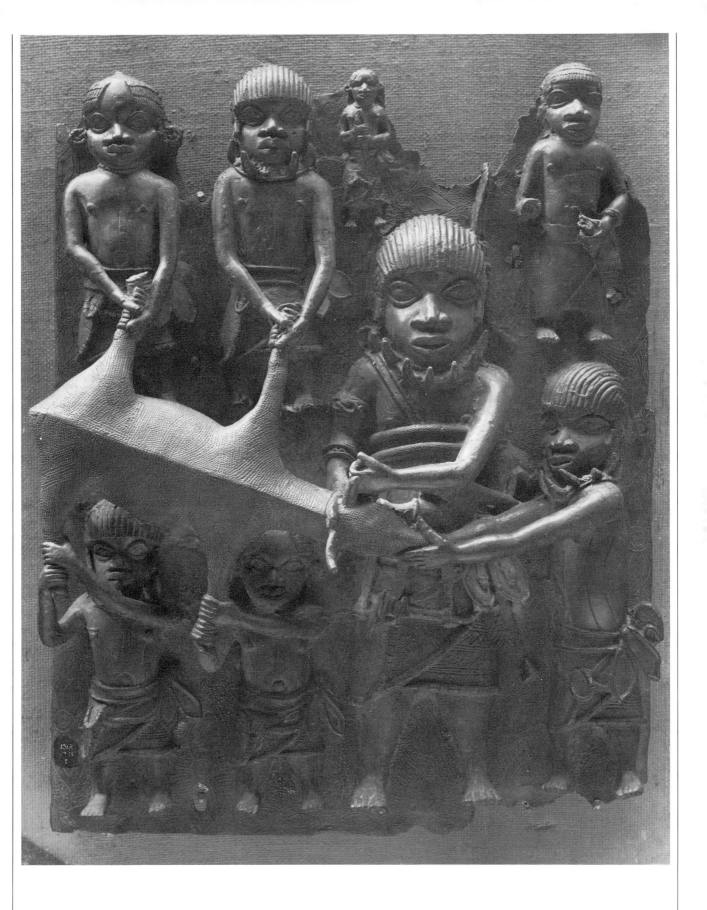

Plaque commemorating the sacrifice of a bull, perhaps at the funeral of an Oba. Bronze. Middle period. Benin. Ht 52cm

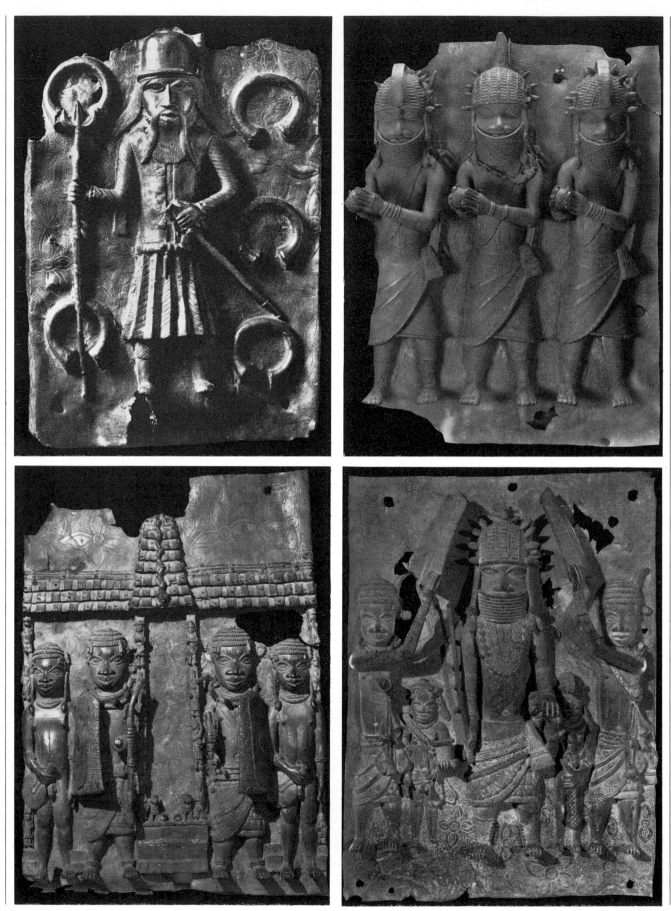

the search for gold. They eventually found it in the Gold Coast. Benin itself had none, but it did have the commodity for which the rulers of the gold-producing kingdoms would gladly trade and on which some of them insisted before they would part with their metal – slaves. So it became the custom for Portuguese ships to call at Benin and collect a cargo of slaves to take back along the coast.

The Oba of Benin welcomed these white strangers. They had firearms, the first the Bini had seen. The Oba at that time was warring with his neighbours and soon he persuaded some of the Portuguese to support his army. The Portuguese brought arquebus, crossbows and cannon, and with their help the Bini army soon became invincible.

These Portuguese soldiers appear on the plaques carrying their weapons. Their heads, long-nosed with straight hair hanging below their steel helmets, appear like badges of power above the images of the Oba, just as leopard heads sometimes do.

The Portuguese paid for the slaves they bought in Benin with manillas, bracelet-shaped ingots of bronze or copper. When they first began trading, a slave could be had for twelve or fifteen manillas, but thirty years later, the price had risen to over fifty manillas. Since great numbers of slaves were transported by the Portuguese, it is clear that they must have taken huge quantities of metal to Benin. Was it not more than likely that they also introduced at the same time the techniques for casting it? Many people in Europe argued that this must indeed have been so – and some can still be found today who refuse to believe otherwise.

The Bini themselves, however, deny such an origin. Their traditions stated clearly that the skill came to them from Ife, the sacred town of the Yoruba people, 110 miles north-west of Benin. It was from the Oni of Ife that the Oba had first derived his divine power, for his dynasty had been founded when a prince of Ife came to Benin, married a Bini woman and had a son who became the first Oba. Since the present ruler is said to be the thirty-eighth in the line, the date of the foundation of the dynasty can be calculated to be as early as the eleventh and as late as the fourteenth century, depending upon the figure used as the length of an average reign.

In the early years of the dynasty, according to tradition, when an Oba died, the head was severed from the corpse and sent to Ife for burial. The Oni then had a memorial head cast in bronze and sent back to Benin to be placed on the shrine of the departed Oba. The sixth Oba, Oguola, asked that a master smith might be sent to Benin to teach his own craftsmen, so that they might make such images for themselves. Accordingly, the Oni sent an Ife bronze-smith named Igueghae.

Doubters of this traditional explanation pointed to one major difficulty. Ife had no living tradition of bronze casting and there was little evidence that it ever had one.

A hint came in 1910. The German anthropologist, Leo Frobenius, visited Ife and found not only many ancient terracotta figures, but a bronze head. However, it was by no means certain that the bronze had been made in Ife and since it was kept buried

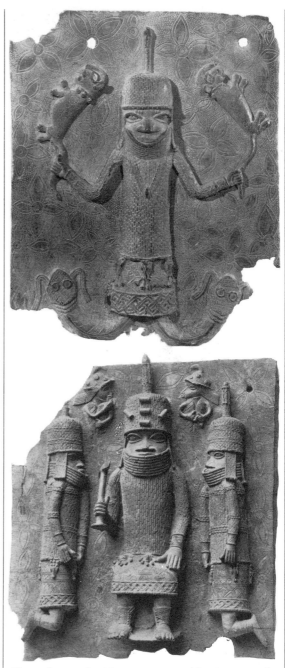

Plaque showing the Oba wearing a coral-bead crown and tunic, with mudfish legs, swinging leopards. Bronze. Middle period. Benin. Ht 40.5cm

Plaque showing the seated Oba with attendants; behind his head, emblems of Portuguese soldiers. Bronze. Middle period. Benin. Ht 42.5cm

opposite:
Bronze plaques. Middle period. Benin.
Top left: Portuguese holding a staff of office and surrounded by manillas. Ht 47cm
Top right: musicians playing calabash rattles. Ht 48cm
Bottom left: gate of the Oba's palace, with a bronze python on the roof and pillars ornamented with plaques. Ht 53.5cm
Bottom right: the Oba escorted by attendants who shade his head with shields. Ht 51cm

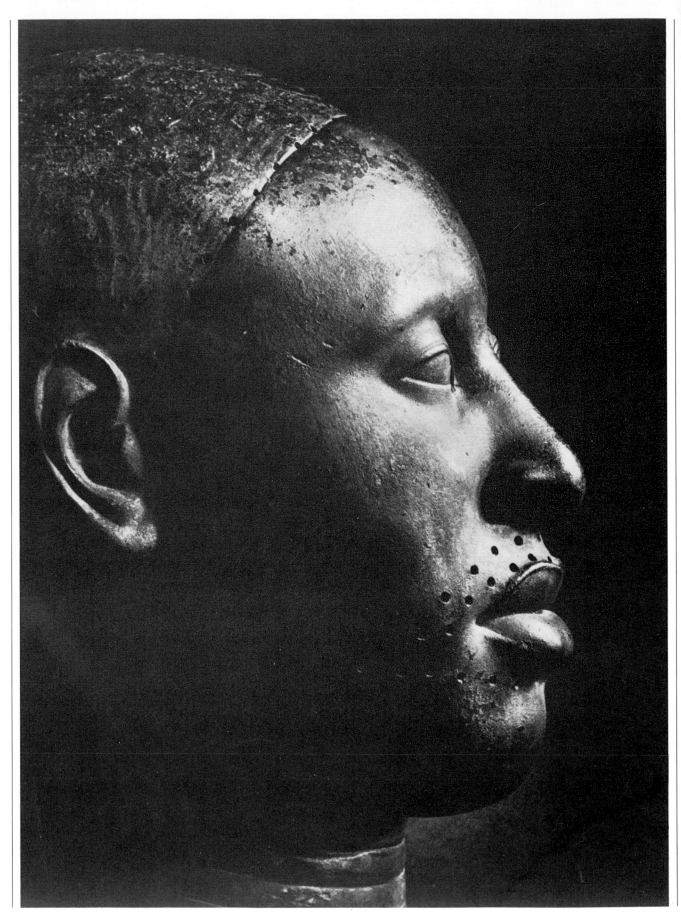

and dug up whenever it was needed for a particular festival, there was no means of dating it archaeologically. Frobenius claimed that he had found the remains of an ancient Greek colony founded in the fourteenth century BC. Few connected his discoveries with the treasure that Britain had taken from Benin thirteen years earlier.

Then in 1938, an extraordinary discovery was made in Ife. A man digging foundations for a new house not far from the palace walls came across eighteen superb bronze heads. They were of great beauty and reflected a sculptural sensitivity that outshone all but a very few of the Benin works. It was extremely difficult to estimate their age. Now it seems certain, from work done on them and from later discoveries, that they date from several centuries before the arrival of the Portuguese.

The heads have holes demarcating the scalp and beard lines. Several bear traces of pigments. In fact, it seems likely that originally they were decorated to appear as lifelike as possible. William Fagg of the British Museum and Frank Willett, who has conducted important excavations at Ife, have looked for an explanation for the function of these heads in the burial rituals of the nearby kingdom of Owo today. For reasons of hygiene, it is common practice in many extremely hot countries to bury a corpse very soon after death. But this gives no time to prepare the elaborate ceremonials appropriate to the passing of a divine king. For such important persons, second funeral rituals are held later and in these the body of the dead king is represented by a full-sized figure of wood dressed in real clothes and decked with the royal regalia.

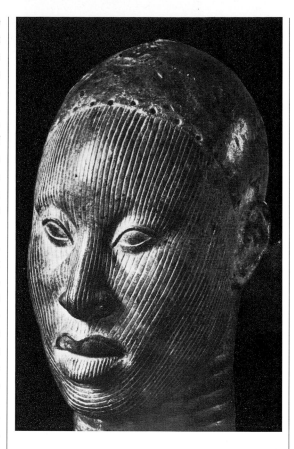

Fagg and Willett suggest that this was the purpose of the Ife heads. Most have holes in the neck which doubtless served to take nails so that they could be fastened to a wooden base. Small black beads have been found jammed in the holes around the upper lip and also in the nearby ground. Strings of these, threaded through the holes, could have represented the beard and moustache. The traditional crowns of Ife are tiered and beaded and their lower edge follows almost exactly the hair-line of the scalp. The holes around the upper part of the bronze heads may thus have been made to provide a fastening for a real crown. This possibility is supported by the fact that the small terracotta and bronze figures of the Oni that were subsequently discovered have modelled crowns. None of the life-sized bronze heads, however, have such a thing. They had no need. They wore the real crown which, after the funeral ceremony, would be removed and then worn by the next Oba.

There is a story in Ife that in ancient times the god-king was not allowed to grow old lest his body should age like that of a mortal. Instead, after serving his people for a fixed period of seven years, the king was himself sacrificed. The possibility gives an additional poignancy to these noble heads.

Ife, then, is likely to be the source of Benin's bronze-casting techniques. There remains the problem of dating the 2000 or so very varied pieces of the Benin treasure. The first attempt was made in 1919 by the German scholar, von Luschan, but it was left

Facing and above: Heads discovered in Wunmonije Compound, Ife. Bronze. Ht of both 30.5cm

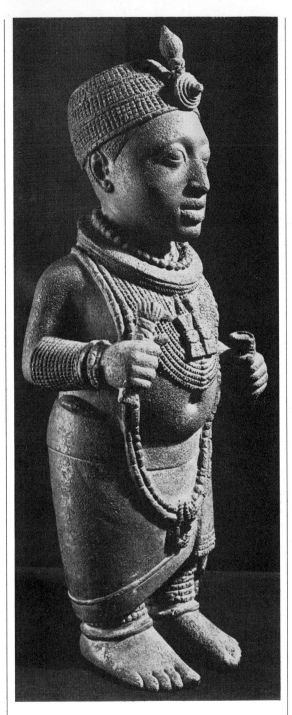

Figure of the Oni of Ife wearing a beaded crown with a badge of office on his chest. Excavated at Ita Yemoo, Ife, in 1957. Bronze. Ht 47cm

to William Fagg in the last few years to propose the most convincing chronology. The plaques are the cornerstone of his argument. The costume of the Portuguese soldiers represented on them can be identified as that current in the middle of the sixteenth century. A Dutch writer, Dapper, reports the account of a visitor to the city who, about 1640, saw the plaques in position, nailed to the wooden pillars of the palace. In 1702, another Dutchman, Nyendael, arrived in Benin. He found the kingdom torn by civil war. Although he gives a detailed account of the palace, he makes no mention of the plaques. It seems likely that they had been taken down and put away for safekeeping in the store room where the Punitive Expedition found them 200 years later. It follows that the plaques must have been made between the middle sixteenth century and the end of the seventeenth century. This Fagg calls the Middle Period and he also allocates to it some other pieces, which share similar stylistic and technical characteristics with the plaques.

There then remain two groups of bronzes. One contains several simple male heads with elegantly stylised braided hair and modest necklaces fitting closely around the neck. These have a sensitive naturalism and a delicacy of casting that link them with the Ife pieces. Fagg believes them to have been made during the fifteenth century and up to 1550, which he calls the Early Period. He places the Queen Mother heads as late examples of this style. The second group, he suggests, belongs to the time after the plaques, the Late Period. Metal supplies were then abundant and the disciplines of casting, so essential when it was rare and precious, have now slackened. The heads of the Oba have become heavy and coarsened in both conception and execution. The biggest are almost ten times as heavy as the Early Period heads. They become increasingly smothered by decorative elaborations of the Oba's coral regalia. The necklaces have been exaggerated in height until they form a cylinder that projects right over the chin to the lower lip. The head-dress sprouts side-wings and then curving rods that project in front of the face. The modelling of the eyes that in the fifteenth-century pieces is so sensitive, becomes crudely simplified and glaring. A profound change has taken place in the sensitivity of the artists. Perhaps it is not too fanciful to suppose that this may reflect a change in the whole of Benin culture, that the early Obas maintained a court that was very different in feeling from the blood-soaked excesses of nineteenth-century Benin.

Bronze-casting by the lost-wax process is still practised in Benin City. The guild of bronze-smiths is a hereditary one and its members claim direct descent from Igueghae, the smith from Ife. They still live today in Igun Street, where the Oba Oguola in the fifteenth century decreed that they should settle. The chief of the guild maintains a shrine to Igueghae in his house. The whole of the street is lined by workshops. Stalls in front of the houses display bronzes, mostly simplified versions of the heads and figures of the famous treasure. The work itself is carried out in the compounds at the back.

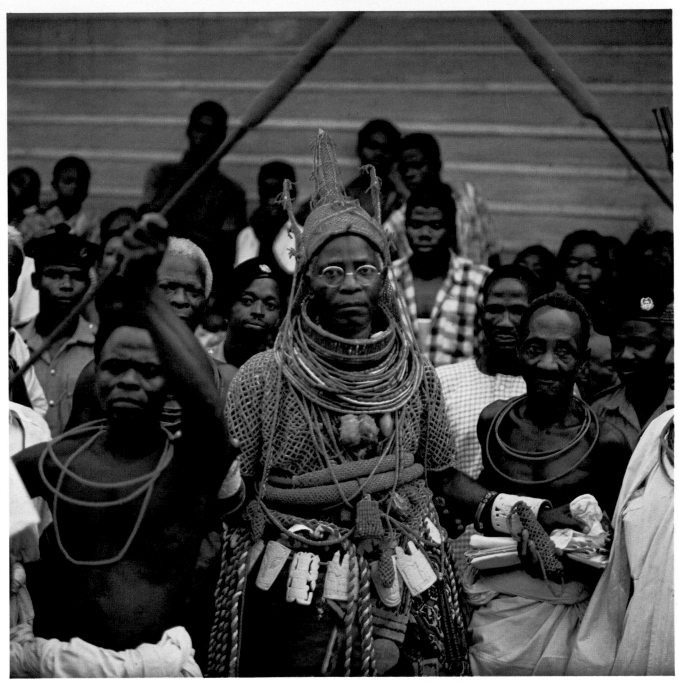

H. H. Oba Akenzua II dancing at Ìgwue, dressed in coral regalia with ivory plaques at his waist, 1964

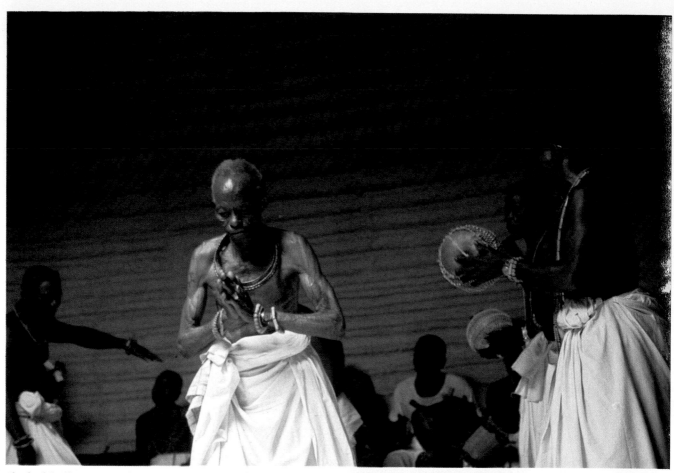

Chiefs of the *ibiwe* society dancing within the palace, Benin

Palace herbalist drumming for dancing, Benin

H. H. the Oba presiding over the *ematon* ceremony, flanked by his attendant holding a ceremonial sword

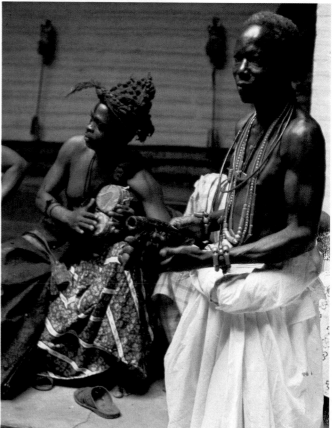

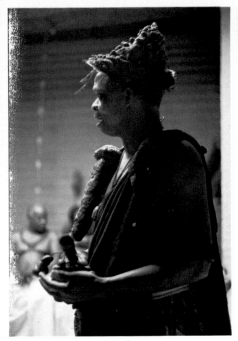

The palace herbalist, Benin

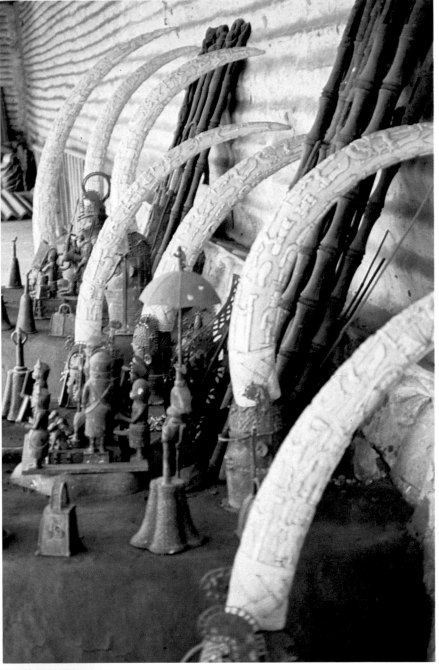

The shrine of Oba Adolo, the present Oba's
grandfather

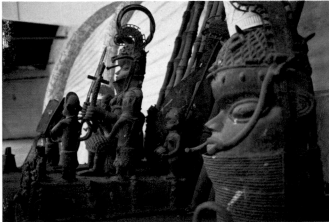

*Bronze-casting in Igun Street,
Benin City, Nigeria*

Making cores

The wax figure modelled on the core

Investing the wax figure in clay

Hammering cartridges before melting

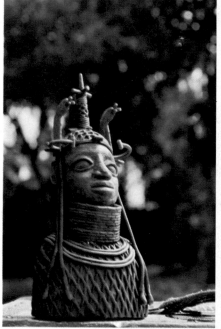

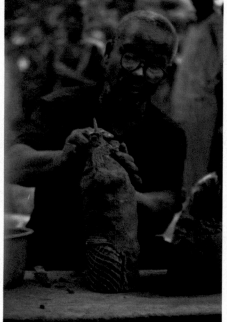

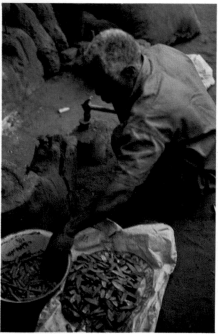

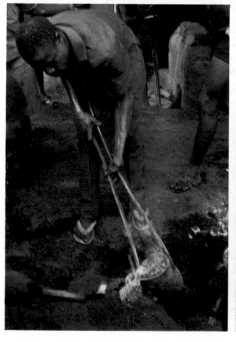

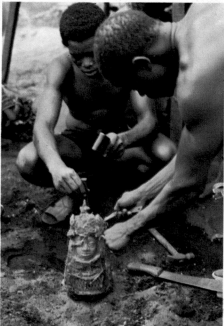

Pouring metal into the mould

Removing the baked investment

Osiosefe is one of the several older craftsmen who still use methods that are the same in essence as those practised in the street for many centuries. All his helpers are his own sons, for by tradition no women may take part in the work. The youngest boys make the cores, simple shapes of coarse sandy clay. Others roll bees-wax into flat sheets or long strings. One of the older sons, or if it is a particularly important piece, Osiosefe himself, carefully wraps this wax around the core and models it. We watched him make the head of an Oba. He shaped the face, working with a knife which he heated when necessary. The bead tunic and the head-dress were built up from wax strings and within a few hours the whole bust was finished.

The following day, he encased the model in coarse clay two or three inches thick. When it had hardened in the sun, he scraped the base so that the wax of the bottom of the bust was exposed as an oval line. To this he fixed four wax rods which he joined at the top like the four legs of a stool meeting in a tiny seat. Later this 'seat' would become a pouring cup and metal would run down tubes formed by the legs into the bust. More coarse clay was then wrapped around this too, so that now the bust was totally enclosed within a rounded lump the size and shape of a vegetable marrow.

The metal used in Igun Street has varied considerably over the centuries. Two main alloys have been used – bronze which contains mostly copper with a little lead and tin, and brass in which the tin is replaced by zinc. Strictly speaking, many of the Benin pieces, which contain small amounts of many metals, approximate most closely to brass, but the term bronze is by custom used to describe them all. Exactly where the supplies of metal came from before the Portuguese period is not known. It may have been brought by camel caravan from mines in the southern Sahara where copper occurs naturally alloyed with zinc and lead or from Morocco where European supplies were probably obtainable. In the 1970s Osiosefe was using old pieces of machinery and spent cartridge cases that were the detritus of the tragic Biafran war which had split Nigeria a few years before.

Work on the day of casting began several hours before dawn. A huge fire of faggots was lit in the compound and the mould we had watched being prepared was placed on it together with a dozen others. As it blazed, Osiosefe gathered his sons around a small shrine made in the ground beside his house wall. He spilled raw spirit on a spike of iron stuck in the earth. A cola nut was broken and shared among them all with a few muttered words of prayer to Ogun the god of iron. As the group broke up, Osiosefe walked quietly across to the fire and threw the remainder of the spirit over the moulds so that the flames spurted a bright yellow.

Several of his sons had been breaking the larger pieces of metal casting with a hammer after they had been made brittle by heating. Others had been flattening the cartridge cases. These fragments were now put in crucibles and taken to a furnace. This was equipped with bellows made of two cups topped with skin. By working the skins up and down with sticks, a draught of air was forced down a tube leading from each cup and through a

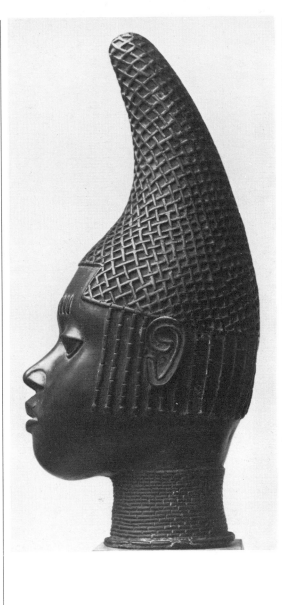

Head of a Queen Mother. Bronze. End of Early period. Benin. Ht 40cm

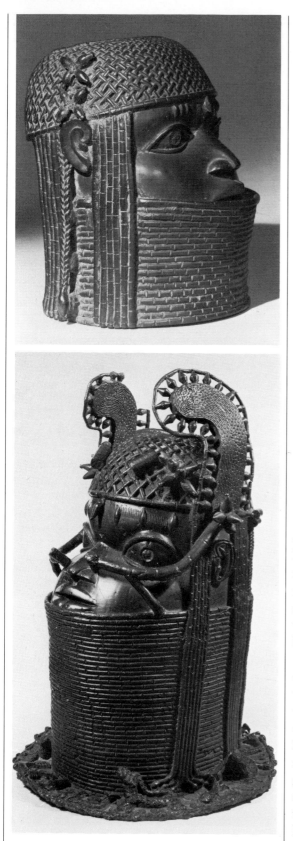

Head. Middle period. Bronze. Ht 21.5cm

Head of Oba. Late period. Bronze. Ht 51cm

nozzle that opened in the hearth. The pile of burning charcoal was soon blown into a blaze the heat of which was intense enough to melt the metal fragments.

The moulds were taken from the bonfire with tongs and tipped so that the wax, now molten, poured out. It was not, however, lost, as the name of the process might lead one to believe, but carefully saved for use on another occasion. The moulds were now reheated for another hour or so, so that their clay baked hard and all traces of wax were burnt out.

Now began the actual casting and a period of feverish activity when a few mistakes could ruin days or weeks of work. The first mould was taken from the fire with tongs, rushed to a pit beside the furnace where earth was piled around it to keep it upright. Speed was now vital, for if the mould cooled too much the hot metal, when it was poured in, might crack it. Amid mounting excitement, a crucible was taken from the furnace with tongs by one of Osiosefe's burly sons and molten bronze poured into the mould so that it spouted plumes of smoke. 'It's cracking,' someone yelled. 'We'll need more metal.' 'It's all right,' Osiosefe shouted back, equally frantic, 'don't get excited.'

When the mould was so full that metal spilled over the hole in the top, another mould was brought and put alongside the first in the pit. It took most of the morning to complete the casting of them all. The men were anxious to see how things had turned out. A bucket of water was poured over the first. It vaporised into steam immediately but eventually the mould was cool enough to handle. One of the men started chipping away at it with a bush knife. The casting became visible within a few strokes. As the cleaning continued, a raised line running across the figure showed where the mould had cracked slightly, but it was of no significance and could easily be filed off. The head, when it was fully revealed, had lost a great deal of the detail of the wax original for the clay investment had been very coarse in texture. This, however, was of no worry to Osiosefe. The next day he set to work, burnishing the surface with a file, adding further decorations and cutting away the sprues, the wax rods now converted into solid metal, which had provided the passage down which the metal had been poured.

It is in these later stages of casting that modern work differs so crucially from the finest of the ancient pieces. In the Early Period, the necessity for thin casting had dictated that the cores were not the crude simple shapes of today but modelled in almost as much detail as the wax itself. The wax was put on in the thinnest of layers and itself modelled with all the details that the sculptor required. The first layer of the investment was of the most fine-grained clay so that it was able to take up all the delicate and subtle details of the original and, in due course, to transfer them to the metal. The finished casting thus needed no chopping with bush knives or coarse filing to remove imperfections, nor were embellishments added by chasing. Consequently the casting retained all the subtle perfection of the original wax model.

Today, most of the castings produced on Igun Street are sold to visitors to Benin, for the city still has a reputation for bronzes. The

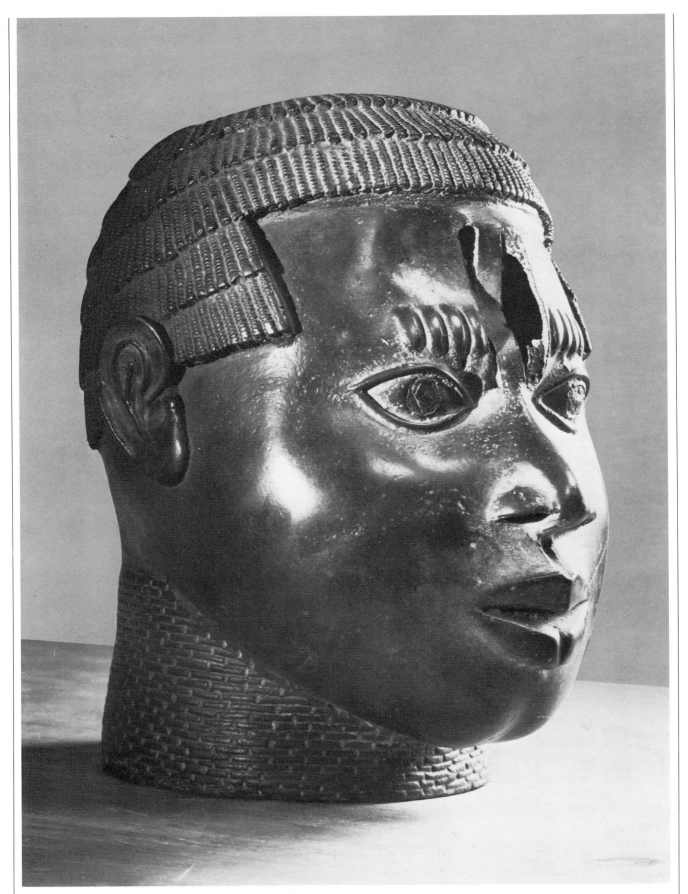

Head. Early period. The casting is between 1 and 3mm thick. Bronze. Benin. Ht 21.5cm

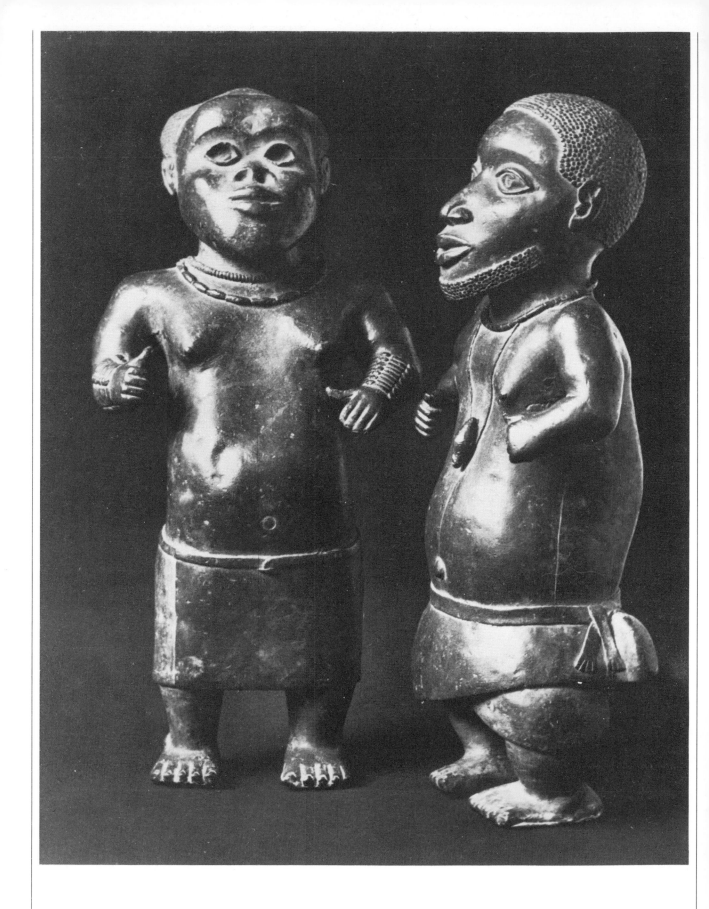

Two dwarfs, like those who served as jesters and tumblers in the court. Probably Early period. Benin. Ht 59.6 and 59cm

Oba himself, however, who once alone had the right to own bronzes, has not commissioned one since 1936, when he ordered a plaque to be made to commemorate his sacrifice of an elephant. But he still rules from his palace in the middle of the city, and much of the ceremonial life there continues today as it did a century ago.

The modern palace, rebuilt after the fire in 1897, is not as large as the earlier one but it has been built on essentially similar lines. The Oba who fled when the Punitive Expedition took the city was captured six months later and sent to exile in Calabar. When he died in 1914, his son Eweka II succeeded to the throne and took up residence in the rebuilt palace. On his death in 1933, the present Oba, His Highness Akenzua II, began his long reign.

Every morning a ceremonial called *ematon* is held. Its function is to demonstrate the allegiance of the people to the Oba and to preserve his health, and thus the well-being of the state. Preparations begin when the court jester, a little man wearing a pink broad-brimmed hat on the back of his head, scuttles busily out of one of the side entrances of the palace with a large leather fan tucked under his arm. He goes to a shrine in front of the palace, dedicated to Oba Ozolua, who reigned at the time of the first Portuguese contact, and bows deeply in front of it. Holding his fan in front of his face, he calls the praises of the present Oba and reports that all is well in the city. Then he scurries off into the palace to repeat the performance in front of other shrines.

The senior chiefs now begin to assemble, coming from all over the city on foot, by taxi, on motor bicycles. Most are naked to the waist and wear court dress, voluminous kilts of heavy white cloth. Each has around his neck a circle of coral beads. These are gifts from the Oba, insignia granted when the individual became a chief. If, like most, his title is not a hereditary one, they will be returned to the palace treasury when the chief dies. The crucial beads in these necklaces are of pink coral that grows, not in West African seas, but in the Mediterranean and it is likely that most if not all of them came from Portuguese sources 500 years ago. They were of the greatest ritual importance in earlier times. The Oba's own regalia is made from such beads and they too have their magical power which once had to be sustained by annual rituals in which they were washed with blood from human sacrifices.

One of the senior chiefs, just before the ceremony begins, comes out of the palace and calls an announcement – 'The Oba is in his palace; the doors will now be barred; *ematon* will now begin.' The rest of the chiefs have assembled in a reception chamber in the palace. This, like many in the palace and the houses of chiefs, is a small courtyard, open to the sky in the centre, with a wide roofed gallery running around it. When all the chiefs are assembled, the Oba appears wearing a coral bead head-dress and preceded by his pages. These are boys who were sent here when very young from all over the kingdom as a gesture of loyalty by their parents. At all times, they wear a bronze anklet on one leg to show their status. For ceremonial occasions such as *ematon*, they put on a red costume with a short pleated skirt, rather like the

The *Akairo-Mnowon*, jester at the court of the Oba of Benin, 1964

doublet of the sixteenth-century Portuguese though this is a relatively recent innovation, for in the past they went completely naked at all times. One of them carries before him the *ada*, the ceremonial sword that may only be owned by the Oba or one or two of the most high-ranking chiefs. The Oba takes his seat on the throne. One by one, the palace chiefs clasp their hands above their heads and rub their palms together in front of them, swearing loyalty to the Oba.

When all have done so, the palace herbalist produces special medicine and in a secret phase of the ceremony that none but an initiated member of the palace society may see, the Oba is anointed with the medicine in order that his life force may be sustained, and with it the well-being of the state. The Oba then distributes cola nuts from a box brought in by one of the pages, the traditional gift of greeting throughout Nigeria.

The Benin chiefs are organised into three separate societies. Each has its own apartments in the palace and each its own responsibilities. The members of the *iwebo* have the responsibility of looking after the Oba's wardrobe and, in particular, the coral beads and the regalia made from them. This is the most senior of the three societies. The *iweguae* chiefs provide the Oba's personal servants. The *ibiwe* chiefs protect the harem and, on ceremonial occasions, have the responsibility of keeping the palace alive with music and dancing, sometimes for days and nights on end.

All Bini men claim membership by hereditary right to one or other of these societies, even if they have never visited the palace. Men who wish to take part in any of the palace ceremonials, or even to visit the society's apartments in the palace, must make payments to the treasury and undergo an initiation.

Thus all Bini men have a direct allegiance to the Oba. Since he is the spiritual head of his people, they must ask his permission to hold any important festival or sacrifice. They also go to him and ask him to judge on their disputes. Even now, when there is a state judiciary, the Oba holds court after every *ematon* and listens to petitioners who come every day to present their cases at the palace and who will unquestioningly accept his verdicts.

The Oba, in turn, must look after his people's spiritual welfare. As a divine being, he occupies a special place between men and their gods, from which he can intervene most powerfully on their behalf. The most important occasion on which he does this is at *igwe*. This is the New Year festival that the Oba was celebrating in 1897 when Vice-Consul Phillips so injudiciously attempted to visit him. It requires that the Oba, over a period of many days, should dance before the shrines in his palace, in full regalia. The sheer weight of all the collars, bracelets, belts, corselets, and crowns is huge and makes it a very exhausting performance. He must make sacrifices in order that the land of his kingdom is rid of defilement and its fertility renewed with blood. The present Oba last held this ceremony in 1967, before the Biafran war, and has declined to do so since, to the real dismay of many of his people.

The palace shrines, however, are still maintained. There are

four in a separate locked courtyard in front of the main palace building, one for each of the last three Obas and a fourth collective one for all the preceding members of the dynasty. The first three closely resemble the shrines that were stripped by the Punitive Expedition. Each stands on a low mud platform beside the courtyard wall and beneath a lean-to roof. There are large memorial heads supporting ivory tusks. There are bells, a figure of the Oba surrounded by his attendants, and a small group of stone axes which people have found in the fields and believe to be thunderbolts. In front of the platform lies a rectangular tablet of medicine – animal preparations, herbs and earths from all over the kingdom, compounded together by the palace herbalist – from which the shrine derives its power. At the back, against the wall, lean several staffs with heads so carved that when the staff is tapped on the ground it rattles and so reinforces a prayer. It is the responsibility of a new Oba, when he comes to the throne, to set up such a shrine in the memory of his father and to make regular sacrifices at it, for he is his father's priest.

Theoretically, bronzes ought now to be being made so that in the event of the present Oba's death, his shrine too should be similarly furnished. It is not possible for anyone in Benin to say whether or not such a thing is being done for that would show great disrespect for the present Oba. Sadly, it is unlikely that many today in Igun Street could produce bronzes that could compare in brutal strength with those made only forty years ago that now stand on the palace shrines, let alone match the splendour of the earlier bronzes that were taken away by the Punitive Expedition less than a century ago. The great eras of bronze casting have passed. The demands for disciplined craftsmanship and sculptural inspiration made by religion and later by a despotic state have now vanished. Today the stimulus of the bronze-casters seems to be only the slack uncritical acceptance of the visitor beguiled by an ancient reputation.

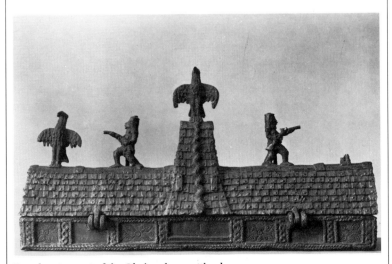

Box showing part of the Oba's palace, with a bronze python on the roof and figures of Portuguese soldiers and birds on the roof ridge. Bronze. Benin. Length 61cm

Top: The Ambassadors (detail) by Hans Holbein, 1533.
Bottom right: Portrait of the Protonotary Juliano by
Lorenzo Lotto (1480–1556)
Bottom left: Madonna and Child with angel and donor
(detail) by Hans Memling, about 1470

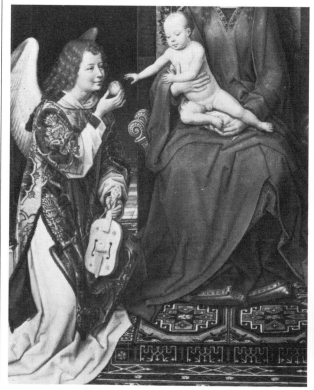

Woven Gardens

The first pile carpets to reach western Europe may well have arrived at the beginning of the twelfth century, in the baggage of men coming home from the first Crusade. During the next hundred years or so, European armies were continually battling their way through Turkey and the lands around the eastern end of the Mediterranean on their way to or from the Holy City of Jerusalem. Returning soldiers have a habit of clinging to tastes acquired during their campaigns, and trade certainly followed in the Crusaders' wake. Into European homes came fine enamelled glass, steel weapons damascened with gold ornamentation from Damascus, damask silk from the same city, muslin from the Persian city of Mosul, gauze from Gaza in the Holy land; and luminous multicoloured pile rugs that were called Turkey carpets.

By the fourteenth century, such rugs were being sold by Armenian traders in the market place at Bruges. They were rare and expensive luxuries. A Pope of the period habitually kept in front of his throne in Avignon a rug patterned with parrots and white swans that must have been woven somewhere in the Middle East. Bishops of the time, either ignorant or oblivious of the infidel origin of oriental carpets, used them in their churches as altar cloths. Noblemen valued them so highly that they spread them on tables rather than floors. The wealthier householders in Italian cities had the habit on festival days of hanging their precious rugs over balustrades and balconies to add splendour to the streets.

Virtually none of the actual carpets imported at this period still survive, but we know how they were used and what they looked like because painters, from the end of the fourteenth century, frequently included them in their pictures. Some rugs are, even now, labelled by collectors and dealers with the names of the European artists who habitually portrayed that particular kind, perhaps because they happened to have examples in their studios. 'Lotto' rugs, which have small geometrical designs, resemble those that appear in the pictures of the sixteenth-century Italian, Lorenzo Lotto. Similar ones are made today in the Ushak district of western Turkey. Hans Holbein's name is also attached to a group of Turkish rugs. In his picture, *The Ambassadors*, painted in 1533, he showed two grandees standing proudly beside a table over which is draped a rug with bold geometrical borders similar to those that are now produced in the town of Bergama. Such

The Mass of St Giles (detail). Flemish. End of 15th century

89

Top: Portrait of Georg Gisze by Hans Holbein, 1532
Bottom: Girl Asleep by Jan Vermeer (1632–75)

names tell little about the rugs themselves. In this case it also leads to confusion, for another type of 'Holbein' appears in his portrait of Merchant Gisze and that one is closely similar to a 'Lotto'.

Although these painters are the two who are most usually connected with rugs, many others have used them as decorative elements in their compositions. In previous centuries, Giotto, Fra Angelico, Van Eyck and Memling often portrayed the Madonna or the Holy Family with oriental rugs laid before them. In later years, Tintoretto and Veronese drew Italian palaces decked with rugs, Vermeer painted the cool interior of a Haarlem house with one rumpled on a table, and in the eighteenth century Copley painted a portrait of George Washington and thought it appropriate to the dignity of the first American president to pose him standing on an Ushak rug.

Hand-knotted pile fabric has been familiar for so long that it is easy to forget what an ingenious invention it is. In essence, it consists of a sheet of parallel threads, the warp, on which rows of knots are tied to form the pile. The warp is bound together by another series of threads, the weft, which runs at right angles to the warp threads and interlaces between them and which is inserted between rows of knots to pack them more tightly together. There are many variations of this basic structure. The kind of knot used for the pile, the number of warp threads enclosed by each knot, the number of rows of knots between each weft thread, the length of the pile, the materials used, all these vary considerably. Taken together, they provide a very strong indication of where the rug was made and by whom.

The technique seems to have been invented somewhere in central Asia. Men from the earliest times must have spread the hairy skins of the animals they hunted on the floor of their shelters and houses to take the chill from the ground. Perhaps the first pile carpets were made in imitation of these skins when people began keeping flocks and herds and preferred to shear their animals rather than slaughter them.

The oldest carpet so far discovered was found in 1949 by the Russian archaeologist, Sergei Rudenko, when working in the Pazyryk valley in the bleak Siberian mountains, close to the border of Outer Mongolia. There, in the fourth century BC, the Scythians, a tribe of nomadic horsemen, had buried their chiefs. Rudenko found fourteen mounds and began excavating them in 1929. Twenty years later he returned. In the fifth barrow he opened he found, inside a deep log-lined chamber, the bodies of a man and a woman lying in wooden coffins. The grave had been plundered by robbers soon after the burial, but their theft had, paradoxically, caused the near-perfect preservation of the objects they left behind. The tunnel they had dug had acted as a channel down which water had poured until the chamber was completely filled. Shielded from the feeble summer sun by the layer of boulders that had been piled on top of the mound, the water in the tomb had turned to solid ice. So the entire contents remained in a deep freeze until Rudenko opened the grave again.

Herodotus, the Greek historian, writing at about the same time

Wool-pile rug from Pazyryk. 5th century BC. Width 94cm *Top:* detail of the border showing a line of deer and a procession of horsemen

Alabaster slab from the Palace of Assurbanipal at Nineveh. 7th century BC

as the Pazyryk burials took place, described the funeral of a Scythian chief in detail. The body was carefully eviscerated and embalmed and then placed on a carriage and taken in procession around the encampments of all the tribes he had ruled. His subjects mutilated themselves in mourning and then followed the procession until all arrived at the newly prepared tomb. There, in a final ceremony, one of the chief's wives was sacrificed by strangling. The horses that had drawn the carriage were killed and all were placed in the tomb with his body and many of his possessions, including the golden cups from which a chief always drank. Then the people raised a huge mound of earth and stones over the burial.

Pazyryk was a striking demonstration of the accuracy of Herodotus' account. Both bodies in the tomb had been embalmed before burial. Their preservation was extraordinary. The man's skin still clearly showed elaborate tattoos of animal designs curling around his arms, chest and one of his legs. Outside the main chamber lay a dismantled carriage and the bodies of nine slaughtered horses, still wearing elaborately decorated harnesses and saddlery, much of it lavishly ornamented with carved wooden plaques covered with gold leaf. The robbers had stolen much of the contents of the burial chamber itself. No golden vessels remained. But they had not bothered to remove felts patterned with animal designs that had been fixed to the log walls of the chamber, and outside, among the bodies of the horses, they had left the greatest surviving treasure of all, a magnificent pile carpet.

It measures 6 feet by 6 feet 3 inches. The knots of its pile are of a kind that is still used in carpet making in many parts of the Middle East. The workmanship is extremely fine, with about 240 knots to the square inch. Its pattern, predominantly red, with details in green, yellow and blue, is basically the same as is found today in the majority of Oriental rugs – a central field surrounded by several borders. There are two broad borders, separated and flanked by narrow stripes. The inner one represents a line of antlered stags, possibly fallow deer; the outer, a procession of horsemen. Some of the men are riding, others lead their horses which have knots in their tails, clipped manes and erect forelocks decorated with some kind of binding.

It cannot be assumed that this superb rug was made by the Scythians themselves. They were a very widespread group who wandered across the lands between the northern steppes of Siberia and the shores of the Black Sea far to the south. Their chiefs, as we know from other burials, accumulated treasures from far and wide. Some of their golden vessels were the work of Greek craftsmen. A silken saddlecloth in the Pazyryk tomb certainly came from China. The rug, therefore, may well have been obtained from other people either as trade or plunder. Many authorities think it was woven by a people living far to the south-west in Persia. The geometrical pattern of its central field is remarkably like a design found carved on the alabaster slabs of the Assyrian palace at Nineveh that was built in the 7th century BC. Archaeologists had long suspected that these were representations of the

'thick yielding carpets' that Xenophon described as being part of the furnishings of the palaces of Babylon. Pazyryk seems to confirm that this was indeed so.

Whether or not the technique of weaving pile carpet was devised by the nomads themselves, the material was certainly ideally suited to their needs. People who are frequently on the move need possessions that are light in weight, easily packed and strong enough to withstand the wear of repeated journeys. Pile carpets have all these characteristics and today nomads still use them for a multitude of purposes. Hung around the tent walls they keep out the bitter winds. Spread on the floor they give warmth in winter and keep the dust down in summer. Many nomads are Muslims and must prostrate themselves in prayer several times each day, so a man often carries a specially fine rug ornamented with a pointed prayer arch which must be directed towards Mecca when he lays it down and kneels upon it to pray. Pile carpet, too, is used to make saddlebags, grain sacks, tent doors, saddle cloths, spindle bags and trappings for horses and donkeys. Every knot is individually tied, so each piece can be decorated with its own characteristic pattern.

Nomads have played a continuing part in Persian history. The two ways of life – wandering on horseback and living in permanent towns – seem to have co-existed since the earliest times in this part of the world. The town-dwellers have always tried to persuade or coerce the wanderers to settle, for only then can they be administered and controlled. Repeatedly, the rulers of the Persian Empire have done battle with the lawless nomads who controlled great expanses of wild country outside the cities. The struggle continued into this century. The tribes were ferocious fighters, their leaders men of great bravery who commanded total loyalty from large numbers of fighting men and who continually challenged the established authority. Reza Shah, the founder of the present ruling dynasty in Iran, regarded the nomadic tribes as a major threat to his rule, and a generation ago his army waged a long guerrilla war against them. The tribal chieftains, the *khans*, were captured and imprisoned. Some were executed. Whole clans were compelled to settle in specially built villages. There were frequent uprisings but they were suppressed by the Shah's army with great brutality. Today only a few of the tribes still maintain their traditional travelling life. One of them is the Qashqa'i.

The Qashqa'i say their original home was in the desert of Central Asia beyond the Pamirs, where they once lived under the rule of Genghis Khan. Some time in the thirteenth century they migrated west and south, joining company with bands of Mongols and other Turks. Over succeeding centuries they moved further and further south, being joined at various times by other groups of Lur, Kurdish, Arab and Persian stock, until at last they reached their present territory in Iran. They are thus a very mixed group with many subsections. Each traces its origin back to a different geographical area and they have only been together as a cohesive unity for about 200 years. At the beginning of this century, they numbered about a quarter of a million and they were one of Reza

Iran

Top: Early morning in the *mu'tavil:* the Qashqa'i packing up camp
Bottom: The Qashqa'i travelling

94

Shah's most formidable tribal opponents. They rebelled against him in 1929 and again in 1932. Although each time they were suppressed, they have managed even now to maintain many of their old ways.

Their wealth lies in their livestock. In spite of the huge number of sheep and goats that a man and his family may own, he seldom slaughters any of them for food. That would be regarded as a profligate destruction of capital. Meat can be obtained from hunting gazelle, mouflon, partridge and ibex. The value of the herds rests in the wool, milk and cheese they produce and the image of affluence they convey as they graze around the family encampment.

The wanderings of the Qashqa'i are far from haphazard. They follow a strict annual pattern that enables them to live off marginal land that otherwise would be unexploited, for none of it can support a permanent population. Their summer is spent 7000 feet or more up in the Zagros mountains, in the *sarhad* or cold country. Each family, by traditional right, grazes a particular patch of mountainside. But they cannot stay at such an altitude for the whole year, for in the winter the pastures are several feet deep in snow. So, some time in September, when the days are beginning to shorten and the nights becoming uncomfortably cold, the people prepare to travel 300 miles to their winter camping grounds close to the shores of the Persian Gulf. They will leave nothing behind them except the right, tacitly acknowledged by the rest of their people, to a particular camp site and a few patches of hillside sown with grain that will sprout the following spring, ready for their return.

On the day of departure, the whole community is busy long before dawn. Fires are blown into life for a quick drink of tea. The flocks, driven by a few of the men, are the first to leave. They travel more slowly than the rest, for they graze as they go and they may want to pick a slightly more circuitous route where the vegetation is greener.

Striking camp is a swift business. The black goat-hair tents are collapsed and bundled up and loaded on to camels and donkeys. Lambs recently born and unable to keep up with the main herd are packed, bleating, into special saddlebags, half a dozen to a compartment. The rugs on which the family slept are slung face down over the loads. Camels complain and spit. Each group of families is in the charge of a senior man who is responsible for their safety to his *khan*. He will decide the precise route they take each day and where the next camp will be, and it is he, while the sky is still pale with the dawn and the air blessedly cool, who gets the whole group on the move.

Within two hours of the sun rising, the heat is intense. Small whirlwinds corkscrew their way across the hillsides. Clouds of dust rise from the hooves of the pack animals. There is water in goatskins, but no one will drink while they are travelling. Most of the men and children walk, dogs trotting at their heels ready to snap and snarl at strangers.

It is a defiantly bright, swashbuckling procession. The harness

Qashqa'i horse and rider are equally splendidly caparisoned

of the riding donkeys and horses is decorated with long red woollen tassels that almost reach the ground. The men wear baggy trousers, tattered jackets and the domed felt hat which is the badge of the Qashqa'i. The women stride along in long skirts, worn over numerous petticoats, that swing from their hips and sweep the ground as they walk. The fabrics are likely to have come from a bazaar in one of the towns and are usually the brightest that they can find, emerald green, scarlet, tawny orange. They wear vivid gauzy headcloths that hang down their backs to the waist and are decorated over the forehead with lines of coins. If there are sufficient pack animals, some women ride, surrounded by bulging saddlebags and trussed flapping chickens. A really wealthy woman may travel perched high on the back of a milk-white camel, seated on a brilliant saddle cloth with her blazing skirts carefully spread around her to make the most flamboyant effect.

The day's travel usually ends early in the afternoon. The head man will choose a place where there is water and reasonable grazing for the herds, if there is any at all to be found. If the journey over the past few days has been hard, if the flocks are hungry and exhausted, then the whole group may decide to spend a few days in that one place and put up tents in order to shield themselves from the sun on the following day. More usually, however, the stop will be for only one night. Then camp will be no more than a rug spread on the ground and a fire of dried dung on which to cook.

The Qashqa'i's route from their mountains runs through the *mu'tavil*, the central region of Iran between three and six thousand feet in altitude. Here most of the country's great cities have been built. The ground is saturated with antiquity. As they travel south, the ragged procession passes close to Persepolis, the vast ruined palace built by the Emperor Darius in the fifth century BC. Darius' empire stretched from the Nile to the Danube, from the steppes of central Asia in the north to Ethiopia in the south. Nomadic tribes were certainly well known to him. Every spring delegations arrived from all over his territories to bring him

Evening camp for the Qashqa'i on migration

Garden rug. Water
channels in which fish
swim flow around three
islands containing
flowering peach trees
and between flower
beds edged with shrubs.
Kurdistan, about 1800

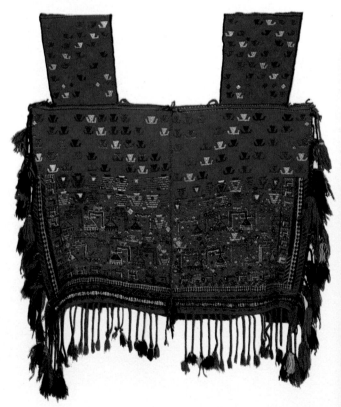

Qashqa'i bags
Above left: design with goats and gazelles.
Width 32cm
Above right: design with a hooked diamond
medallion, trees and rosettes. Width 32cm
Below: Horse cover. Rows of confronted
peacocks with tree and plant ornaments and a
line of goats in the innermost band. Hanging
in this position, the figures are upside down.
Flat-weave

Floor rug. In the large
central medallion,
serrated leaves and
palmettes. In the field,
ducks or chickens, goats,
gazelles and rosettes.
Hayat Davudi group of
the Qashqa'i. Length
220cm

Breaking camp at dawn in the *mu'tavil*

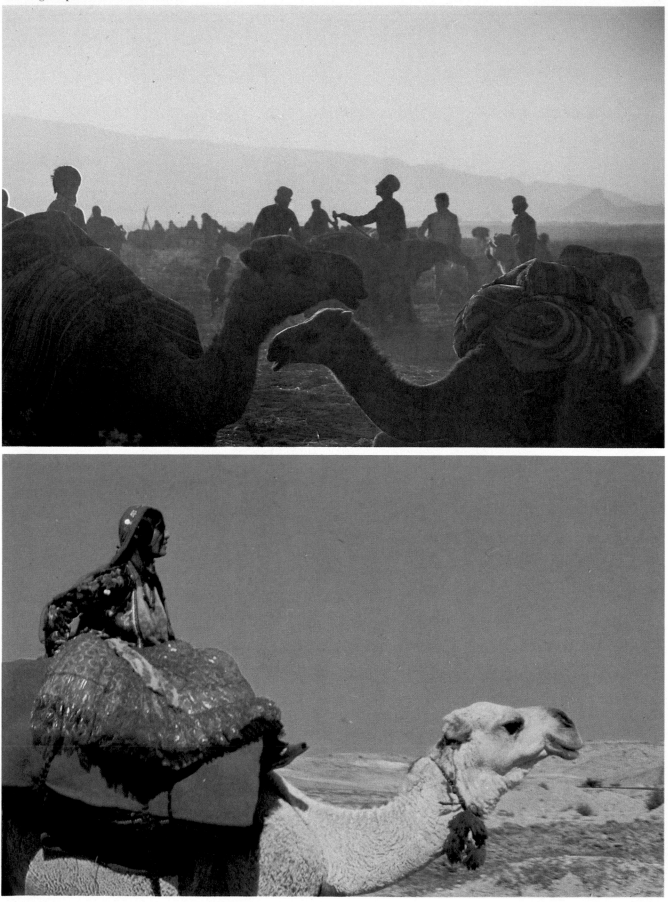

Qashqa'i woman travelling

tribute. These processions are depicted in exquisite detail on the stone walls of the Apadana, the Hall of Audience, at Persepolis. Each group of people can be identified by their costume, the gifts they bear and their facial features. There are Ethiopians, Arabians, Indians and Greeks; and there are heavily bearded nomads from the north, wearing pointed hats and leggings, with swords at their hips. The horses they lead are dressed in exactly the same way as those shown on the Pazyryk carpet, with knots in their tails and erect forelocks tied with a ribbon. With them they bring tribute, limp sheepskins hanging over their arms and bales of what appear to be fabrics with elaborately tasselled hems. They might well be pile carpets.

Further south, the migration route skirts the city of Shiraz and takes the Qashqa'i into the Tangi-Ab gorge. It is by far the easiest way through the tangle of mountains that lie between the plains of the *mu'tavil* and the coastal lands, and people have been travelling through it since the earliest times. An ancient fort, built in the second century AD by the Sassanian kings, themselves of nomadic origin, overlooks the gorge from the top of a commanding cliff and a ruined bridge 1000 years old spans the river. The rock wall opposite the bridge has been carved with a bas-relief showing Ardeshir, the first Emperor of the dynasty, receiving his crown from the god Zoroaster in the year AD 224.

On the plain beyond the gorge once stood the Sassanian capital city of Firuzabad. Some of the walls of the palace still remain, massive cliffs of stone and brickwork beside a small patch of lush fields kept green by the water of a perpetual spring. Beyond this again lies the site of the town itself, an uneven expanse of ramparts and ditches, hummocks and hollows, and in the centre of it all a spindly tower of masonry nearly a hundred feet high with traces of a spiral staircase running up its sides.

This is a favourite camping place for the Qashqa'i. The dusty ground is strewn with fragments of pottery. The women often pick up silver coins 1500 years old and thread them on string to wear as a necklace or sew them to the hems of their veils.

A few days' journey more and the Qashqa'i descend into the

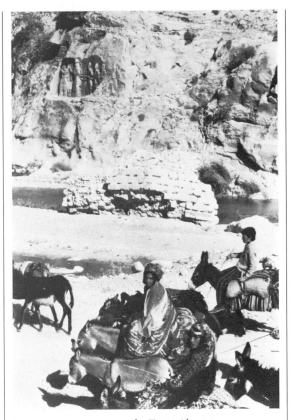

Passing Sassanian ruins in the Tangi-Ab gorge

Qashqa'i camped on the plains of Farashband

Spinning black wool: Farashband

garmsir, the hot lands that run from 3500 feet down to the sea. Here lies one of their traditional wintering grounds, the plains of Farashband. The grass is wretchedly thin, the dusty earth showing red between the straggling blades, but there is enough to sustain them for the next few months and there is permanent water. They will stay here throughout the winter and spring until, towards the end of April, the increasing heat of the approaching summer makes the plains unbearably hot. Then once more they will have to make the three-week journey back to the mountains.

Now, however, they can make as permanent a camp as they ever have. The large rectangular black tents are fenced around with palisades of dried reeds to keep out the dust carried by the hot wind. Rugs are laid on the tent floor and all who enter will take off their shoes so as not to soil them. Such ground coverings may be changed several times a day, specially clean and splendid rugs being produced to honour a visitor. Flat woven cloths, called *ghelims*, boldly patterned with geometrical designs, cover the piles of storage bags at the back of the tent. And now the looms are set up for the first time since the people left the mountains and the women begin to weave.

Sheep's wool is not all the same. The agile animals belonging to the nomads that habitually graze poor pastures have a much silkier fleece than the animals that spend their lives feeding on the lusher grass around the towns. The quality of wool also varies with an animal's age. The younger it is, the softer its fleece. An animal's finest wool grows on its shoulders, the coarsest on its legs and belly. So a woman who knows her own flocks, by selecting from the fleeces of her youngest and best animals, can gather wool of a fine silkiness that cannot be matched by any that is commercially produced and bought wholesale from a merchant in a town bazaar.

She turns the wool into thread with a simple spindle, a wooden rod weighted at the end with a pottery whorl or two pieces of curved horn or metal, and she spins continually, sitting in her tent, on the plains watching the flocks, even as she travels on the back of her donkey. The thread must then be dyed. In the past, dyes were gathered from the countryside through which the tribe travelled. Rich red came from the boiled and pounded root of madder, the older the plant, the deeper the colour. Another sharper red was produced from *kermes*, an insect that lived on the bark of oak trees. Yellow came from saffron, the dried stamens of a species of crocus; blue from fermented indigo blossoms. Deep brown was produced from oak galls or walnut skins, orange from turmeric root or pomegranate rind. A deep and permanent black is one of the most difficult colours to produce. Most traditional methods involved boiling with iron filings and this corroded the wool badly. In consequence, the black sections of a finished rug made with such wool become threadbare much more quickly than the rest of the pile. A better way is to sort out the naturally occurring black wool from the fleeces and use it undyed. The Qashqa'i rarely use black at all and what passes as such is usually a very dark indigo.

Preparing colours in this way involved a great deal of labour

and detailed knowledge. In the 1860s, however, European chemists synthesised dyes, many based on aniline, and very soon they appeared in the bazaars of the Middle East. Weavers adopted them eagerly. Unfortunately they had many defects. Many of the colours were harsh and acrid. Some rotted the wool even more seriously than the traditional black dye produced from iron. Nor were they fast, so that a carpet not only lost much of its colour when it was washed but its pattern became smeared as a dye spread into other parts of the design. The aniline dyes also faded in strange ways. Whereas wool coloured with vegetable dyes might mellow into lighter shades of the original colours, aniline dyes on exposure to sunlight changed their tone quite radically so that, as the rug aged, its colour balance became seriously distorted.

Most of these defects were put right in later versions of these synthetic dyes. A completely new range, which uses potassium bichromate as a fixing agent, is now widely used. Supplies are cheap and easily available. Today, only a few nomad groups collect the traditional vegetable dyes and remember the skills necessary to produce the wide range of subtle and mutually harmonious shades that were used in earlier rugs.

The looms used by the Qashqa'i are simple horizontal structures pegged into the ground, consisting of little more than a rectangular framework over which the warp threads are stretched, and a device for lifting alternate threads of the warp so that the weft may be inserted to bind them together and consolidate the knots. The women sit at their looms for many hours at a time. They squat on the finished section of the carpet, taut on its frame a few inches above the ground. Beside them, or hanging above, are balls of coloured wool. Their hands flash over the bare warp threads, tying the tiny knots and cutting off each as it is completed with a small knife. Swiftly they put in all the required knots of one colour in the line and then the other colours, in turn, until the row is complete. Then a weft thread is passed through and beaten hard with a heavy metal-toothed comb against the knots that form the edge of the completed section of the carpet. After several such rows have been completed, the ragged ends of the knots are sheared with scissors to produce an even pile in which the design can be clearly seen for the first time. The finer the wool used and the more tightly packed the knots, the sharper and more detailed the finished pattern will be. Two hundred knots in a square inch is not unusual. An ordinary rug of this quality, six feet long and three feet wide, contains over half a million knots and this might well have taken a nomad woman, working by herself, two or three years to complete.

Throughout the time occupied on the rug, the weaver will have been selecting her wools from each season's shearing and dyeing them batch by batch. So the shade of a particular colour in a true nomadic rug often varies – a dark blue changes suddenly to a lighter colour half-way down the rug as one batch of wool is used up and another has to be prepared. This characteristic is known as *abrash*. Sometimes these changes are very frequent and the rug has a delightful shimmering quality.

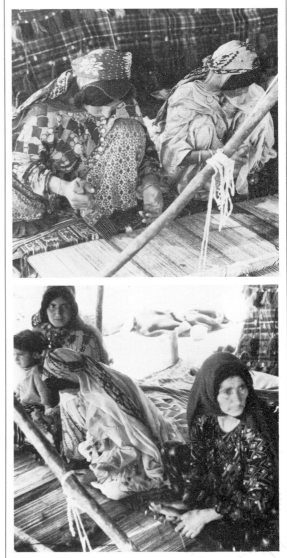

Beating down the weft with combs
Qashqa'i family weaving

99

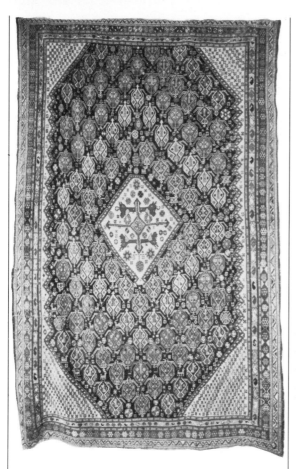

Since a rug takes so long to make, the loom has to be folded up and transported many times on the migrations. When it is set up afresh, it is seldom possible to get exactly the same tension of all the warp threads as before. The finished rug, therefore, may have a bowed end or be wrinkled when it lies on a perfectly flat surface. But neither characteristic is of any consequence in a Qashqa'i tent.

Each tribe has its own repertory of patterns. Some are for borders, others for the main designs in the central field of the rug, and each has its own name. The weaver, when she laces the warp threads on the loom and begins her rug, must decide which of the several alternative patterns she will use, how she will combine them and in what colours she will knot them. She knows all these motifs by heart and the correct number of different coloured knots required in each of the 200 or 300 successive rows of a large pattern will come almost automatically to her fingers. A sister, a daughter, a friend, can sit beside her and help occasionally, since the patterns are common tribal property and a glance at the completed section will make clear how the design should be continued. But the process is far from being an unthinking one. There is considerable scope for improvisation. Stars may be strewn across a patch of the field and small flowers made to blossom unobtrusively in a corner.

Nomadic carpets are seldom precisely symmetrical. Irregularities in the design are often said to have been inserted for religious reasons. To be symmetrical, the argument runs, is to be perfect; to be perfect is an attribute only of God; and therefore to attempt to weave a perfect rug is tantamount to blasphemy. Such an explanation may be a dealer's invention. It is certain, however, that the women weaving these rugs have great flair and artistry in creating individual felicities and placing irregular details like a small brilliantly coloured rosette in just the right place to enhance the overall balance of the design.

Many Qashqa'i motifs have a naturalistic basis. Gazelles, chickens and small human figures often appear. There may be creatures too that the weavers themselves have never set eyes on. A memory of a distant past spent in a different land may lead them occasionally to include a camel with two humps like those that are found much farther north, instead of the single-humped camel of their own herds. Peacocks, with a crest on their heads and spreading triangular tails, are commonly woven all over the Caucasus and far to the south, although the bird itself does not occur naturally nearer than India. Above all, on these nomad rugs, there are flowers.

Flowers and the garden have a central place in Persian culture. The traditional garden is surrounded by high walls to keep out the desiccating winds. It has a brimming cistern of water at its heart from which streams flow, gliding and gurgling along rectangular stone-lined channels beneath shady trees and between beds of flowers. Here grow roses, jasmine and hyacinth, and trees bearing apricots, pomegranates, quinces and peaches. The garden provided Persian poets with their metaphors and the religious

Floor rug (detail facing)
Two pairs of stylised chickens meet beak to beak in the central medallion. The field is filled with angular *botehs* between which appear occasional gazelles and goats. Qashqa'i. Length of complete rug 258cm

painters with their symbols. The sparkling fountain is a symbol of youth, the dark unfading cypress the emblem of immortality. Our own English word 'paradise' derives from the Persian word for a walled garden. For the nomads, pitching their tents among the drab dusty hills, the memory of such places must be sweet indeed. Little wonder that they filled their carpets with fanciful flowers and turned them into bright woven gardens that could be spread in the stony desert.

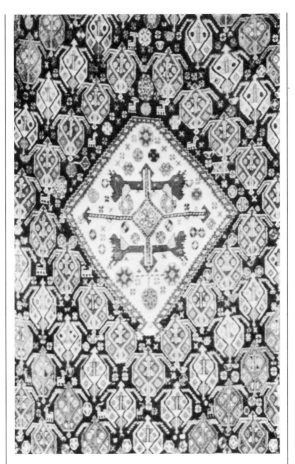

Many of the designs on the carpets are so highly stylised that their naturalistic origins, if they ever had any, are unrecognisable. One such is the *boteh*. It is a lozenge shape with a tail or a stalk and it appears, in one form or another, not only on Qashqa'i rugs but on those that are woven by tribes throughout the Caucasus between the Black Sea and the Caspian Sea and far into Turkey and Central Asia. Some say it is a geometricised cypress cone, a pear or an almond, that it represents a clenched fist or the flame of Zoroaster. The word *boteh* in Persian means no more than a cluster of leaves. Whatever its original meaning, its use is now largely decorative. Almost every tribe with a *boteh* in its repertory has its own version so that an expert can tell quickly and decisively which people wove it. That, indeed, may be one of its functions. It is an easily recognisable badge.

The patterns a woman uses are as characteristic of her tribe as a Scotsman's tartan used to be of his clan. They were evolved to exploit to the best effect the colours available and the qualities of wool produced by the flocks. They proudly proclaimed identity. Yet although the range of colours and patterns was limited, it was possible to produce with them an infinity of combinations so that no two nomadic rugs are the same. Each is an individual creation.

When a woman marries a man from another clan, she takes with her into her new home the designs that her mother taught her. Her husband will wish her to weave the patterns of his own group and so she produces rugs in which there are elements of both traditions. A rug thus may enshrine the history of a group. The Qashqa'i, for example, frequently weave a large lozenge shape surrounded by hooks. This design can be traced in rugs up through the Causcacus and into eastern Turkey where it occurs frequently and in its most dominant form. This, in itself, suggests that the group came from this area at one time and that is confirmed by the Qashqa'i's own historical traditions and the fact that the language they speak is a dialect of Turkish.

The nomadic rugs, on which such care and skill have been lavished, have always been greatly prized by others and the nomads often bring them into the bazaars of the big towns by which they pass on their travels. In Shiraz bazaar, you may often see a Qashqa'i woman, in her glinting skirts, striding unveiled among the meek black-swathed figures of the townswomen. From such markets, merchants have for centuries sent carpets to Europe, shipping them along the Mediterranean to Venice or sending them by caravan overland.

In Europe the rugs were marketed with the name of the town where they were collected. This has caused considerable con-

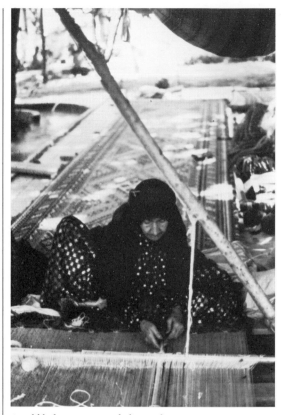

An old lady weaving a *ghelim* in the carpet-weaving school, Shiraz

fusion in the naming and classification of rugs. Collectors in Europe and America for many years have given the name Bokhara to a whole group of magnificent red rugs. Bokhara, however, is not the name of a tribe but of a town with a large bazaar where several very different peoples bring their rugs for sale. Most of the rugs belong to the Turkoman group, but even within that group it is easy to recognise the various subsections – the Salor, the Tekke and the Yomud. Only now is enough accurate and first-hand information becoming available to make it possible to sort out the confusions that western connoisseurship has brought to the study of rugs.

Townsfolk also weave rugs and sell them in bazaars. These differ crucially from those of the nomads. The looms in towns are permanent and so can be built in a fashion and on a scale that would be impossible for the nomads to adopt. They are vertical with long rollers at the top and bottom, so that the finished section of the rug can be wound on to the lower roller in order to keep the row of knots being tied directly in front of the weavers. It is also possible on such looms to weave on a much bigger scale and sometimes twenty girls at a time may be working on a single immense carpet, seated shoulder to shoulder along its width. In such circumstances, individual weavers cannot be allowed the freedom to introduce their own inventions or exercise their own taste. They must conform to an overall pattern. This may have been designed by a great artist working for one of the major workshops that provided rugs for the Persian nobility. In the past, masterpieces of the most marvellous delicacy and intricacy have been produced. But the girls today are more often instructed to weave routine patterns and turn out almost identical rugs. Often the designs and colours have been adapted, on the instructions of middlemen, to suit the requirements of unknown and unseen customers overseas. Such carpets are fundamentally different in feeling from the small rugs designed and woven by nomad women for use in their own tents.

The relationship between townsfolk and the nomads is now known to be much closer than had previously been suspected. It seems that for centuries, if not for millennia, there has been a continuous interchange between the two groups. As nomad *khans* became wealthier, they built themselves houses in the towns and settled down. Sometimes, too, their people settled in villages. Then it was possible to weave rugs with the old designs, using the traditional flat looms but on a much larger scale. Such rugs, too big to be used in any tent other than a *khan's*, are intermediate between town rugs and the true nomadic kind.

Many nomads have been persuaded to settle in this way. The Turkoman travel no longer in Russia. In Persia, the Qashqa'i are almost the last, and even they are not as determined travellers as they once were. Their *khans* have houses in Shiraz and no longer lead their people on the arduous migration twice a year. Summer in the mountain pastures has become for them a splendid holiday when the cool uplands make a delightful refuge from the summer heat of the cities. But when that season passes, lorries drive up to

collect them and their household possessions and take them back to town.

So the nomadic way of life is disappearing and with it is going the traditional style of rug. The government is doing what it can to preserve the techniques and designs. A school has been established in Shiraz, run by Bahman Begi, himself a Qashqa'i man. He has brought to the school, as teachers, old ladies who still remember how to knot the patterns of their past when, as the most skilled weavers of their tribe, they made carpets for their *khans*. Fragments of ancient rugs have been rescued from dustbins, their knots carefully counted and the formulae for their patterns reconstituted. The pupils come from many groups where the old traditions have already been forgotten. In Shiraz, they learn designs that were once the exclusive property of an alien people. So the personal improvised rugs, created by a woman sitting in her black tent among the mountains and deserts, woven over years and employing patterns that are her birthright, may soon be made no more.

Qashqa'i girls weaving in a settled village near Firuzabad

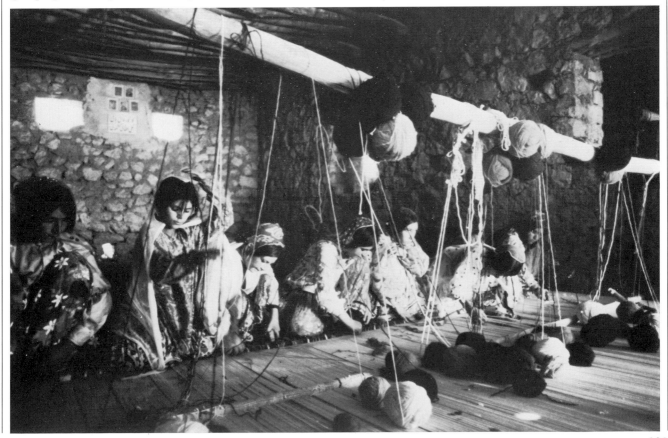

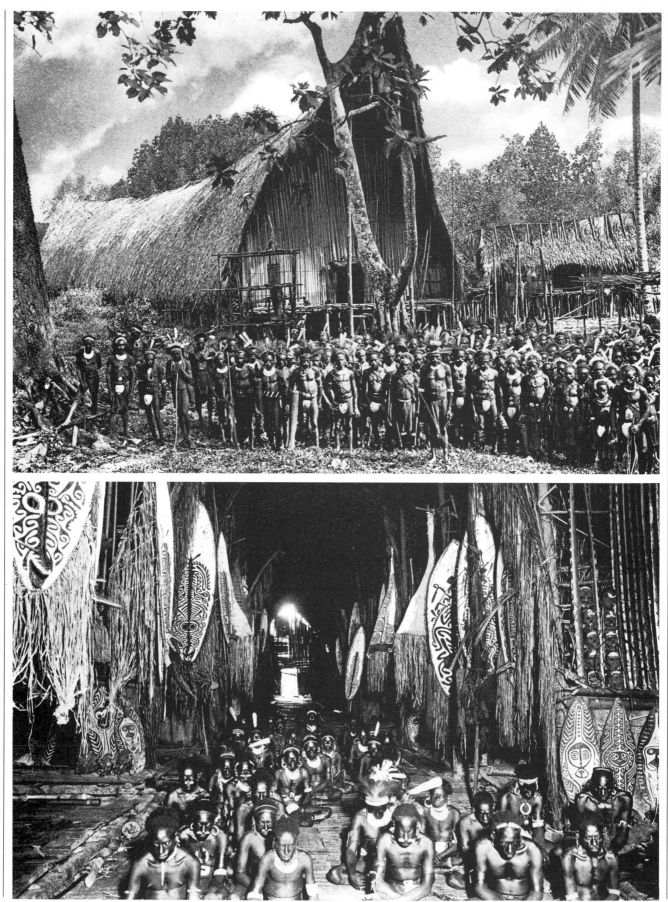

Cult Houses

In the nineteenth century, names were invented for the varied inhabitants of the Pacific islands. Those who lived in the south-western corner were called Melanesians, 'black islanders', because they have a negroid appearance with frizzy hair and often very black skins. The Polynesians, who live in the 'many islands' of the central and eastern Pacific, have brown complexions and straight hair, as do many of the Micronesians from the 'tiny islands' in the tropical northern part of the ocean.

The sculpture that comes from Melanesia rivals that of Africa in its richness and variety. The people themselves are a very diverse group, their ancestors having migrated in several waves, over many centuries, across the mainland of Asia and eastwards along the island chains of Indonesia. Some settled in New Guinea. Others continued still further east and, about 7000 years ago, ventured into the Pacific.

Since then, the Melanesians have become even more diversified. Each tribe has developed its own particular culture – its own way of structuring society, of marking the crises of life, of regarding the supernatural world. Tiny groups a few hundred strong have even developed their own languages. In New Guinea, the largest Melanesian island of all, there are thought to be at least a thousand mutually incomprehensible languages, so many, in fact, that no one has yet managed to list them all.

The artistic styles are just as multifarious and as bewildering. The people carve images from stone, wood and bone. They mould

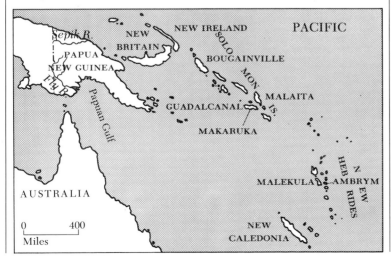

Facing
The exterior and interior of a cult house, Urama, Papuan Gulf, photographed in 1924

The islands of Melanesia

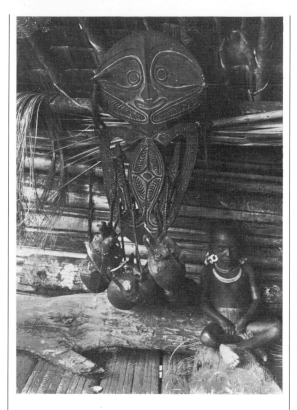

Spirit figure, *agiba*, hung with human skulls. Kerewa area, Papuan Gulf, photographed in 1930

them in pottery and weave them in fibre. They decorate them with feathers, shells, brilliantly coloured seeds, mud ochres and juices from berries. Most of the sculptures are extremely melodramatic. Perhaps the people's imagination is coloured by the dramatic character of their surroundings, where volcanic eruptions, torrential rains and hurricanes are everyday events. At any rate, the gods they create, with staring eyes, writhing tongues and huge fangs, some animal, some human, seem to match the violent mood of their islands. The images appear everywhere. Spear-throwers, head-rests, canoe prows and paddles, pottery hearths and wooden bowls, all may be decorated. But the most spectacular assemblages of carvings were kept, often in the strictest secrecy, in the cult house.

The cult house, in most Melanesian societies, was the exclusive preserve of men. It was their club where they could retire to drink kava or chew betel nut, to debate village affairs or simply to gossip. But it was also a shrine. Religion was largely the concern of men, and in the cult house long rituals could be held away from the inquisitive eyes of women and children. Young boys, as they approached puberty, were brought there and kept in isolation, sometimes for months, as they were initiated and instructed in religious mysteries. Sculptures were often hung around the walls. Others are hidden away, only to be produced by the oldest and wisest men on the most important occasions.

In the past, the violation of a cult house taboo could bring punishment by death. Today, when traditional faiths have lost most of their power or been abandoned altogether, breaking an old taboo is likely to be regarded by villagers as little more than bad manners. Only a few people have kept their cult houses inviolate. One such group lives in the interior of Malekula in the New Hebrides.

Captain Cook in 1774 was the first European to land on Malekula. By the 1860s European ships were sailing through the islands on 'blackbirding' voyages, recruiting tribesmen, often forcibly, and taking them to serve as labourers in the sugar plantations of Australia and Fiji. Later in the nineteenth century, when copra became an important crop, white settlers came to the New Hebrides to establish coconut plantations around the coasts. But few people bothered to investigate the interior of a mountainous island like Malekula. Drenching rain falls regularly throughout the year and lush jungle grows on the rich volcanic soil of the steep ridges and peaks. It was no place for growing coconuts. There was no sign that minerals or any other natural wealth might be found. So the bush people, who were known to be cannibals, were left alone. Over the years, many of them came down to settle on the coast, attracted by the white man's goods. The few that remained in the forests had the reputation of being extremely aggressive and resentful of intruders.

Today, only about 250 resolute pagans remain thinly scattered through the mountains of the interior. They belong to two tribes. The white settlers on the coast differentiate between them by the penis-wrapper, the *nambas*, worn by the men. In the north of the island, it is a large untidy bundle of fibres and the people are

known in consequence as the Big Nambas. In the south, the Small Nambas wear only a bandage made from a strip of banana leaf, the end of which is tucked under their broad bark belt.

The Small Nambas, or, to give them the name they use themselves, the Botgate, have remained the least contacted of the two tribes. The only practical way of reaching their villages is on foot along the steep valleys that run down the flanks of the central massif. The rivers that eroded them wind across the valley bottoms so tortuously that they may have to be forded twenty or more times in a day's walking. A sudden rain storm can make them rise so swiftly that within a few hours a stream no more than thigh-deep becomes an impassable torrent. So hopeful visitors may have to turn back, and successful ones may be cut off in the mountains for weeks.

The Botgate villages are ritual centres rather than permanent homes. Most of the people spend a great deal of their time in the forest beside their plantations of taro and yams. Only the oldest, most senior men live always in the village. But on important ceremonial occasions everyone assembles there.

Yabgatass is such a settlement. A steep path of mud, as slippery as soap, leads up to it. Its dozen low, thatched houses are surrounded by a double fence within which pigs are kept. Its heart is a ceremonial dancing ground in which stands a group of vertical log gongs, each slit up its length and hollowed out, with a face carved on its top. A garden grows beside the dancing ground, containing plants that are needed for ceremonies – crotons, cycads, hibiscus, breadfruit, papaya, banana, wild oranges. And close by, screened by a tall hedge, stands the cult house, the *namal*.

The life of a Botgate man is dominated by ritual. The sequence begins when, as a boy, he is taken into the *namal* for initiation. There he is deliberately terrorised by masked figures that appear from the gloom. Plaques covered with grinning faces hang over him. He is fed on special foods and may be kept there for days or weeks.

When his ordeals are over he has become a member of one of the men's secret societies. From now on, if he is to retain the respect and admiration of his fellows, he must labour and save in order to sacrifice pigs at a succession of ceremonies that will continue throughout his life. Only by doing so will he be able to acquire status in this world and ensure that his spirit will assume a privileged place in the next.

Each successive ceremony demands pigs. Nor are ordinary pigs the only kind needed. Special boars are required that have had their upper incisors knocked out when they were young. As a consequence, the tusks of their lower jaws grow upwards unimpeded and circle round until they pierce the flesh under the jaw and thrust close beside the bone to form a complete ring. A pig with such tusks is worth many ordinary ones. It is likely to be a sickly creature because of its mutilations. The ingrowing tusks must cause it considerable pain. They make eating so difficult that women must chew food for the animal and feed it by hand. If it survives long enough for its tusks to complete a second spiral, it

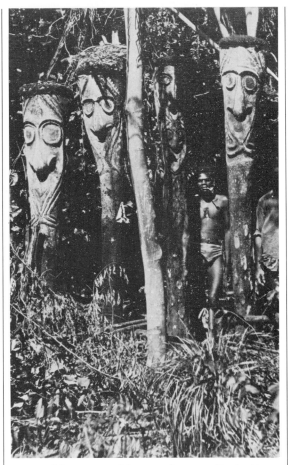

Ancestral figures carved from tree fern, standing beside a dancing ground. Ambrym, New Hebrides

A tusked pig reared for sacrifice, New Hebrides

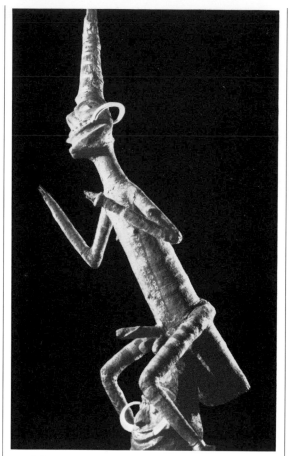

Head-dress worn in a grade ceremony. Cane, bark
fibre and clay. Malekula, New Hebrides. Ht 140cm

becomes so great a treasure that people will travel long distances
simply to gaze upon it and marvel.

Pig rearing can become an obsession. A man may marry more
and more wives to ensure that there are enough women in his
household to raise the pigs he needs for his next ceremony. He
may borrow pigs from his friends and mortgage his labour for
years to come to pay for them. Even the preliminary rituals for a
grade-taking ceremony may be very demanding. A senior grade
may require a man to remain isolated in the cult house for as long
as a year. The climax is heralded by a team of men playing the log
gongs in the dancing ground. Then, in front of the assembled
people, the pigs, one after the other, are clubbed on the head or
shot through the heart with an arrow. As the most valuable tusker
is killed, the donor of the sacrifice assists, giving it a symbolic
touch, and simultaneously his new name is proclaimed.

His new rank brings with it special privileges. Some may make
his life marginally easier. Most do little more than make explicit
his exalted status. He now has the right to gather fruit from
specially marked trees in the bush that have been denied him
hitherto. He must only eat with men of his own grade or by
himself. He may wear particular flowers in his hair and leaves in
his belt, put special bands on his arms and, for celebrations, paint
himself in a particular fashion. At future ceremonies, he may wear
certain masks and carry out from the cult house images of the
temes, the ancestral ghosts. His rank also brings him new know-
ledge. The older men of his new grade now tell him in the privacy
of the *namal* more about the meanings of the rituals, the way they
should be performed and the manner in which they bring him
closer to the spirit world.

Only the hardest-working and the longest-lived may hope to
attain the higher grades. The highest of all, in the past, demanded
not only tusked pigs in great numbers, but human beings – a
prisoner taken in battle or a child. Such sacrifices were usually
commemorated with a monument erected beside the ceremonial
ground. In some parts of Malekula, standing stones or stone
dolmens were put up. In the neighbouring island of Ambrym, a
huge figure was carved from the trunk of a tree fern, painted with
dazzling eyes and provided with a special shelter of bamboo.

The variety of ceremonial within the New Hebrides was
enormous. New dances, names, and images spread from group
to group, the 'copyright' being purchased by payment in pigs.
Although detailed accounts have been written during the past half
century of the ceremonies once held by the coastal people, most of
those of the Botgate are still undescribed.

When a man dies, his funeral must be appropriate to the rank
that he finally attained. The Botgate practice is to keep the body
initially in a special communal hut and then place it, covered with
leaves, on a wooden platform beside the dancing ground. It will
remain there for months, slowly decomposing. After some time,
the head is pulled off. The scalp and hair are carefully cut from it
and the skull is put in an ant-hill so that the insects may strip it
clean and white.

A life-size effigy of the dead man, a *rambaramp*, is now constructed in the privacy of the *namal*. The body is made from bamboo and leaves. The size and proportions are carefully judged to match those of the headless skeleton still lying beside the dancing ground. The skull is fleshed out with a vegetable paste and, as far as possible, made to resemble the face of the dead man. The original hair is stuck back on the bone of the cranium with sap from a breadfruit tree. Finally the whole figure is given the armlets and legbands and painted with the patterns that the dead man wore to denote his seniority.

People from all over the mountains will travel for days to be present at the last rites of an important man. A long screen of woven palm leaves is set up outside the *namal*. As the women chant, small puppets appear above it with outstretched arms, jigging to the rhythm of the log gongs. These, the people say, are the children of the *rambaramp*. Then the *rambaramp* itself is brought out from the *namal* and stood in front of the people. Long yams, specially grown for the occasion, are placed in front of it as offerings. Pigs are slaughtered and men dance. The proceedings may continue for several days. When all is finished, the people disperse and the *rambaramp* is taken back into the *namal*. There it will stay until the fabric of the body has fallen to pieces. Then the skull is hung in the rafters beside those of other men who, during their lives, belonged to the *namal*.

At the time of our visit to Yabgatass, no outsider had ever seen inside the *namal*. The ritual life of the settlement and the taboos that surrounded all activities there were supervised by the oldest and most senior man in the village, Mulu-mulu-nasurr. We were only allowed to stay there when he had given his explicit approval. He issued instructions as to where we might walk and which parts of the village were forbidden to us. An invisible line ran across the path that led from the dancing ground through a gap in the hedge to the *namal*. We were forbidden to cross it. We could not even go down the path far enough to look through the gap. All we could see of the *namal* was its thatched roof and tree-fern ridge pole, above the top of the hedge.

A newly-made *rambaramp*, Yabgatass

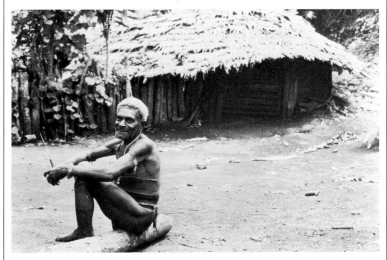

Mulu-mulu-nasurr beside his house in Yabgatass

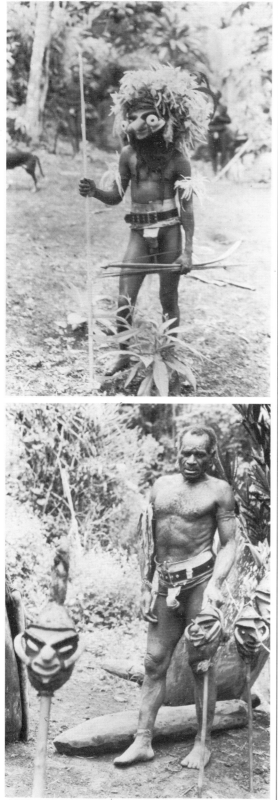

Mulu-mulu-nasurr, during his long life, had raised and sacrificed over 300 pigs. His status was now so high that people said he was already half-dead. When he sat on his haunches, contemplating his pigs, he had to be approached quietly and with reverence, for his spirit might well have left his body and be visiting the other world. But Mulu-mulu-nasurr was deeply troubled. An important funeral had been held only recently in the area. He had supervised the rituals and danced, for the dead man had been of the same high rank as himself and only he was qualified to perform the steps that were essential if the spirit was to be sent properly on its way. Now he was alone. No other man living had attained his grade, nor was a younger man likely to do so within the next few years. When his funeral was held, there would be no one to conduct it properly. The just destination of his spirit was in jeopardy.

One evening, the men who had guided us up to the village called us to the dancing ground. Unexpectedly, Mulu-mulu-nasurr had decreed that, although the *namal* was forbidden to us, some of the objects it contained might be brought out for us to see.

We sat beside the log gongs. No women or children were present. One by one, men came out from behind the *namal* fence carrying sacred images. They set them down in front of us and told us their names. *Metenyelli*, a circular board two feet across, painted ochre orange with long stalked eyes and an even longer nose: this was the image of the sun shown to young boys during an early stage of their initiation. A group of heads on sticks made from bundles of fibres covered with a tissue of spiders' webs and painted red and blue were called collectively *temes nevenbuhr*. Some had boars' tusks arching from the side of their mouths to their cheeks. Others had a grinning gape and pointed seeds for teeth. Each had its own particular name – *nelu-pas-pas*, *nem-elalox*, *nagarr*, *alisin*. These were some of the images that had been made and paraded as part of the recent funeral.

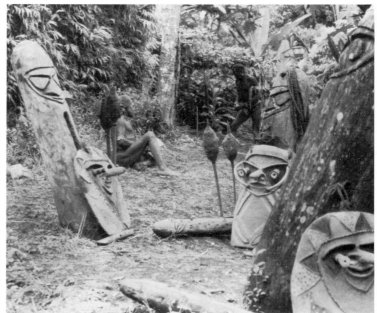

Top: The *nampuki*, Yabgatass
Bottom and right: Sacred images form the *namal* displayed by the log gongs on the dancing ground, Yabgatass

While we were talking about them, a long scream came from the forest and a masked figure, a *nampuki*, ran onto the dancing ground. Its hair was a waving mop of croton leaves. Huge tusks sprouted from its lips. Its eyes protruded on stalks. In its hand it brandished a bow and arrows. Three times it walked around the dancing ground. Then, without a sound, it disappeared into the *namal*.

It was the last mask we saw in Yabgatass. That night there was a heavy rain storm. In the morning, the black clouds were still massed above and thunder exploded around the peaks. Within a few days, the rivers might become impassable and we might be trapped for weeks. We had no alternative but to leave.

There are many kinds of cult houses in Melanesia. The smallest and most modest are those in the mountain villages around the source of the Sepik River in central New Guinea. They are only marginally larger than the other houses in the villages, but inside the walls are covered with lines of pig jaws stained brown from the smoke of the fire that burns in the middle of the house. Among them hang human skulls in woven fibre bags. These are used in the fertility rites that must be regularly performed to ensure the continuing productivity of the fields.

Farther down the same river, in the lowlands, stand some of the biggest cult houses of all. These were made by the Iatmul people. A village might contain several, one for each clan. One still standing close to the river's edge is about 100 feet long with a thatched saddle roof that rises, at each end, to a peak fifty feet high, surmounted by a finial carved in the shape of a river eagle crouching in the head of a human figure. The massive hardwood pillars that support this roof are elaborately carved with the faces of spirits, grotesque and haunting like the gargoyles in a medieval cathedral.

Inside lie huge *garamuts*, horizontal log gongs, with ends the shape of crocodiles, and stools with high backs carved in the form of human faces which are used by orators during rituals. The river often floods the village so the most valuable objects are kept on an upper floor, close to the rafters. There, grimed with smoke and dust, are human skulls captured during head-hunting raids generations ago, elaborate masks and specially precious relics – an ancient carving of a head, a strangely-shaped rock, each with its own name, history and significance.

No woman or child at any time would dare even to approach the house across the open lawns of grass that surround it, but when preparations are begun for a ceremony, the whole building is surrounded with plaited screens so that no one may get the smallest glimpse of what is going on inside. At such times, the *garamuts* inside the house are beaten by teams of men for hours on end. Ten-foot-long flutes are brought down from the rafters and played in duet. As the music sounds through the village, the women speak of the spirit voices they hear singing in the cult house. No one is supposed to know that such sounds are produced by mortal means. On the day of the festival, masked men in

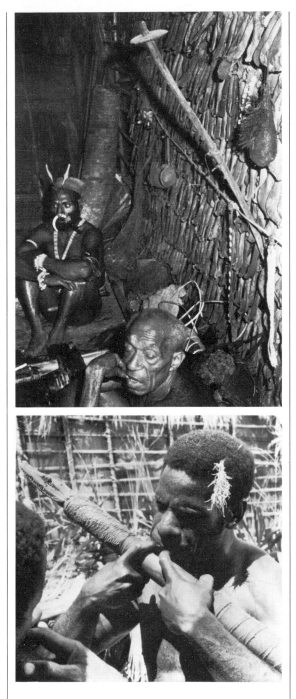

Inside a cult house, Efokavip, near the source of the Sepik River, Central Highlands of New Guinea. The wall is lined with several thousand jaws of sacrificed pigs. The skull of an ancestor hangs in a woven bag. An ancient stone mace head is displayed on a stick

Playing the sacred flutes, Middle Sepik River

Skull rack and spirit boards in a cult house, Urama.
Papuan Gulf, photographed in 1924

elaborate costumes of leaves come prancing out of the cult house to gyrate on the dancing ground. Sometimes they carry within their costumes bamboo tubes down which they drone and grunt to give unearthly voices to the spirits they impersonate. Such performances continue for days, the men coming out in relays. When all is over and the last masked spirit has returned to the cult house, the masks are hidden once again in the rafters.

To the north of the Sepik, in the Maprik mountains that lie between the river and the coast, the cult houses have a different shape. There is no danger of flooding here and the thatched roof at one end slopes right down to the ground. The other soars up sixty or seventy feet, to form a peak the front of which is emblazoned with rows of spirit faces, brilliantly painted in red, yellow, white and black. The only entrance is a small hole in this resplendent façade, close to the ground, through which you must crawl. Inside, in the darkness, are kept rows of painted wooden figures carved from logs. In these mountains, the growing of yams is all-important. The sculptures in the cult house are again the sources of fertility. Before yam seeds are planted they must be brought into the house and ritually placed against the figures. Later, when the plants have sprouted, more offerings must be made to the prostrate figures. They are presented with food, rubbed with special herbs, and magical formulae are chanted over them to ensure the proper growth of the tubers in the garden.

In the south of the island, on the coast and islands of the Papuan Gulf, the people build yet another version of the cult house. These, perhaps, were the most impressive of all. Flat lozenge-shaped boards carved with highly stylised human faces, dwelling places for the ancestral spirits, were stacked there in huge numbers. Other spirit figures were carved with special hooks at their base so that human skulls could be hung from them. Photographs

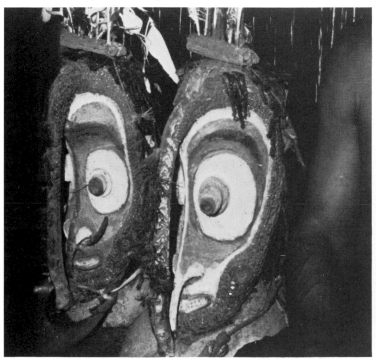

Sacred images, kept inside the cult house, Korogo.
Middle Sepik River

Grade figure carved from a tree-fern trunk. Ambrym, New Hebrides

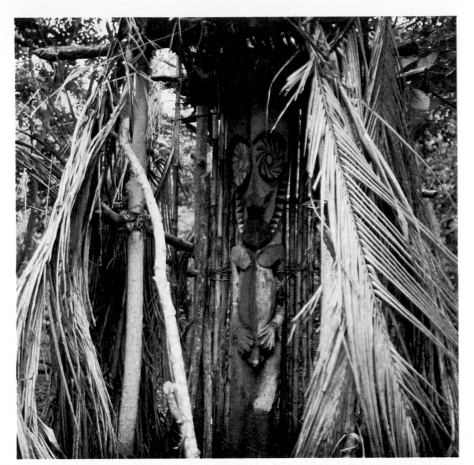

Men playing log gongs, Yabgatass village, Malekula, New Hebrides

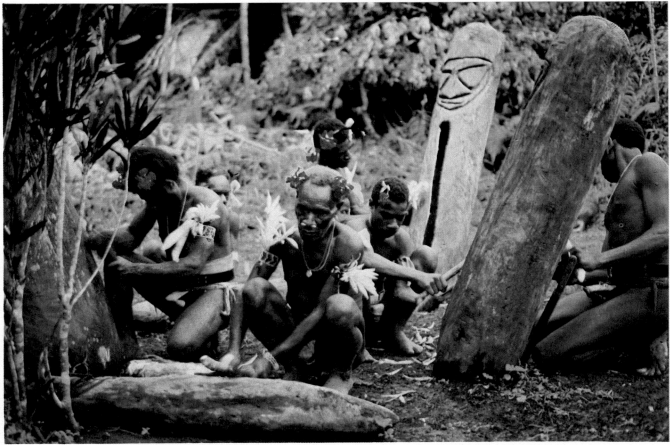

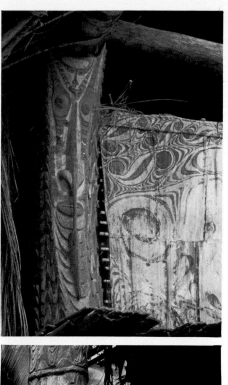

House post

*Cult house,
Kanganaman,
Middle Sepik,
New Guinea*
House post

Interior

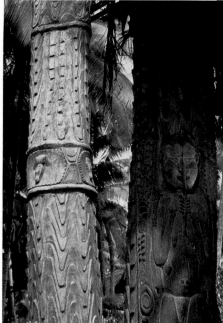

House post

Exterior

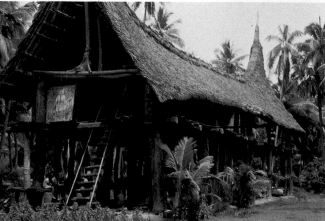

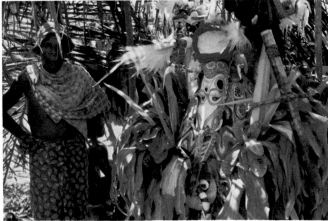

Mwai dancer with
his costume

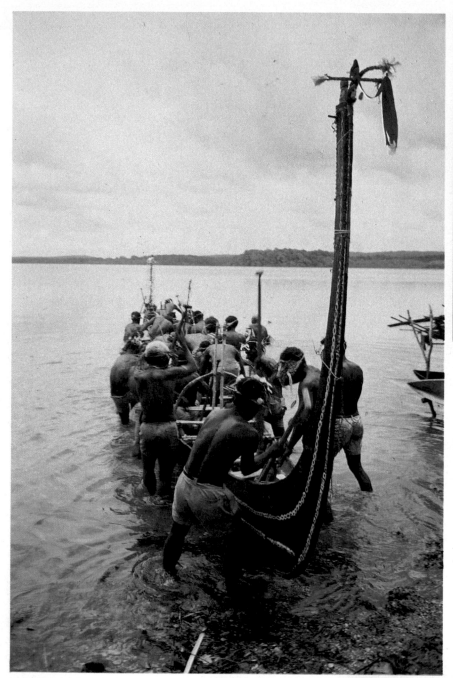

Tomako being launched, Roviana Lagoon, Solomon Islands

Moro

Traditional dancers, Makaruka, Southern
Guadalcanal

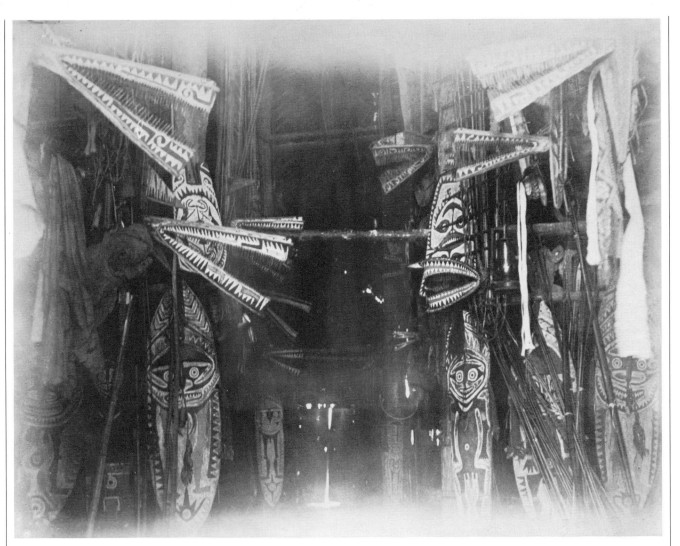

taken fifty years ago show how spectacular these houses once were. It is not difficult to imagine the important part these sculptures once played in the lives and imaginations of the people who created them.

There are also cult houses a thousand miles away to the east, in the Solomon Islands between New Guinea and the New Hebrides. The coastal people here spend much of their lives at sea. To travel across the lagoons, or to fish close inshore, they use small dug-out canoes. But once they also regularly made daring journeys across the open ocean between islands, and then they used huge plank-built canoes. On such voyages, their lives were in real danger. A sudden storm, a hidden reef, a mistake in navigation or seamanship, any of these could be fatal. Not surprisingly, therefore, the vessels were the focus of a great deal of ceremonial and magic, and in consequence, of decoration.

 In New Georgia, and other islands in the centre of the Solomons, the most magnificent and important vessel was the *tomako*. This sixty-foot-long war canoe was capable of carrying a hundred warriors on head-hunting raids for several hundred miles through the archipelago. Even European ships had reason to

Interior of a cult house with ceremonial shields, masks and spirit boards. Vailala, Eastern Papuan Gulf, photographed in 1912

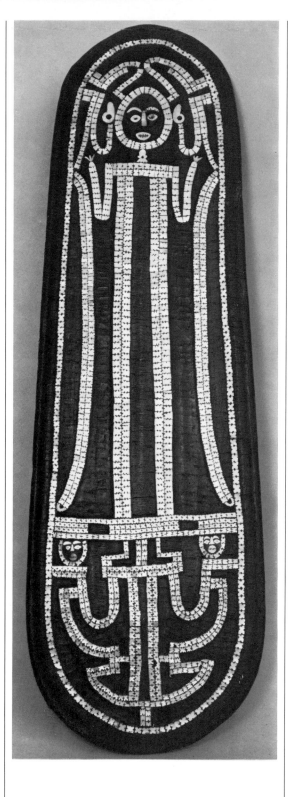

fear them, for unless winds were particularly favourable, a *tomako*, driven by a hundred men paddling in unison, their strokes synchronised by blasts on a conch trumpet, could reach speeds of fifteen knots and overhaul them.

The *tomako* had no outrigger and seldom any provision for a sail. The planks forming its sides were sewn together with split cane and sealed with a mastic made from the flesh of putty nuts, pink and soft when fresh but becoming hard and black on exposure to air. The posts at stem and stern were decorated with lines of large white cowries and hung with tassels of stained leaves and feathers. Sometimes, tiers of small horizontal spars were tied to the prow so that they and the stays holding them in position hummed in the wind when the canoe travelled at speed. The whole vessel was stained black and ornamented with lines of discs, rings and bird emblems cut from nautilus shell. A big *tomako* might have as many as 50,000 pieces of inlay, each meticulously cut and filed, on its hull.

At the bow, just above the water-line, hung a *nusa-nusa*, a spirit figure with ferocious jutting jaws and staring eyes. Its piercing gaze could detect shoals or evil spirits that a man's eyes might miss and so it was able to guide a canoe safely around such hazards. So powerful was its stare that no one would dare to pass close in front of it, at sea or on land.

In San Cristobal and other islands in the south-east, particular attention was lavished on the canoes that were used for bonito fishing. Bonito is the most prized of all fish in the islands. Swift and sleek, three or four feet long, it hunts lesser fish in the surface waters of the ocean. When a pack of bonito come upon a shoal of their prey, they feed with such voracity and cause such havoc that the surface of the sea boils. Hundreds of shark, attracted by the carnage, swim around the fringes of the massacre, taking the bonito. The sky above fills with birds, boobies diving into the shoal to snatch fish and frigate birds robbing other birds of their catch in mid-air. Such an extraordinary spectacle is regarded by people as a manifestation of the power of the sea gods that must be treated with both gratitude and reverence. The canoes that went in search of such shoals, therefore, were engaged in a sacred activity and were embellished with shell inlays of frigate birds, porpoises and sea spirits.

Both the bonito canoes and the *tomakos* were kept in special houses along the beach. These served many of the functions of cult houses elsewhere in Melanesia. Only men were allowed to enter them. Bachelors often slept there and young boys were initiated in the dimness beside the great canoes. And they were places of magnificence and spectacle. The pillars and rafters were carved with figures of humans and of sea spirits, *adaro*, which had human bodies but fish in the place of hands, feet, and heads. An image of an *adaro* was often fastened to the house finial. Bonito skulls and vertebrae, threaded on bamboo, were stored here together with the jaws of sacrificed pigs. There were human skulls too, of the ancestors or of *ifalamoa*, the men who were sacrificed on the death of a chief. These were overmodelled with clay, painted

Ceremonial dance shield. Pearl shell mosaic on resin-covered wicker base. Central Solomon Islands. Ht 87cm

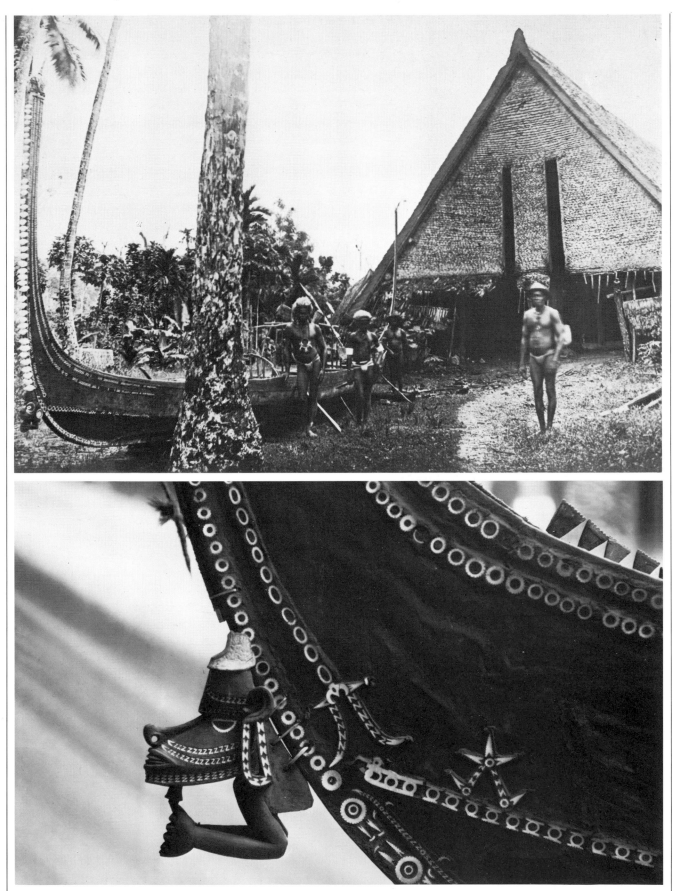

Top: a head-hunting canoe, *tomako*, outside the canoe house, Roviana Lagoon, Solomon Islands. Photographed about 1890
Bottom: the bows of a *tomako*, with a *nusanusa* guardian spirit in position, and mother-of-pearl decoration. Vella Lavella, Solomon Islands 115

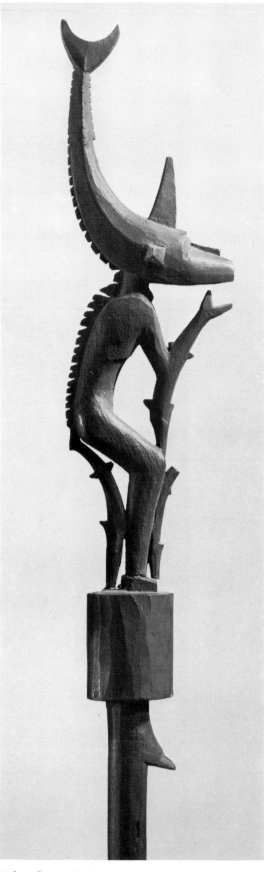

Fishing float in the form of a sea spirit, *adaro*. Wood.
Solomon Islands. Ht of entire float 87cm

black and decorated, in typical Solomons fashion, with pearl inlay. Wooden feast bowls, similarly ornamented, were stacked in corners together with other objects required for ritual – sculptures of sharks, bonito, frigate birds, turtles, crocodiles and sea spirits. Such canoe houses must have rivalled the cult houses of the Sepik and the Fly River in magnificence.

None of the ancient ones is left. In the middle of the nineteenth century, the Melanesian Mission was founded to spread Christianity throughout the south-west Pacific. The British administrators stopped head-hunting and human sacrifice and the missionaries persuaded the people to destroy the canoe houses and the other small 'custom houses' where the traditional priests kept some of their paraphernalia. One such custom house, said to be the last, still survives on the tiny islet of Adigege on the north-east coast of Malaita. It is a small thatched building scarcely ten feet long, standing in its own enclosure close to the sea's edge, half hidden among pandanus trees and hibiscus bushes. When we went to see it, we were greeted by the old priest who still cares for it. He was grey-haired and frail. He had dressed specially for the occasion with a porpoise-tooth necklace over his bare chest, shell bead ear-rings and a hibiscus blossom behind his ear. He waved a sprig of leaves in front of him, like a Christian priest with a censer, as he led us into the house.

We stooped through the low door and found inside the cold ashes of a fire, a crude wooden cut-out of a frigate bird hanging upside down from a rafter and beyond, at the back, a battered tin trunk. It contained the skull of his father, the priest said. That was all.

The need for cult houses, however, has not entirely disappeared. Recently, one community in the Solomons has recreated such a house in a most dramatic fashion.

The Second World War brought devastating changes to the Solomons. After the horrors of the battles by which the Americans drove out the Japanese came the occupation by the American forces. They brought with them material wealth far beyond the imaginings of the people who, until the war, had been accustomed only to the modest resources of a British colonial administration. Furthermore, among the men who squandered these goods in such an astounding fashion came black men, very similar in appearance to the Solomon Islanders themselves. Clearly the comfortable life led by the British, and the abundance of manufactured goods that went with it, were not the exclusive prerogative of white men.

When the British resumed control after the war, they found a restive people. Soon a revolutionary movement, called by its leaders Marching Rule, was openly declared in Malaita. It was similar to many other movements that have arisen in Melanesia and elsewhere when Western technology has collided with a near Stone Age culture. Collectively they have been called cargo cults, 'cargo' being a pidgin word used for western manufactured goods.

Marching Rule prophesied that before long ships laden with

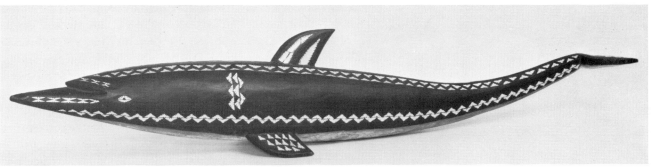

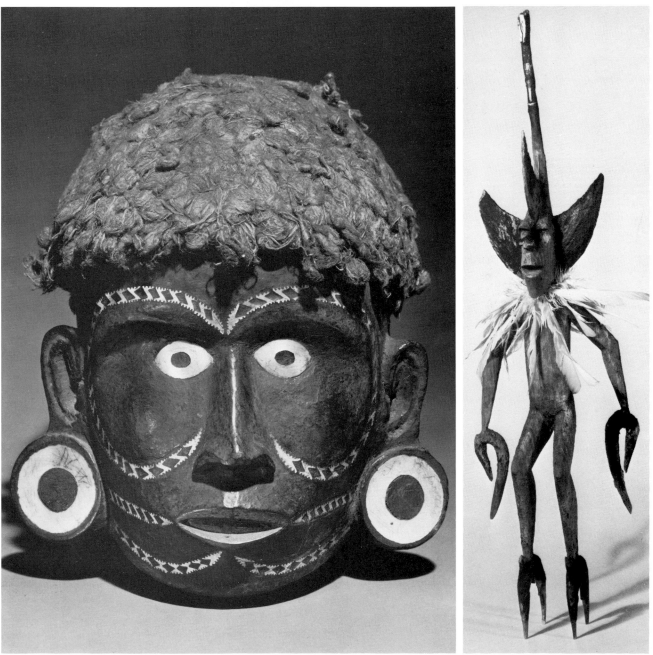

Top: figure of a dolphin, probably used in connection with a sea-spirit cult. Wood inlaid with mother-of-pearl. Ulawa, Eastern Solomons. Length 105.5cm
Right: Sea spirit, *adaro*. Wood. San Cristobal, Eastern Solomon Islands. Ht 72cm
Bottom: Human skull with hair of vegetable fibre, fleshed out with hardened black gum inlaid with mother-of-pearl. Solomon Islands

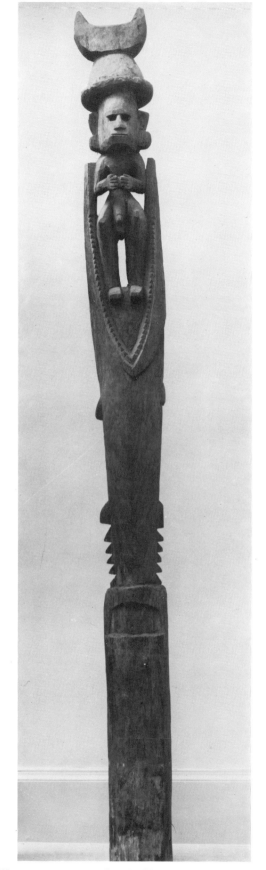

House post: a man inside a shark's mouth, San Cristobal, Eastern Solomon Islands. Ht 280cm

trade goods from America would arrive in the islands. This time, however, the cargo would go not to the whites as it had always done before, but to the native-born Solomon Islanders. The rebels urged their followers to ignore the rules and instructions of the whites. No one should work in a white-owned plantation. No one should pay taxes or assist in censuses or accede to any other administrative requirements demanded by the whites. Instead they should appoint their own teachers, judges and police. Marching Rule leaders began to levy their own taxes. They built offices in the villages for their officials and put up sheds ready to receive the cargo when it arrived.

The movement soon became violent. People who did not obey its instructions were threatened and intimidated. The British administration was compelled to act. Several thousand avowed supporters of Marching Rule were gaoled and by 1952 the Movement was apparently broken.

Five years later, however, a new cult arose in the southern part of Guadalcanal. That end of the island is very difficult to reach. There are no roads to it, even today, and the approach by sea is not easy. There are no harbours, and the trade winds blow with such force that huge breakers pound the open beaches and often make it impossible to land. Catholic missionaries began working there many years ago, seemingly with great effect. Traditional religion was largely abandoned. An anthropological survey in the 1950s could discover no signs of the old forms of sculpture.

Then in 1957 a local man named Moro, a baptised Catholic, fell down in a trance. It was said later that he lay without even breathing from dawn until midday. His family thought him dead and dug a grave for him. But in the afternoon he began breathing again and opened his eyes. When he had fully recovered, he declared that he had seen the creation of the world in a vision. The story has now become codified with the help of disciples including in particular a teacher from the mission school, David Valusa, who, unlike Moro, speaks excellent English.

In the beginning, the story explains, there was only darkness and Iroggali the Creator. He was like both a man and a bird and his name means 'he who sits on high looking around'. He created the stars and water, the sea and the land and two ancestral birds. He gave them all names. The birds laid three eggs on the land. Two hatched into dogs, Lauala and Lauili. The third sank into the ground and remains there today as a source of power.

Iroggali then changed the dogs into human beings. They were neither male nor female. They had no mouths, lips or voice. One of them was given a rod of shell money. This became his source of power and made him virile. He opened the door of knowledge of the other, making her feminine by cutting a slit at the bottom of her abdomen and thus allowing her to give birth. So the island was populated and Iroggali called it Isatambu.

In later visions, Moro was told that the island belonged only to Iroggali and the people he had created. No one else must be allowed to exploit or control it. Henceforth, the island must not be called Guadalcanal, the name given to it by its first Spanish

Moro and his lieutenants outside the House of Memories

visitors, but Isatambu, Iroggali's name. The ways of the white man must be abandoned and the people return to the customs they practised before the white man arrived. Moro himself must lead a movement to bring all this about.

So began the Moro Custom Movement. It spread rapidly. There were rumours that black Americans were supporting it. At one time, followers mounted regular watches on the coast for the American ships that must soon arrive bringing cargo. Others collected money to buy 'tickets' and prepare 'passports' so that visitors could sail away in the ships back to the source of the cargo. Doubtless these stories derived from the prophecies of Marching Rule. Moro, however, was emphatic that they were no part of his vision. He insisted that people must not rely on outside help but had to regain their independence by their own efforts in returning to traditional ways. Within a few years, three or four thousand had joined his movement.

All the old crafts were revived. People began to make axe blades from stone and fishing hooks from pearl shell and bone. They lit fires by rubbing a wooden point in a grooved log and cut meat with bamboo knives. Shell money had figured prominently in Moro's creation story. It consists of long strings of button-like discs cut from a particular shell found on the reefs. It is still used in many parts of the Solomons in traditional transactions such as marriages and it is even exported to communities as far away as New Guinea. One or two villages in Malaita still make it. Moro's people now began to use it as their primary currency. And at the village of Makaruka, which became the movement's head-quarters, Moro built a cult house.

We had met one of Moro's most senior disciples in Honiara, the

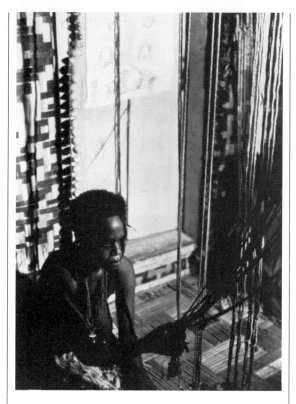

capital of the Solomons, on the north-eastern coast of Guadalcanal, and it had been agreed that we might visit Makaruka. We sailed overnight and early on the morning of the agreed day we dropped anchor off Makaruka beach. As we prepared the dinghy to go ashore, the beach slowly filled with people. The men carried long spears and were naked but for loin cloths of *tapa*, bark fabric. The women wore only fibre skirts. As the dinghy came into the breakers, men waded out, lifted it on their shoulders and carried us ashore in it. An avenue opened in the crowd and we walked up the beach accompanied by an orchestra of men playing pan-pipes. At the top of the beach, a short man with a wispy beard stood waiting. He wore a woven hat covered with shell beads, with a terminal spike and strings of shell beads hanging from the brim. From his neck hung a pearl crescent, and a long baldric of shell money hung down to his waist back and front. His shoulders were covered with a beadwork cape. This was clearly Moro. In spite of the splendour of his regalia, he seemed almost diffident as he waited. The pan-pipes stopped playing and in respectful silence we shook hands. As we did so, the whole assembly began to sing God Save the Queen. The harmony was impeccable, the singing as well drilled as the best mission choir.

Moro turned and led us up to the cult house. It stood at the head of the beach with several others, on a terrace edged with coral blocks and surrounded by a flimsy bamboo fence. The gateway to the terrace was formed by a ceremonial arch decorated with yellow palm nuts on which was pinned a notice, 'Only special person allowed to visit the custom area'. We were led through it to a row of seats. There David Valusa, a handsome full-bearded man, made a speech of welcome on behalf of Moro and recited the story of the creation of Isatambu and the origin of its population.

If we wished to visit the important parts of the custom area, David told us, we must first take off all our European clothing and wear only *tapa* loin cloths, like every one else. We changed in a small hut. Then Moro, with David and other senior officials of the movement, each with his own shell money regalia, took us into the cult house.

Its interior was laid out like a small museum. Shelves lined the walls. On them lay piles of stone axes, woven baskets, pan-pipes, pearl-shell fish hooks, tobacco pipes made from cone shells, oddly shaped waterworn stones and shrivelled yams. One shelf was lined with simple wooden carvings stained black. Each had a curling paper label. One beside a bird read, 'The Memory of Iroggali', another, beside a human figure, 'The Memory of Lauili' and underneath an odd four-legged creature, 'Memory of Opossum. How the Opossum got plenty'!

From the cult house we were taken across the compound between lines of swaying singing girls to a three-gabled building. It was dark inside, for there were no windows, but enough light filtered through chinks in the atap walls to show that it was hung from ceiling to floor with what seemed at first to be row after row of bead curtains. It was shell money. The building was clearly the Moro Movement's treasury.

Inside the Makaruka Treasury, hung with shell money

A passage through the dangling money led to three small apartments. Outside the entrance to each, women sat cross-legged, impassive and silent. They were Moro's wives. The first room contained baskets full of stone axe blades and a long-armed cross of shell money carefully laid out in the middle of the floor. This represented both the four points of the compass and the four ancestral clans to whom the island originally belonged. Another more complex mat of shell money mosaic was spread out on the floor of the second chamber. This, David explained, was a diagram of Isatambu showing just which parts of the island belonged to which clans. In the last room, there were sculptures. Two small figures of blackened wood, each dressed in a tunic of shell beads, with a spike of white wood through its nose and white circular earrings. One represented Iroggali in human form. He held in front of him a thick staff covered in shell money. This was *penda* the source of his power. The other, crouched in front of another rod of shell-money, was Koriba, a 'paramount chief from the Beginning'. In front of these figures lay two wooden snakes. In the coils of one of them stood the figure of a man. They were magical snakes that lived under the ground. In style, they were very similar to the small cult figures that missionaries collected and that are now in the museums of Europe and America. These, David said, had not been carved by the hand of man. Moro had seen them in a vision. When he awoke he told his followers where they lay in the bush. Men had followed his instructions and found them exactly where Moro had predicted they would be.

In spite of so many years of missionary labour, which seemed to many to have been so successful, tradition still made strong and precise demands. Moro and his people within a few years had succeeded not only in re-creating a cult house, but had provided it with images like those in the cult houses of the past that had not been made by man, but by the gods.

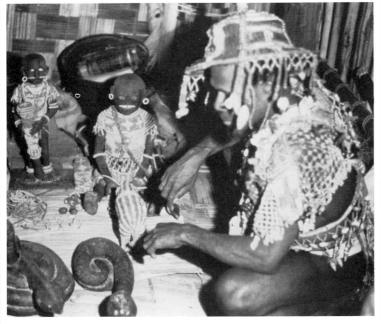

Moro with sacred objects, inside the Treasury, Makaruka

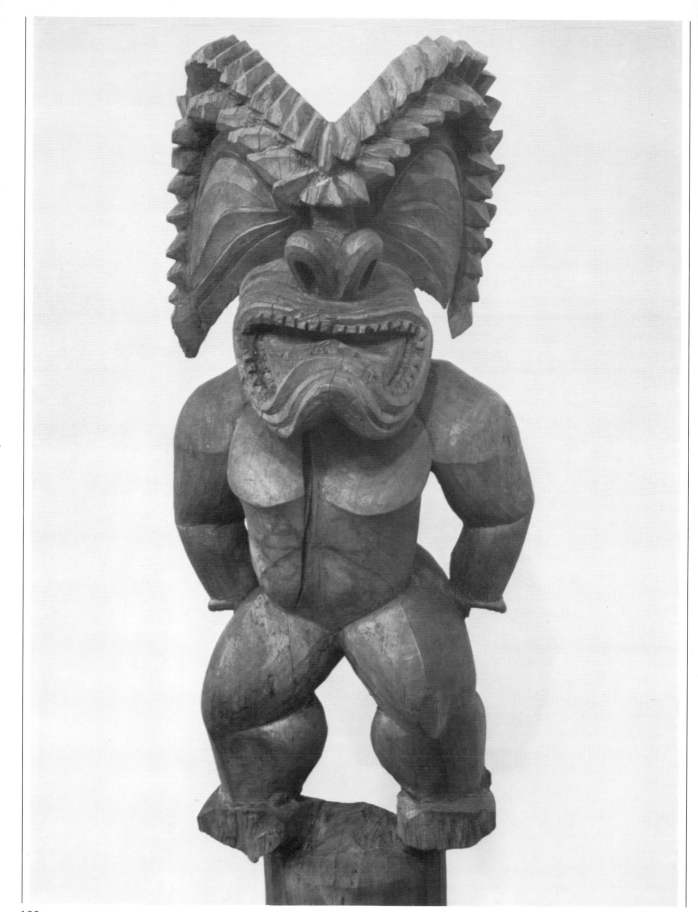

Across the Frontiers

Evidence for the ways in which tribal arts have changed over the centuries has seldom been easy to find. Wood, which has been used by so many societies, seldom lasts long in the tropics, thanks to the insatiable appetites of insects. Nor have many tribes rated age as a quality. The Dogon abandoned their masks in the Tellem caves when they became tattered or broken, or when they reached the end of their ritually prescribed life-span. Sometimes, indeed, it was essential that objects be destroyed after they had served their ceremonial purpose. The Australian Aborigines bury such things or sink them in a river to make sure that the uninitiated do not catch sight of them.

Nigeria is a famous exception. The evidence for the history of the court style of Benin still survives in an abundance of pieces of bronze and William Fagg, by establishing their chronology, has enabled us to see how the early humanistic style slowly changed to reflect the pomp of an increasingly despotic state. The Ife finds pushed our knowledge back to at least the twelfth century, and Bernard Fagg, working with material found around Nok, in the northern part of the country, has described terracotta heads of yet another style that date back to the fourth century BC. In New Guinea, ancient and enigmatic stone figures, markedly different from anything produced today, have been discovered by the people when digging in their plantations. On the Northwest Coast of America, stone sculptures are now being excavated which appear to be about 2000 years old. While they have a plain affinity with the work of the historic period, they nonetheless differ from it.

These examples, and many more, demonstrate the falsity of the notion that the creators of tribal art today carve in a style that has remained unchanged since time immemorial. Tribal styles have developed and altered over centuries just as European styles have. The fact that they continue to do so should not, therefore, surprise us; nor should we automatically dismiss modern pieces as worthless simply because we can detect new influences in them.

However, in the past, a community changed the way it carved gradually, over long periods of time, and any new influences were likely to come from neighbours with whom they already had much in common. Consequently they were able to graft fresh ideas on to the living tradition without killing it. But when European man began to overrun the earth, he introduced his own brand of highly-developed technology to people who lived in very different

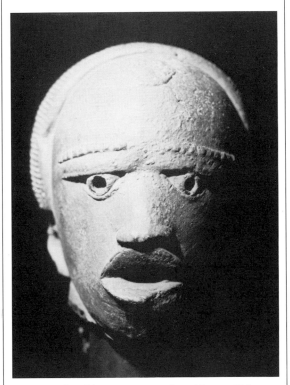

Terra-cotta head from Jemaa, Northern Nigeria. Nok culture, 500 BC–AD 220

Facing
The God of War, *Ku-kaili-moku*, from the temple of Kawaihae, Hawaii. Wood. Collected before 1829. Ht of figure 75.5cm

societies from those in which these technologies had been developed. Furthermore he often changed or destroyed the purposes for which the people carved or painted. The effect on their art was catastrophic. Even today, when the excesses of nineteenth-century colonialism are past and there is now a wide and genuine respect for the integrity of other cultures, the destruction of artistic traditions continues.

An early stage can be seen in the cult houses of the Sepik valley in New Guinea. One village on the main river, Korogo, produced *mwai* masks, wooden faces with shell discs for eyes, human hair stuck to the top and long noses that curve down to join the elongated chin. The *mwai* mask was not worn on the face but hung on the front of a bell-shaped construction, splendidly decked with coloured leaves, which forms the costume of a dancer.

The Middle Sepik remained a wild area where cannibalism and head-hunting were practised until the 1920s. Then the Australian government, which administered this part of the island at the time, set up a patrol post on the river and slowly established control over the area. So a few examples of *mwai* masks came to the ethnographic collections of Europe and America.

Only a limited number of *mwai* dancers performed in the festivals and it was not often that a new mask had to be made. The design did not vary greatly. The mask constituted a detailed symbol which the Korogo villagers well understood and which had been refined by the inspirations of generations of Korogo carvers into something that was uniquely theirs. This did not mean that all the images were identical, nor that the people were not able to appreciate qualitative differences between them. They were certainly critical of craftsmanship and had no hesitation in praising a mask that was skilfully carved or deriding one that was sloppily conceived or carelessly executed. But radical novelty was not required.

In the late 1940s and 1950s, visitors to the Sepik became more frequent, but when they took away an occasional *mwai* mask, there was no problem in making a replacement for the next festival. It might even be that this limited trade stimulated creativity in the village by helping to keep the sculptors busy and their skills alive.

In the 1960s, however, things started to change in a more wholesale way. In Europe and America, a taste for Melanesian art began to grow. When *mwai* masks appeared in the salerooms they fetched prices not in tens but in hundreds of pounds or dollars. The effect on Korogo was swift. Dealers began to pay regular visits to the village and were clearly prepared to buy all the masks that the people had available.

So the carvers started to work hard not to satisfy the demands of their own rituals but in order to have something for sale by the time the next dealer arrived. Soon after this, an enterprising tour operator began to ferry groups of wealthy visitors up the river in houseboats. Korogo, with its spectacular cult house within a few yards of the river bank, became a popular stop and the demand for masks increased yet again.

The sculptors were not slow to discover that the qualities they themselves prized in a mask were by no means those that ensured a quick sale to strangers or persuaded them to give a high price. Indeed it might well be the reverse. A large crude piece, more grotesque and therefore in the eyes of the visitors more barbaric, might appeal to buyers more strongly than a smaller more modest mask with the carefully worked details required if it was to be used in ceremonies.

Inevitably, making *mwai* masks for sale changed their character. The sculptors worked for customers whose tastes they did not understand and the visitors selected objects that they hoped were genuinely 'primitive' but without any comprehension of their visual idiom.

Thirty years ago, a visitor might, after much persuasion, have been allowed to see one or two of the *mwai* masks that were kept in the cult house hidden from the eyes of the uninitiated. Today, as soon as the visitor arrives, eighty or ninety masks are laid out in a long line on the floor for his inspection. Not all are totally debased. Among the inflated and distorted versions there are some that still conform to the earlier disciplines. The ceremonials are still held and there is still a demand for masks that serve their original function. But when the tribal religion, which is already in decay, finally loses its grip upon the people, the making of true *mwai* masks will doubtless cease altogether.

The end of the process of decay can be seen on the other side of the Pacific in Hawaii. When Cook arrived there in 1778, he found carvings that are among the most spectacular and powerful of all tribal works. Most awe-inspiring of them all were the images of *ku-kaili-moku*, the 'eater of land', the god of war. Cook's expedition collected several examples. Later visitors to the islands sketched the wooden gods as they stood in a grimacing line in the temple enclosures. By the early years of the nineteenth century, however, the increasing familiarity with the outside world that came with the burgeoning trade in sandalwood and the regular visits of European ships in need of victualling, eroded the people's faith in their old gods. In 1819 the old king, Kamehameha, a resolute pagan, died. A few months afterwards, the first American Christian missionaries were welcomed to the islands. The making of temple statues was forbidden, the existing ones were overthrown and either deliberately destroyed or allowed to rot. A few wooden carvings – about 150 in all – survived, some in forgotten caves on the island, most in museums and collections in Europe and America.

Today, Hawaii is visited by millions of people hoping to find hints of a Polynesian paradise where unspoiled people once lived carefree lives beside idyllic lagoons. So the tourist trade has resuscitated the old images and fitted them out with new names and bogus legends. They are called 'tikis', a Maori name that has nothing to do with Hawaii. *Ku-kaili-moku* has become the Ancient God of Good Luck, or alternatively the God of Love, neither of which existed in the traditional Hawaiian pantheon, and his terrifying, grimacing face has been mass-produced in plastic by a

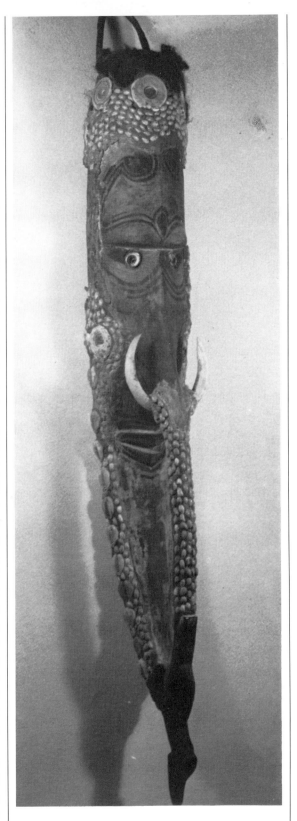

Mwai mask. Wood with clay, seeds and pig tusks. Korogo, Sepik River, New Guinea. Modern. Ht 71cm

Wooden souvenir mugs, Hawaii

factory in the Philippines, to be used as the handle of a bottle-opener or a key-ring charm or grossly simplified and degraded to form a modern mug.

Since art reflects the life and aspirations of a people, radical changes in their lives sooner or later alter the way they carve and paint. And change is inevitable. The world is contracting so fast that it is no longer possible for communities to remain totally isolated from the rest of mankind. Nor would many wish to do so. They can see skills and objects, devised by others, that could make their lives easier – and they want them. Such innovations need not be catastrophic. A society can absorb even revolutionary changes without damage if they are introduced with wisdom and insight.

The Dogon are oppressed by drought. Not only are their women condemned to hours of wearying labour fetching water from wells that may be miles away from their settlements, but sometimes even these distant wells fail and whole populations face death by drought. During the few weeks when the rain does come, it falls in torrents, cascading down the cliff-faces and turning the sand-filled gulleys into surging rivers. But within days of the end of the rainy season, most of this water that might make the difference between life and death in a few months' time has vanished into the ground.

An American anthropologist, Hans Guggenheim, visited the Dogon initially to study their art. Appalled by their plight, he spent a long time trying to devise some practical way by which he might help alleviate their slow annual torture by drought. Western methods of water storage, such as cisterns of corrugated iron, were out of the question. There was no money for such things in the kind of numbers that would be necessary. In any case, the country is so wild, with so few roads of any kind, that it would be impossible to get the construction materials to where they would be needed. Any scheme, to have a chance of real success, would have to rely on materials that were to a large extent available locally, and on a technology that was closely based on the people's traditional skills. Guggenheim, alive to the importance and significance of domestic architecture to the Dogon, determined that any solution would have to be one that did not destroy the aesthetic unity of the villages.

In the end he hit upon the idea of using ferro-cement – roughly speaking chicken-wire covered in cement. Every Dogon household has a granary, built with bricks of sun-dried mud and roofed with a cone of straw. Guggenheim's idea was that the interior of such a building should be lined with ferro-cement and that guttering should be built linking the surrounding flat roofs so that rain water falling on them would be channelled into the water-granary.

The first question was whether ferro-cement would be able to take the strain of several tons of water. Guggenheim arranged for engineering calculations to be made at the Massachusetts Institute of Technology. They confirmed that it would do so. But could the Dogon themselves construct such a building and would they want to anyway? Might there not be some fundamental religious reason that would prevent the people from putting such

a building in a household where every room has its symbolic meaning; and even if they were persuaded to accept it, might it not disrupt the philosophical basis of the people's lives and bring about profound sociological upset?

With such worries in his mind, Guggenheim introduced the idea with the greatest circumspection. The whole proposition was discussed in detail with Ogobara Dolo, headman of one of the main Dogon villages. Guggenheim built a small clay model to show exactly what he had in mind. After much discussion, Ogobara agreed that an experimental water-granary might be built in the courtyard of his own house. Before work could begin, however, one of the wise men of the village had to seek approval from an oracle.

Such consultations are customarily made at a special place outside the village in the dry bed of a stream. Ogobara and Guggenheim went down with the old man who was to perform the ritual. He drew a rectangular grid in the sand with a stick. In each square he placed a separate symbol – a hole stabbed with his forefinger, a small pebble, a twig, a tiny cone of sand poured from his half-clenched fist. Each represented a person, a place, a day. Finally he scattered a few grains of bait over the grid and en-

Frieze at the bottom of the newly carved door for the water-granary. Beneath a line of masked figures, the desert fox visits the sand oracle, a chicken is sacrificed and a goat led to the altar

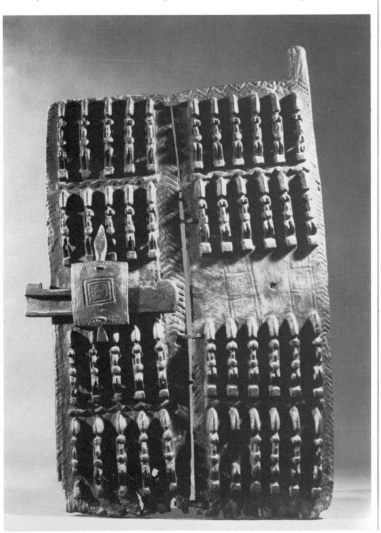

A traditional granary door, carved with lines of ancestor figures. Dogon. Wood of the panels joined with iron clasps. Ht 73.6cm

127

Hans Guggenheim supervising the placing of a straw roof
on the finished water granary

circled it with a ring of thorn branches to keep out the chickens.
During the night, the little desert fox, who is the representative of
Yurugu, the Spirit of Creativity and Prophecy, would be attracted by the bait, force his way through the branches and trot over
the grid leaving behind his footprints. Some symbols he would
obliterate, others would be left untouched. Such signs would
indicate to those who understood these matters whether or not
the water-granary scheme was acceptable to the gods.

Happily, the next morning the verdict was favourable. Even so,
no risks could be taken. A chicken and a goat were sacrificed on
the village shrine.

Guggenheim brought some of his students from America to
help in the construction of this first experimental building. But the
Dogon masons quickly grasped the principles and though the
technique of making ferro-cement was new to them, they understood far more than the American team about the potential and
limitations of mud-brick. The actual building took a mere two
weeks. The only materials needed from the world outside the
village were a roll of chicken wire and a few bags of cement. The
finished building was given a conical straw roof so that outwardly
it looked exactly like any other granary in Ogobara's household.
But Guggenheim wanted to add one final detail. In past times, the
granaries of an important man always had a special door, richly
carved with designs of the *nommo*, the ancestral spirits, and with
symbols that linked it not only to its owner but to the gods. Surely
this water-granary that was so new and yet so similar to the
traditional kind should also have a carved door?

The only man entitled to make these doors is the smith. He
agreed to accept the commission and there was considerable
discussion as to what symbols should be used. Those appropriate
to a granary for storing millet were not necessarily the right ones,
it was felt, for one that was to hold water. A week later, the smith
produced his answer. Two-thirds of the door was, like many
another granary door, filled by lines of *nommo* figures. But at the
bottom the smith had carved a frieze which told, as a comic-strip
does, the story of the genesis of this first water-granary. Yurugu is
shown trotting over the sand oracle, a sacrificed chicken is held in
the air and at the end a man leads a goat to a sacrificial altar.

Months had to pass before the arrival of the rains, but when
they came and water swirled across the roofs and down the
channels that led to the cistern, it filled to the brim – and held.
Now such cisterns are being built in several Dogon villages. Their
design does no violence to the coherence of village architecture,
they pay respect to traditional forms, and a new and life-giving
technology, wholly within the control and comprehension of the
people, has been assimilated into traditional life.

If the water-granary has had any effect on the sculptural tradition of the Dogon, it is likely to have done no more than to
stimulate it to proceed along traditional lines with renewed
vigour. The same material – wood – is being used for the same
function – a decorated door – by the same person – the blacksmith
– working with tools he has been using all his life.

Western influence on a people's art is not always so minimal. Sometimes it changes all those elements. People in the community who have never carved before start working a new material with new techniques and for unprecedented purposes. Then, hardly surprisingly, the people may produce new and extraordinary objects.

In 1948, a young Canadian artist, Jim Houston, went north to Cape Dorset on the far northern shores of Hudson's Bay to paint. He spent a great deal of time with the Eskimo. One day a man named Nonulialuk brought him a gift, a tiny stone caribou with inset ivory eyes. He had made it himself, yet it seemed to Houston to have all the qualities of the ancient ivory carvings that had been collected in the arctic a century earlier and which belong to a tradition that stretches back to prehistory. Some were shaman's charms, some counters for games, some were used for hunting magic and worn as amulets. Understandably, since these nomadic people had to carry all their belongings with them, these carvings were all tiny.

At the time of Houston's visit, the life of the Eskimo was changing radically. They no longer spent months sledging and hunting on the polar ice, but were settling, with the encouragement of the government, in permanent villages. They were progressively abandoning their old hunting life, but they found little to replace it in the new settlements. The people were in urgent need of a new way of earning a living and Houston saw it in Nonulialuk's carving. He took the little caribou and a dozen or so other pieces, some in stone and some in ivory, back to his studio in Quebec. Everyone who saw them admired them. Soon Houston, with the support of the government foundation, was back among the Eskimos, collecting more pieces and encouraging men throughout the settlements to start carving objects for sale in the south.

So began an industry which today has reached huge proportions. In the past, ivory from walrus and fossil mammoth tusks had been a favourite material, but there was nothing like enough of it to meet this new demand. So the men used stone. In the first years, the carvings were relatively small. Some, like the ancient ones, were only an inch or two long and could be held in the palm of the hand. Others were over a foot in length. The initial supply of handsomely patterned serpentine discovered by the first Cape Dorset carvers was soon worked out. New rocks were tried, including a smooth-grained slate. As time passed, even this became difficult to find and the carvers turned to the bones of whales that they found washed up in great numbers along the arctic beaches. And year after year, the size of the sculptures increased. Those responsible for organising the work, collecting it and shipping it down to the warehouses from which it is distributed to galleries throughout North America and beyond, encouraged the carvers to make traditional subjects – animals such as seals, caribou, owls and polar bears, or Eskimo scenes in which the figures wear seal-skin costumes and carry harpoons, even though such weapons and clothes are becoming increasingly rare in the Canadian Arctic. Such links with the tribal past have proved

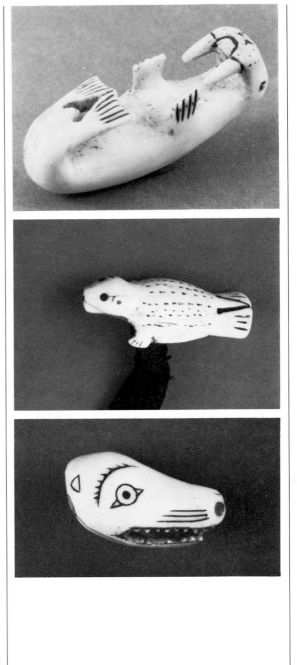

Ivory carvings. Western Eskimo. Alaska
Walrus. Length 3.5cm
Seal toggle 4cm
Dog's head 3cm

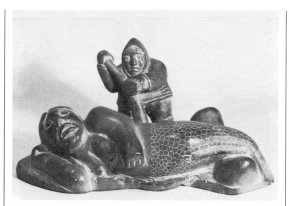

Hunter and mermaid. Stone. Modern Eskimo. Length 35cm

to be strong selling features. Houston and other admirers of this modern Eskimo art maintain that apart from the increase in dimensions and the utilisation of new materials, the work remains true to ancient traditions and feelings.

But there are critics, like the anthropologist Edmund Carpenter who has also had considerable experience of the Eskimo. He says that the carvings no longer have anything to do with Eskimo tradition except in the most superficial way. He quotes the example of Sedna, one of the most powerful and important of Eskimo deities, a sea-goddess who underwent many ordeals in the freezing Arctic waters during which she lost her fingers and one of her eyes. As a result of her mutilations, she is unable to comb her hair which hangs in matted locks over her face. She is a creature of deep tragedy and as poetic an image in Eskimo mythology as Orpheus in that of ancient Greece. This figure, Carpenter maintains, has been prettied up and, for the sake of sales, turned into a saccharine mermaid. The Eskimo are now carving not to meet

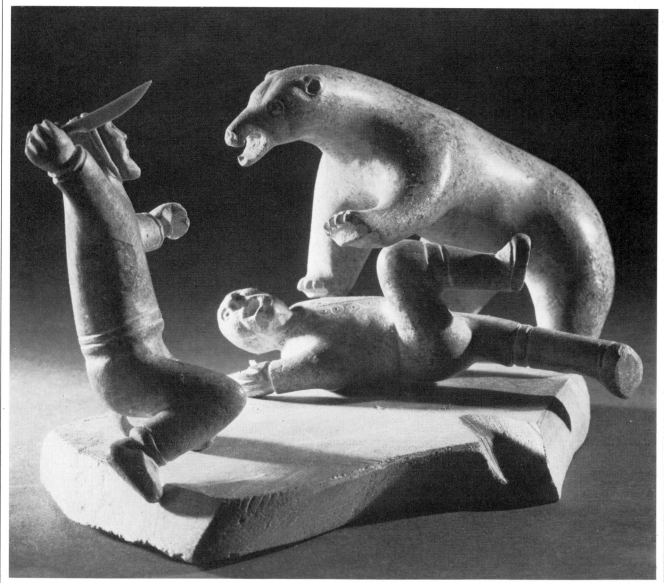

Man attacking bear. Stone. Carved by Kaunak, Repulse Bay, Northern Canada

their own needs but to satisfy the decorative tastes of an unknown and wealthy community a thousand miles away and making objects in which they represent themselves not as they believe themselves to be but as others wish to see them. The results, Carpenter and others claim, have lost everything that once gave Eskimo carving its unique power.

A similar controversy surrounds a development that is taking place in Nigeria. Here, however, it concerns not a tribal people producing work for a European market, but a European artist striving to put her skills at the service of a tribal community.

Susanne Wenger was born in Austria and trained, in the years immediately after the war, in the art schools of Vienna and Paris. She studied pottery and she painted pictures with intense mythological themes in a style that owed much to the Expressionist school of central Europe.

In 1950, she came to Nigeria. She continued painting on canvas but felt increasingly uneasy at doing so. Studio pictures meant nothing in the context of the Yoruba community in which she had settled. Her attention was caught by the local *adire* cloths. These are patterned by painting designs on them with cassava starch and then dyeing them with indigo. So she started painting on cloth but using *batik*, a similar resist technique from the Far East which uses wax instead of starch. This gives the artist better control and makes it easier to use many colours.

She settled in Oshogbo, a Yoruba town in central Nigeria. As time passed, she became more and more involved with the Yoruba way of life. Their traditional religion appealed deeply to her and Oshogbo is sacred to many *orisha*, Yoruba deities. However, both Christianity and Islam are today very strong in the town and many of the ancient shrines were falling down. She managed to get some money for restoration work and engaged two masons. Neither were *olorisha*, worshippers of the deities, but as they worked, building a wall around a sacred grove just outside the town, one of them modelled in the cement surface two little prancing spirit figures. Susanne Wenger was delighted and encouraged them to extend the figures in a frieze running right along the wall.

Her interest in the *orisha* deepened and she became an initiated priestess of one of the cults. When later she was asked to build a gate into the grove she had, for the first time, the opportunity of erecting a sacred building that was entirely new and had no precedent. For months she visited the site, sitting there for many hours at a time looking into the branches of the huge trees, 'begging them', as she put it, 'to transmit their aesthetic laws to me'. Eventually the project became clear in her mind. It would take the form of two huge pythons with their heads intertwined above the gate. She described her idea to Adebisi Akanji, the mason who was to do the work, drawing a plan in the dust and indicating the shapes with her hands. Adebisi then began the construction, interpreting Susanne Wenger's ideas into swirling shapes of mud cement. Every day, they reviewed progress together and debated plans for the next stage, until the gateway was at last complete.

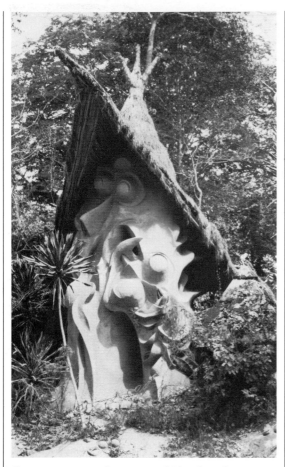

Shrine representing the meeting of Obatala and
Shango, designed by Susanne Wenger. Oshogbo

This was the first in a series of extraordinary buildings that now
stand on the sacred sites of Oshogbo. They are unlike anything
else in all Africa. The biggest of them so far is a huge triple shrine
dedicated to the Ogboni society whose concern is the worship of
the *orisha* of the earth. Three peaked roofs, representing lizard
heads, crane thirty feet into the sky, supported by a forest of
pillars carved with figures by another Yoruba artist collaborating
in the projects. Beneath, huge-eyed creatures of cement peer
from dark corners. In a nearby building a group of giant figures
lean out stretching their fists in front of them in a gesture that is
used by Ogboni worshippers to greet the earth.

These shrines are now used by the *olorisha* for their cere-
monials. People come from distant towns to take part and the
worship of the *orisha* in Oshogbo has suddenly had a new surge of
life. The power of the shrines is recognised even by non-believers;
one of them was burnt down by a Muslim fanatic.

There can be no dispute that these amazing shrines represent a
radical departure from Yoruba style, which has been, and remains
elsewhere in Yorubaland, one of the most noble and inventive of
African artistic traditions. For many critics, that in itself is enough
to make the buildings desecrations of ancient sacred sites. But if
novelty itself is not an automatic condemnation, how are we to
assess the shrines? Should they be judged according to the canons
of Yoruba tradition or those of post-war European art? Or is there
any need to relate them to either? Similar questions can be asked
about the Eskimo stone carvings and many other recent products
of tribal people. How should we rate the fantastic ebony carvings
produced by the Makonde of East Africa, the bark painting of the
Australian Aborigines and the gourds decorated with lively scenes
of village life made by Peruvian Indians. What, too, are we to make
of the ranks of carvings that line the pavements outside every
tourist hotel in the tropics and crowd the shelves of airport shops?

A further fundamental question underlies these specific ones.
Museums, films, books and magazines today parade objects from
countless widely-different cultures for our inspection and plea-
sure. There is no part of the world, no chapter of man's known
history that has not now surrendered a representative selection of
its artefacts to our gaze. Never has any society been confronted
with such a varied babel of visual riches. Is there a universal
aesthetic by which we can divine the quality of a work, no matter
where it comes from, simply by looking at it shorn of all context?

Sculpture, like all art, is a form of communication. We, who
are reared in the Western European tradition, are predisposed to
communication by the written word. Consequently, we are accus-
tomed to assessing the quality of a piece of writing. We can
without difficulty recognise the richness of its vocabulary and the
correctness of its grammar. We readily appreciate the aptness and
elegance of a phrase and relish the originality of a metaphor. We
have fairly clear ideas about what constitutes the difference be-
tween prose and poetry. Sculpture has elements which parallel all
these characteristics. What is more, if we use literary terms to
examine a carving, we may not only gain new insight into a work,

Susanne Wenger painting batik in Oshogbo Shrine depicting the meeting of Shango and Obatala, designed by Susanne Wenger. Oshogbo

but also come closer to appreciating the reactions of a tribal people for whom sculpture is a primary language.

There are qualities in a spoken or written language that we can appreciate even if we do not understand the meaning of a single word. We can, in an unknown poem, recognise rhyme and rhythm and a certain musicality of sound. Similarly, we can see abstract qualities of form in a sculpture made by an unknown people. Its curves may move in a rhythmic way, its shapes echo one another pleasingly.

A predilection for a particular repertory of shapes is what characterises a tribal style. It becomes the accepted convention to represent an eye by a particular geometric shape and to make the length of a torso bear a certain proportion to the size of the head; to favour rectangles rather than curves. So it is possible to look at an object and deduce from its style alone that it was made by a particular people, just as you may guess from rhythm and vowel sounds that a language is Italian, German or Dutch even when you have no idea of what is being said.

A sculptural tradition has implicit rules that are akin to a grammar. Bill Holm, the anthropologist and art historian, has described a particularly complex and strict set that was followed by the Northwest Coast Indians. It specified the correct order in which the elements of a design should be carved. It determined particular symmetries and stipulated precise ways in which lines should expand, contract and turn upon themselves. Grammatical accuracy does not guarantee eloquence in sculpture any more than it does in a piece of writing, and there are Indian carvings that are both correct and banal. Equally, a great sculptor, like a great writer, could break a rule on occasion in order to achieve a dazzling effect. But in general, grammar was an aid to comprehension and a measure of elegance and skill. Ignorance of it, or slipshod attention to its requirements, not only exposed the ineptitude of the artists but seriously risked confusion of the message.

To the extent that shapes imitate nature, their meaning is as easy to understand, just as it is easy to guess the meaning of words like *hiss*, *crash* and *buzz*, which mimic natural sounds. In most sculpture, naturalistic elements are much more important than they are in a spoken or written language. There are also shapes which, while they do not bear a detailed resemblance to the object they represent, have such a deep significance for us that they are universally recognisable. A phallus, a breast, a vulva can be indicated by the simplest of geometrical shapes and still be instantly meaningful. Similarly, the sound *mama* lies so close to the roots of human speech that it is common to many languages. Even so, we must be cautious about making easy deductions. The bared teeth of a statue may not be a scowl but a welcoming smile.

Some visual motifs, like most words, have a meaning that is arbitrary and unguessable. A zig-zag diaper pattern is used by the Murngin of Australia in their bark paintings to represent thunder clouds. The artists of the Italian Renaissance painted a dove flying in a shaft of sunlight to represent the Spirit of God descending to the womb of a mortal woman. Both symbols were well understood

by the people for whom they were painted. But if the spectator knows nothing of Murngin myth or Christian iconography, it is as unreasonable to expect him to divine their meaning as it is to expect someone who knows no German to guess that *Kartoffel* means *potato*.

Symbols can be manipulated, juggled and borrowed just as words can be. If a word has several meanings in the same language, it can be used as a pun and both the Northwest Coast Indians and the Eskimo had a particular delight in visual punning, using one shape to represent two different things at the same time – a staff is also a phallus, a whale's fin is simultaneously a seal's head. Both words and symbols may be borrowed by one language from another. A New Guinea man may incorporate a Christian cross on a spirit board with as vague an idea of its original meaning as an Englishman using a French expression that he does not quite understand.

So with a vocabulary of meaningful shapes, deployed according to the conventions of an accepted grammar, tribal artists conveyed their messages. The Northwest Coast sculptors proclaimed pride in lineage and the entitlements won by ancestral demi-gods; the Malekulans revealed the nature of the spirit world to newly initiated boys; and the Benin bronze-casters commemorated the military power of their god-king. The message might be as trivial as an everyday sentence – a simple statement of ownership or a magical spell to bring effectiveness to a weapon – or it could tell with eloquence and subtlety of the most profound matters, as a poem does, and so become a major work of art.

When people who speak different languages meet regularly, they invent a form of communication called pidgin. Pidgins of various kinds exist all over the world. They are based on a tribal language and a European one, usually that of an erstwhile colonial power such as English, German or French. In the initial stages of their development, they have a very restricted vocabulary and a simplified grammar. As a consequence, although they can be used effectively to express simple messages, it may be very difficult if not impossible to convey subtle details or abstract ideas with them.

The sculptural equivalent of pidgin is airport art. The message its purchasers require it to carry is primarily a simple declaration of where it was produced. It does this by concentrating on subjects that are widely identified with the place concerned and representing them in a straightforward naturalistic way that will be swiftly understood internationally. So sleek antelopes come from East Africa, full-breasted girls from Bali and hunters in seal-skin costumes carrying harpoons from the Arctic. Sometimes the image itself is freshly invented for the trade and empty of meaning – New Guinea people produce grotesque masks that symbolise generalised barbarism to their visitors but which bear no resemblance to any traditional piece.

So the carver of airport art limits his vocabulary; he abandons the traditional forms of his tribal style in favour of a universally comprehensible naturalism; and he produces an object that, while it may have charm, is a slogan rather than a poem.

Pidgin languages, however, develop. When contact between two peoples becomes more sustained, when they wish to say increasingly complex things to one another, then the language begins to grow into something new. It may become so elaborate and endow its inherited words with such specialised meanings and novel pronunciations that it has to be learned with as much care, and be spoken with as much regard to grammatical nicety, as any other developed language.

New Guinea pidgin is in such a condition. So, doubtless, at some time in the eleventh century was the combination of Norman-French and Anglo-Saxon that was the predecessor of medieval English. This is the parallel we should bear in mind when we try to assess the work of contemporary Eskimo carvers and Susanne Wenger. They are creating new sculptural languages, drawing elements from other traditions and with them constructing vocabularies and grammars of their own. In this difficult, demanding process, they may discover new formal qualities and bring to light new beauties that no one has recognised before. Their complexity and subtlety will be determined to some degree by the nature of their message. Susanne Wenger is not concerned with simple decoration. She and the Yoruba artists with whom she is working are striving to make statements of deep religious fervour. It is the fate of such innovators to speak in a language that is to a large extent incomprehensible except to those with whom they are communicating directly. It may be some time before it is possible for others to assess the quality of what they are saying.

A full understanding of a sculpture must take into account the three elements that the parallel with language has helped to identify – the universally appreciated abstract qualities of its form; the particular language of its style; and the message that it was created to convey. All three, however, form one indivisible amalgam. Each affects the way the others are expressed, so to be aware of only one or two elements is to risk misunderstanding the work as a whole.

The Dogon used sculpture to record their sacred knowledge and to convey it from one generation to another. Consequently a major piece like the Primordial Couple illustrated opposite provides a particularly rich example of eloquence on all these levels.

Paul Guillaume and Thomas Munro, in *Primitive Negro Art*, one of the first European books to examine African carvings as art, published in 1926, analysed the formal qualities of a very similar piece. 'The trunks, stiff and solid,' they wrote, 'are entwined with smaller rods, some long and some shortened to mere protuberances, all jointed in an angular staccato rhythm and flowing down with increasing unison to the springy and intricate framework of the base. The constantly varying direction of the rods gives the design three-dimensionality, in spite of the slenderness of its parts. The spaces between the rods, especially around the shoulders and the hips, function as do those about flying buttresses of a Gothic cathedral, to give a sense of airy dispersion and delicately articulated structure.'

Such an analysis helps to explain why the work may have so

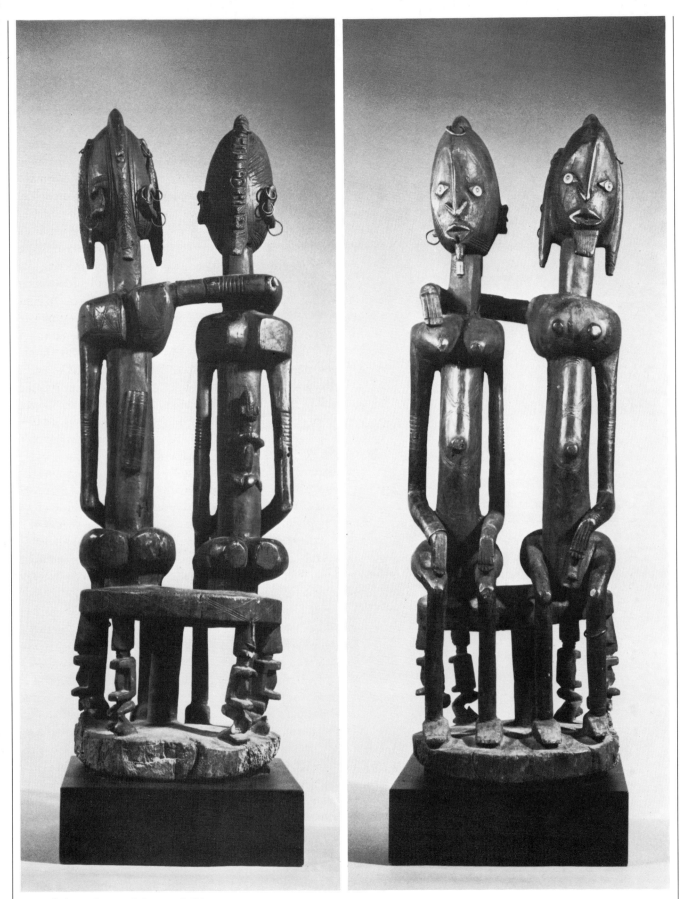

Primordial Couple. Wood. Dogon. Ht 74cm

powerful an impact upon those who look at it, no matter what their cultural background. It was this aspect of African sculpture that so impressed the Parisian painters at the beginning of the century. They found in such shapes sculptural ideas that helped them solve the problems of form with which they themselves were struggling. Their understanding of the exotic pieces was, however, far from complete. They believed, for example, that the tribal carvers had great freedom in the way they worked and admired the objects specifically for this imagined quality. They had no idea that the sculptors obeyed grammatical rules that were far more strict than the academic conventions against which they themselves were rebelling.

No one would judge a poem in a foreign language entirely in terms of its formal qualities of metre and rhyme, no matter how beguiling or inventive these may seem. It would be almost as unjust to limit an appreciation of the Primordial Couple to a consideration of its geometrical characteristics. A few years after the appearance of Guillaume and Munro's book, Marcel Griaule began to publish his researches into Dogon religious thought and in 1959 the American anthropologist Robert Redfield, in an important lecture at the Museum of Primitive Art in New York, contrasted the earlier aesthetic analysis with an interpretation of the symbolism of the Primordial Couple made possible by Griaule's work. Today, the continuing researches of the French school and others have given us even more information about the significance of the details in such figures.

The language in which the Primordial Couple is expressed is clearly far from incomprehensible even to someone who has never seen a piece of Dogon sculpture before. It is, to some degree, naturalistic – a male and a female figure are seated on a stool – but they are portrayed in a style that is by no means a slavish imitation of nature. The visual vocabulary employed and the grammar that governs it can be learned from other sculptures produced by the Dogon.

The disproportionate length of the torso and the portrayal of the buttocks by extending the cylinder of the upper thigh are both standard Dogon conventions. The differing number of rings in the ears is not accidental: four is the number appropriate to femininity and three the male number. The simple horse-shoe shape which represents the ears is not a quirk on the part of this individual sculptor, nor did he select it because he felt that it particularly suited the design. He used it because it is the recognised sign by which to show that a figure is a god. No attempt has been made to represent musculature of the limbs because Dogon style does not require this element of verisimilitude in either gods or men, but the bend in the arms, so much lower down than a normal elbow, and the drooping wrists and hands may have a particular significance. It may be an indication that these two beings were created before limbs acquired their joints, that they are, in fact, none other than the Primordial Couple.

Until we have such knowledge of the sculptural language of the Dogon, we cannot make an informed assessment of the eloquence

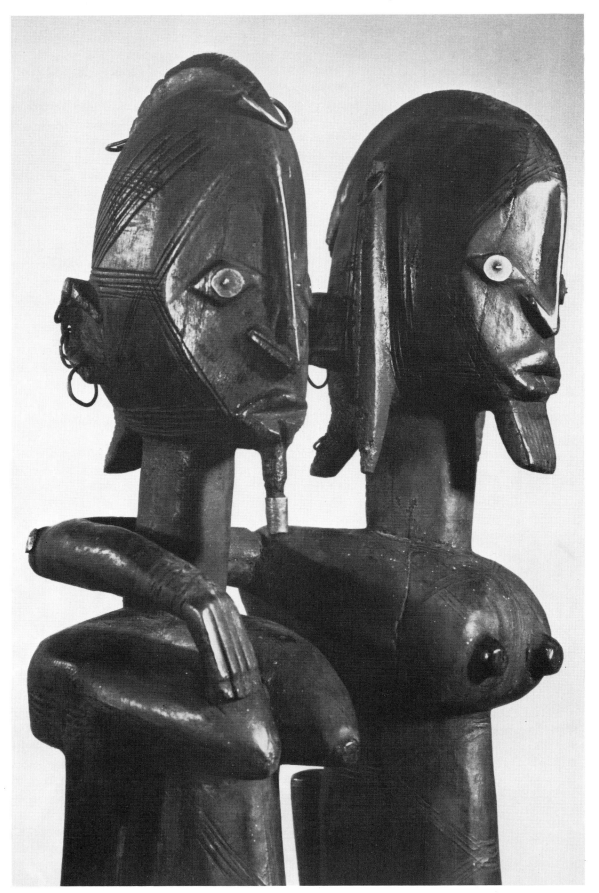

Primordial Couple – detail

of this particular piece or sense which of its statements are conventional formulations and which original inspirations.

And what of its particular message? The shapes of the ears and arms have already proclaimed the identity of these gods. The stool on which they sit has a central pillar, for it is an image of the world, the sky above linked to the earth below by a great tree, the axis of the universe. It is supported by the four ancestral spirits, the offspring of the Primordial Couple, each of whom was both a twin and a man and a woman in a single body. These are carved in a quite different style from the seated figures and one that harks back to the ancient carvings found in the Tellem caves. The rod projecting from the lip of the woman, which so elegantly echoes the peak of hair over the nape of her neck and parallels the man's beard, is a labret of a kind that is no longer used by the Dogon. The head-gear worn by both is not a Dogon style at all but that of the Peul, the nomadic neighbours of the Dogon with whom they were once at war and with whom, centuries ago, they made a pact.

Already we begin to see that this carving is an encapsulation of the structure of the universe, a testament to religious belief and a record of history. But why does the man have an empty quiver on his back? Why does he touch his genitals with his left hand and keep his right arm above the woman's shoulders, touching her so delicately with the tips of his fingers. Is this an invention of this particular artist or is it stipulated by the iconographic requirements of his message?

Even if we knew the answers to all these questions and many more, we may still be very far from appreciating the carving in a way in which it would be seen by a Dogon worshipper who, throughout his life, has been accustomed to comprehend philosophical ideas in visual terms. Content is not divisible from form; a message cannot be divorced from the medium in which it is expressed. The analogy with written or spoken language may be valid but it is only an analogy, and while a sculpture may convey a truth, it is not possible to do more than hint at that truth in words without distorting it. Ultimately, a sculpture can only be understood in its own terms.

Tribal objects appeal to us for many reasons and on many different levels. It is not only their formal sculptural qualities that move us, powerful though these may be. Were that the case, accurate copies or even the more skilfully made fakes that now abound in the art market might please us to an equal degree, even when we are aware of their real nature. The antiquity of an object or its rarity will make it attractive to many. The way it exploits the material from which it is made, the forms that come when hard wood is painstakingly worked with stone chisels, the patina produced by daily handling over a lifetime, these too can be a source of delight. There is also a special quality in a carving that achieves its effects within the rigorous discipline of a known tradition and which was made not as mere decoration but to serve a particular and important function.

Ultimately, however, the crucial characteristic of a work of art is its capacity to communicate. Like language, it is capable of

expressing the quintessence of a people's genius. Once we have learned to understand the individual as well as the universal language of works of tribal art, they can give us a unique insight into worlds that have now disappeared, a glimpse of the many different ways that once existed of being human.

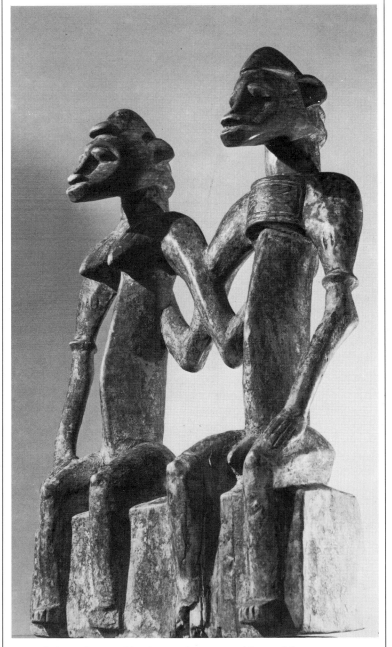

Primordial Couple carved by the Senufo, near-neighbours of the Dogon.
Wood. Ht 58cm

Further Reading

General

Biebuyk, D. (ed.), *Tradition and Creativity in Tribal Art* (University of California Press, 1969).

Christensen, E., *Primitive Art* (Crowell, 1955).

Forge, A. (ed.), *Primitive Art and Society* (Oxford University Press, 1973).

Frazer, D. *Primitive Art*. Thames and Hudson, 1962.

Frazer, D. (ed.), *The Many Faces of Primitive Art* (Prentice Hall, 1966).

Goldwater, R. *Primitivism in Modern Art* (Vintage Books, 1967).

Otten, C. (ed.), *Anthropology and Art* (Natural History Press, 1971).

Wingert, P. *Primitive Art* (Oxford University Press, 1962).

Chapter 1

Elisofon, E., and Fagg, W., *The Sculpture of Africa* (Thames and Hudson, 1958).

Griaule, M. *Conversations with Ogotemmeli* (Oxford University Press, 1965).

Laude, J. *The Arts of Black Africa* (University of California Press, 1971).

Laude, J. *African Art of the Dogon* (Viking Press, 1973).

Leiris, M., and Delange, J. *African Art* (Thames and Hudson, 1968).

Leuzinger, E. *The Art of Black Africa* (Studio Vista, 1972).

Meauzé, P. *African Art* (Weidenfeld and Nicholson, 1968).

Willett, F. *African Art* (Thames and Hudson, 1971).

Chapter 2

Boas, F. *Primitive Art* (Dover Publications, 1955).

Drucker, P. *Indians of the Northwest Coast* (Natural History Press, 1963).

Feder, N. *American Indian Art* (Abrams, 1973).

Hawthorn, A. *The Art of the Kwakiutl Indians* (University of Washington Press, 1967).

Holm, B. *Northwest Coast Indian Art* (University of Washington Press, 1965).

Chapter 3

Emmerich, A. *Sweat of the Sun and Tears of the Moon* (University of Washington Press, 1965).

Gallo, M. *The Gold of Peru* (Aurel Bongers, 1967).

Jones, J., and Bray, W. *El Dorado. The Gold of Ancient Colombia* (New York Graphic Society, 1974).

Wardwell, A. *The Gold of Ancient America* (New York Graphic Society, 1968).

Chapter 4

Dark, P. *An Introduction to Benin Art and Technology* (Oxford University Press, 1973).

Fagg, W., and Dark, P. *Benin Art* (Hamlyn, 1960).

Fagg, W. *Nigerian Images* (Lund Humphries, 1963).

Willett, F. *Ife* (Thames and Hudson, 1967).

Chapter 5

Allgrove, J. *The Qashqa'i of Iran* (Whitworth Art Gallery, Manchester, 1976).

Bennett, I. *The Book of Oriental Carpets and Rugs* (Hamlyn, 1972).

Erdmann, K. *Seven Hundred Years of Oriental Carpets* (Faber, 1966).

Haack, H. *Oriental Rugs* (Faber, 1960).

Chapter 6

Buhler, A. *Art of Oceania* (Atlantis Verlag, n.d.).

Force, R., and Force, M. *The Fuller Collection of Pacific Artifacts* (Lund Humphries, 1971).

Guiart, J. *The Art of the South Pacific* (Thames and Hudson, 1963).

Schmitz, C. *Oceanic Art* (Abrams, 1972).

Chapter 7

Beier, U. *Contemporary Art in Africa* (Pall Mall Press, 1968).

Beier, U. *The Return of the Gods. The Sacred Art of Susanne Wenger* (Cambridge University Press, 1976).

Burland, C. *Eskimo Art* (Hamlyn, 1973).

Carpenter, E. *Eskimo Realities* (Holt, Rinehart and Winston, 1973).

Redfield, R., Herskovits, M., and Ekholm, G. *Aspects of Primitive Art* (Museum of Primitive Art, New York, 1959).

Index

° indicates an illustration

abalone shell, 37
abrash, 99
Adam, Leonhard, 11
adaro spirits, 114, 116°, 117°
airport art, 135
Akanji, Adebisi, 131
Alert Bay, facing 32°, facing 33°, 43–46
Ambras Castle, 48
Ambrym Islands, frontis°, 107°, 108, facing 112°
aniline dyes, 99
Anthony Island, 30, facing 32°
Ardeshir, 97
Argillite carving, 37, 38°
Atahualp, 57
Australian Aborigines, 123, 132
Aztecs: capital, 49, 50; history, 50; mosaics 47°, 48°, 51°; myths, 50; noblemen, 51; temples, 50

Begi, Bahman, 103
Bella Coola, 29, following, 32°
Benin bronzes: casting, 80–82, facing 81°; dating, 80, 123; figures, 68°; heads, 73°, 74, 80, 81°, 82°, 83°; origins, 77; sale of, 72; source of metal for, 81
Benin herbalist, following, 80°, 86
Benin ivory, 72°, 73°
Benin jester, 85°
Benin Massacre, 69–70
Benin palace, 72, 73, 80, following 80°, 85, 86, 87°
Benin Punitive Expedition, 69, 71°, 72, 80
Bergama, 89
Bini, 11, 69, 73
Boas, Franz, 11
Bogota, 63, 65
Bokhara, 10
bonito, 114
boteh, 100°, 101
Botgate, 107–110
Braque, Georges, 9°, 10
British Museum, 36, 47, 72

Cajamarca, 57
cargo cults, 116
Carpenter, Edmund, 130

Carpets; in European painting, 89, 90; invention and technique, 90; use by nomads, 93; woven in towns, 102, 103°
Caso, Alfonso, 54
Cellini, Benvenuto, 48
Charles V of Spain, 47, 48, 57
Chibchas, 63
Chilkat blanket, 31°, 32, 42
Coclé, pendant, 61°, following 64°
Contractors Ltd., 65
Cook, Captain James, 36, 37, 106, 125
Copper, natural occurrence, 36
Coppers, 39, 41°
Coral beads, Benin, facing 80°, 85
Coricancha, 56, 57
Cortes, Hernan, 47, 49, 52
Costa Rica, pendant, 58°
Crusades, 89

Damascus, 89
Dapper, 80
Darius, 96
Darwin, Charles, 9
Derain, Andre, 9, 10
Diaz de Castillo, Bernal, 51, 58
Dick, Arthur, facing 33°, 44–46
Dogon: architectural symbolism, 14; *awa*, 16, following 16°, 20, 23; blacksmith, 14°, 15°, 26; caves, 24, 26°, 123; carving technique, 16–17, following 16°; costume, 23; divination, 127; funerals, 17, following 16°, 22–23; *ginnas*, 13, facing 16°, 17, 26; granary doors, 25, 127°, 128; history, 24; *hogon*, facing 17°, 20, 25, 26; iron figures, 15°, 16°; *kanaga*, 16, 18°; *lebe*, 20, 25; masks, 19°, 23°; mythology, 20; *nommo*, 20, 26°, 128; *nyama*, 17, 20; Primordial Couple, 13°, 26, 136–140; sacrifice,

facing 16°, facing 17°, 17–18; shrines, 14; *sigi*, 16, 23; Tellem, following 16°, 24; territory, 13; *toguna*, 14, facing 17°, 20, 24°, 25°; tortoise, 25; water storage, 126–128; wooden figures, 20°, 21°, 22°
Durer, Albrecht, 47, 49, 67

Edenshaw, Charles, 38°
El Dorado, 63, 64, following 64°
Emeralds, 63
Eskimo, 129°, 130°, 132, 136

Fagg, Bernard, 123
Fagg, William, 79, 80, 123
Fang, 8°, 9
Farashband, 98
Fauves, 10
ferro-cement, 126, 128
Frobenius, Leo, 77–78
Fry, Roger, 11
funerals; Botgate, 108–110; Dogon, following 16°, 22–23

Gallwey, Captain Henry, 69
ghelims, 98, 102°
gold: appeal to Europeans, 49; collection, 54; occurrence in South America, 52–53; techniques for working, 55; West African, 77
Golden Man, 63–64
grade rituals, 107°–109, facing 112°
grammar, 134
Griaule, Marcel, 14, 138
guacero, 58–59
Guadalcanal, 118, 119
Guatavita, Lake, 64
Guggenheim, Hans, 126–128
Guillaume, Paul, 136

Haida: argillite carving, 37, 38; contemporary art, 42; poles, 30°, facing 32°; rattle, following 32°, 42°; style, 32; territory, 29; villages, 28°, 30

Hamilton, Ron, 44, 45
Harris, Walter, 43
Hawaii: souvenirs, 125, 126°; war god, 122°, 125
Herodotus, 90, 92
Holbein, Hans, 88°, 89, 90°
Hole-in-the-Sky pole, 30, facing 32°
Holm, Bill, 42, 134
Houston, Jim, 129, 130
Hunt, Henry, 42

Iatmul, 111
Ibo, 74
Ife, 77, 78°, 79°, 80°
Igueghae, 77
Ika, 60, 62
Incas, 55, 56°, 57°, 58, 67°
Indian Act, 41
Iron: occurrence on the Northwest Coast, 36, 37; use by the Dogon, 15°, 16°

Kitwancool, 30
Korogo, 124
'Ksan', 42, 43
Kwakiutl: bowl, 35°; cannibal spirits, 33, 34, 45; contemporary arts, 42; crests, 29; dancers, 29; doorpost, 43°; *hamatsa*, 33, 34, 44; history, 36; *hohok*, 33; masks, 34, 35°, 45; myths, 29; paints, 37; poles, 32, facing 32°; potlatch, 41, 43; property, 39; territory, 29; *tseyeka*, 33, 36; style, 32, 33

Lotto, Lorenzo, 88°, 89
Luschan, Felix von, 79

Makaruka, facing 113°, 120, 121
Makonde, 132
Malekula, 106, 108
Manillas, 77
Maprik, 112
Marching Rule, 116, 117
Matisse, Henri, 9, 10
Melanesians, 105, 106
Michtlantecuchtli, 52°, 54
Mixtec, 54°, 55°, 58, following 64°

Mochica, 56°
Montezuma, 47, 49, 50, 51, 52, 54, following 64°
Moro, facing 113°, 118–121
Muiscas, 63°, following 64°, 64°, 66°
Muldon, Earl, 43
Munro, Thomas, 136
Museum of Primitive Art, 11, 138
mwai masks, following 112°, 124, 125°

nambas, 106
New Guinea: cult houses, 104°, 111°, 112°, 113°; early styles, 123; languages, 105
Niger River, 24, 69
Niger River Protectorate, 69
Nimpkish, 43
Nineveh, 92°
Ninstints, 30, facing 32°
Nok, 123°
Nomads, 93, 96, 102
Nootka, 29, 36, 37, 44, 46°
Nyendael, 80

Oaxaca, 54
Oba of Benin 69–70, 73, 77, 85, 86
Oba Adolo, following 80°
Oba Akenzua II, facing 80°, 85, 86
Oba Oguola, 77
Oba Ozuola, 85
Oshogbo, 131

Paints, on Northwest Coast, 37
Panama, 58°, following 64°
Papuan Gulf, cult houses, 104°, 106°, 112°
Pazyryk, 90, 91°, 92, 97
Persepolis, 96, 97
Phillips, Vice-Consul James, 69, 70
Picasso, Pablo, 9, 10°
Pidgin, 135, 136
Pizarro, Francisco, 56, 57
Portuguese, in Benin, 74, 76°, 77, 80
Potlatch, facing 33°, 38–41, 43, 44–46
Primitive, inaccuracy of term, 11
Puns, 32, 135

Qashqa'i: costume, 96; looms, 99; migrations, 95°, 96, following 96°, 98, 102; origins, 93, 101; patterns, 100, 101; rugs, following 96°; weaving, 98, 99°; wintering grounds, 98
Quesada, Hernan de, 64, 65
quetzal, 48
Quetzalcoatl, 50, 51
Quimbaya, 59°, 62°, following 64°

rambaramp, 109°
Redfield, Robert, 138
Reid, Bill, following 32°, 42

Reza Shah, 93
Rockefeller, Nelson, 11
Rudenko, Sergei, 90

Sahagun, Bernardino de, 54
Salish, 29
Sapele, 69, 70
Sassanians, 97
Scythians, 90, 92
Seaweed, Willie, 41°, 45
Senufo, 141°
Sepik River, 111, following 112°, 124
Sepulveda, Antonio de, 65
Shell money, 119
Shiraz, 97, 102, 103
Sinu, 59°, 61°, 65°
Slaves: in West Africa, 77; on Pacific Northwest Coast, 29
Smallpox, on Northwest Coast, 37
Solomon Islands, 113, 114, 115°, 116°, 117°
Sotheby's, 65
Spaniards, on the Northwest Coast, 36, 37
Symbols, 135

Tairona, 59°, 60, 62°, facing 64°, following 64°
Tangi-Ab Gorge, 97°
Tellem, following 16°, 24, 123
Tenochtitlan, 49, 51, 52
Timbuktu, 24

Tlingit, 29, 32, 40°, 42°, 43°
tomako, 113, facing 113°, 114
totem poles, 27, 29, 30, 37, 43
Tribal, justification of term, 11
tribal style, 134
Tsimsian, 29, 30, 31°, 32, facing 32°, following 32°, 33, 41°, 42
tumbaga, 35
tunjos, 63
Turkoman, 102

Ushak, 89

Vakusa, David, 118, 120
Vermeer, Jan, 12
Vienna Ethnographic Museum, 48, 49
Vlaminck, Maurice de, 9, 10

Webber, James, 36
Wenger, Susanne, 131, 132°, 133°, 136
Willett, Frank, 79
Wool, 98

Xenophon, 93

Yabgatass, 107, 109, facing 112°
Yoruba, 77, 131

Zagros Mountains, 95

Acknowledgement is due to the following for permission to reproduce illustrations:

Black and White

Pages 8, 18, 23, 26(i), Musée de l'Homme, Paris; Page 9, Claude Laurens, Paris; Page 10, Collection Museum of Modern Art, New York, Lillie P. Bliss Bequest; Page 13, Private Collection, Germany; Pages 14, 15, 19, 20, 26(i), 127 (bottom), 137(i) and (ii), 139, Wunderman Collection; Page 16, Herbert Rieser Collection, Werner Forman Archive, London; Pages 17, 55, 83, 85, 141, Werner Forman Archive, London; Pages 20, 22, Charles Uht, Museum of Primitive Art, New York; Pages 21, 24, 25, Hélène Kamer, Photo Raymond de Seynes, Paris; Pages 28(i) and (ii), 40, American Museum of Natural History, New York; Page 29, Edward S. Curtis; Pages 31(i), 35(i) and (ii), 38, 44, 45(i), British Columbia Provincial Museum, Victoria; Pages 30, 36, 37, 41(ii), 42, 46(i) and (ii), 47, 48, 51(ii), 68, 71, 72, 73, 74(i) and (iii), 117(i), 122, 129(i), (ii), (iii), (iv), British Museum, London; Pages 39, 43(i) and (ii), 130(i), National Museums of Canada, Ottawa; Pages 34, 35(ii), Douglas Wadden, University of Washington Press; Page 31(ii), Smithsonian Institution, Washington D.C.; Page 41, W. Duff 1955; Page 42(ii), Peabody Museum, Harvard University; Page 53, Oaxaca Museum, Mexico; Pages 54, 56(i), 59(ii), 62(ii), 64(ii), 66, 67, 74(ii), 87, Museum für Völkerkunde, Berlin; Pages 56(ii), 60(i), (ii), and (iii), 64(i), 108, 119, 126, Michael Macintyre; Pages 58(i), 61(i), Museum of the American Indian, Heye Foundation, New York; Page 58(ii), Dumbarton Oaks (Trustees for Harvard University) Washington D.C., Robert Woods Bliss Collection; Page 61(ii), University Museum, Philadelphia;

Pages 65, 107(i), 113, 116, 117(ii), Field Museum of Natural History, Chicago; Page 63, Cleveland Museum of Art, Ohio; Pages 76(i), 78, 79, 84, Prestel Verlag, Munich, Herbert List; Page 80, F. Willett; Page 88(i) and (iii), 89, National Gallery, London; Page 88(ii), Kunsthistorischen Museum, Vienna; Page 90(i) Gomäldegalerie, Berlin, Jorg P. Anders; Page 90(ii), Metropolitan Museum of Art, New York; Page 91, Novosti Press Agency, London; Page 100, Whitworth Art Gallery, University of Manchester; Pages 106, 118, Museum für Völkskunde, Basel; Pages 109(i) and (ii), 110(i), (ii) and (iii), Kirk Huffman; Pages 104(i) and (ii), 112, Frank Hurley; Page 123, Jos Museum, Nigeria; Page 130(i), Hudson's Bay Company, Winnipeg; Page 132, Anna Benson Gyles.

Colour

Following Page 16: Sacrifice, Big House, David Collison; Hogon, Hans Guggenheim.
Following Page 32: All by Michael Macintyre except Hole-in-the-Sky Pole and Potlatch sequence.
Following Page 64: All by Michael Macintyre except feather head-dress, Werner Forman Archive; and jaguar pendant.
Following Page 80: Oba, Werner Forman Archive.
Following Page 96: Garden rug, Metropolitan Museum of Art, New York – Gift of William R. Pickering; Floor rug and bags, Whitworth Art Gallery, University of Manchester.
Following Page 112: Gong players, Kirk Huffman; Tomoko launching, Michael Macintyre.
All the other photographs are by David Attenborough. Picture research by Claire Leimbach. Maps drawn by Arthur Shelley.